D1603512

*136842

Weis

The silent scream: Alfred
Hitchcock's sound track

PN
1998
A3
H578
1982

**CHABOT
COLLEGE
HAYWARD CAMPUS
LEARNING RESOURCE CENTER**

25555 Hesperian Boulevard
Hayward, CA 94545

The Silent Scream

The Silent Scream

Alfred Hitchcock's Sound Track

Elisabeth Weis

Rutherford • Madison • Teaneck
Fairleigh Dickinson University Press
London and Toronto: Associated University Presses

PN
1998
A3
H578
1982

Associated University Presses, Inc.
4 Cornwall Drive
East Brunswick, N.J. 08816

Associated University Presses Ltd
27 Chancery Lane
London WC2A 1NS, England

Associated University Presses
Toronto M5E 1A7, Canada

Library of Congress Cataloging in Publication Data

Weis, Elisabeth.
 The silent scream.

 Bibliography: p.
 Filmography: p.
 Includes index.
 1. Hitchcock, Alfred, 1899–1980. I. Title.
PN1998.A3H578 791.43′0233′0924 80-71093
ISBN 0-8386-3079-0 AACR2

Printed in the United States of America

Contents

Preface———————————————————

If we are to believe what we read about the movies, film is a medium that should be seen and not heard. As a study of images, film criticism has achieved, in the last decade or so, a high level of sophistication. Yet most writers have concentrated only on visual style and have neglected the other equally important dimension of filmmaking—sound.

If we look at the movies themselves, however, we find that since the early seventies sound has been undergoing the renaissance predicted by Francis Ford Coppola in 1971 as the next major preoccupation of filmmakers. The major innovative artists are avidly exploring the expressive possibilities of sound. Robert Altman did it, in films such as *Nashville* and *A Wedding,* by experimenting with multichannel recording of dialogue. Alan Pakula did it in *All the President's Men,* when he overlaid the sound of gunfire with the sound of typing to suggest that the pen is mightier than the sword. George Lucas did it in *Star Wars,* where the computer-generated bleeps of two robots are—perhaps unintentionally—considerably more expressive than the trite dialogue of the human characters. And Coppola himself did it in his *The Conversation,* a film about electronic eavesdropping that explored the ambiguity of the sound track just as the earlier *Blow-up* had explored the unreliability of the image.

Long before the seventies, however, there were a few directors who consistently showed an interest in sound. Renoir, Lang, Antonioni, Godard, and Bresson are among those directors whose aural style is as distinctive and personal as their visual style. I have chosen to write about Alfred Hitchcock's sound rather than, say, Orson Welles's, because Hitchcock's aural style is relatively unobtrusive. To be sure, Hitchcock was an important innovator of sound techniques: *Blackmail* contains perhaps the earliest examples of expressionistic sound; *Murder* introduces the first known

interior monologue; *The Secret Agent* uses subliminal sound; and
The Birds includes experiments with computer-generated effects.
These innovations provide exciting high points both in the history
of film and in Hitchcock's own career. However, I do not intend to
treat these achievements as isolated events. Rather I wish to stress
how they fit into Hitchcock's overall style, to suggest that aural
style is inseparably linked with visual and thematic concerns. Thus
most of the book is about aural motifs that recur in the work of a
director who characteristically found something healthy in a
scream and something sinister in laughter or a children's song.

 This study, then, is a first step toward defining one director's
style descriptively rather than prescriptively—by what I have
found instead of by what theoretically ought to be possible. The
study shuttles between two purposes: to enrich our understanding
of Hitchcock, and to set up a few terms by which the aesthetics of
the sound track can be discussed. The latter purpose is undoubt-
edly hampered by the lack of an established vocabulary about the
use of sound. It is difficult to discuss what is unique about Hitch-
cock's way of filming a scene unless we have a sense of the conven-
tions against which he is working. We know the visual conventions
for filming routine scenes such as a conversation, but there is little
literature about the conventions and terminology of sound editing. I
hope someone will write a book that both defines the language of
film sound and describes the evolution of sound aesthetics. It could
answer such questions as: When did filmmakers first start cutting
away from speakers in midsentence? When did it become accept-
able to accompany a long shot of a couple in a car with the close-up
sound of their speech? How does postdubbing affect Italian films?

 I hasten to add that such details are not the major concern of my
book. Readers who find such matters of less than burning interest
may want to skim the first half of the chapter on the early talkies,
Blackmail and *Murder*. That chapter is necessarily more historical,
detailed, and technical than the rest of the book because it was the
limitations of primitive sound equipment that challenged Hitch-
cock to develop much of his approach to sound.

 Only when Hitchcock had worked out the relationship between
sight and sound could his style fully mature. Hence my title. The
opening image of the first personal Hitchcock film, *The Lodger*, is a

close-up of a woman screaming. Because *The Lodger* is a silent movie, the scream can be seen but not heard. In his penultimate film, *Frenzy* (like *The Lodger*, the story of Londoners pursuing a sexual psychopath), Hitchcock in two key scenes shifts away from the victims to the street below and plays with audience expectations about when, and if at all, a scream will be heard but not seen. The shifts to the outdoors in *Frenzy* tell us something both about Hitchcock's bleak view of the victim's chances for rescue and about the director's attitude toward his audience. For all the virtuosity of Hitchcock's visual style, his films became considerably richer when the availability of sound enabled him to work the image and the sound track against each other. This book is about the difference between the first silent scream and the last.

Two sets of thank-yous are needed. Some of the generalizations I make below about sound-editing practices are based on a series of unpublished interviews I conducted in New York and Hollywood with various recordists, sound and music editors, a cinematographer, an editor, and a director. The following people very generously taught me basic concepts, invited me to sound mixes, and provided some invaluable historical material: Mimi Arsham, Mark Dichter, Leonard Engel, Rudi Fehr, Lee Garmes, Erma Levin, Gordon Sawyer, Ed Scheid, Murray Spivack, James G. Stewart, Ken Wannberg, and Robert Wise.

Finally, I wish to express a word of thanks to John Belton, Leo Braudy, and Tom Gunning, who gave me the kind of ideas and advice that cannot be acknowledged in mere footnotes.

Photographs are reproduced by courtesy of: The Museum of Modern Art/Film Stills Archive (stills from *Strangers on a Train*, *Notorious*, *Blackmail*, *Secret Agent*, and *The Man Who Knew Too Much*), Movie Star News (stills from *Shadow of a Doubt*, *Lifeboat*, *Marnie*, *Rope*, *Vertigo*, *The Birds*, *Stage Fright*, *Rear Window*, *Frenzy*, and *Family Plot*), and Cinemabilia (*The Thirty-nine Steps*).

The Silent Scream

1 Introduction_____

In a famous attack on Alfred Hitchcock's work, Penelope Houston once complained that in *The Birds* (1963) "most of the menace [comes] from the electronic soundtrack, to cover the fact that the birds are not really doing their stuff."[1] I shall point out later how *The Birds*'s great reliance on sound effects is not only an aesthetic strength but a logical outgrowth of Hitchcock's creative development at that point in his career.[2] However, Miss Houston's comment is fairly representative in its implication that Hitchcock's use of film sound is a "poor relation" to his manipulation of the image.

The belief that aural techniques are a means of expression inferior to visual ones is shared by most film scholars and, indeed, by many filmmakers. It lingers from the beginning of the sound era, when visual expressiveness was limited by the technical necessities of recording sound. Sound technicians ruled the set for several years, and, as the traditional film histories rightly say, early talking pictures—with a few conspicuous exceptions—were inferior to their silent predecessors. Furthermore, the critical neglect of sound can be seen as a vestigial bias left over from the days when film scholars were struggling to define their discipline. Until recently serious film analysis predominantly emphasized visual style as an antidote to noncinematic approaches to film.

Hitchcock himself appears to have accepted this bias by constantly defining "pure film" as film that expresses its meaning visually—specifically through montage.[3] A close examination of his statements, however, reveals that he is objecting not to sound but to an excessive reliance on dialogue. He told Truffaut: "In many of the films now being made, there is very little cinema: they are mostly what I call 'photographs of people talking.' When we tell a story in cinema, we should resort to dialogue only when it's impossible to do otherwise. . . . In writing a screenplay, it is

13

essential to separate clearly the dialogue from the visual elements and whenever possible, to rely more on the visual than on the dialogue."[4]

Hitchcock's condemnation of static dialogue sequences therefore does not include sound effects or music. Hitchcock's often-stated goal was to hold the audience's fullest attention, and to this end he applied whatever techniques seemed most effective for his purposes. In his desire to maintain close control over his audience's reactions he never overlooked the possibilities inherent in the sound track. From the time of his first sound films he treated sound as a new dimension of cinematic expression. He hardly ever used it redundantly but rather as an additional resource. Indeed, he was actually very proud of his control over the sound track. Much later in the interview with Truffaut, Hitchcock said, "After a picture is cut, I dictate what amounts to a real sound script to a secretary. We run every reel off and I indicate all the places where sounds should be heard."[5] Such attention to sound is rare in commercial filmmaking. Most American directors leave all but a few important decisions to their editors and sound editors.

Of course, the proof of Hitchcock's claim about control of the sound track does not lie in his words but in his films. Close analysis of his work reveals a consistent aural style, one that is inseparable from his visual style and ultimately inseparable from his meaning. By demonstrating that sound is much more central to Hitchcock's work than has heretofore been appreciated, I hope to suggest that research into the aural styles of other directors will also be valuable. (Sound is so readily ignored that a recent book on movie *music* could be entitled *Soundtrack* as if the two were equivalent; only the subtitle properly delimits the subject.)[6] To date there have been no extensive analyses of aural style. Numerous theoretical essays on sound appeared during the late 1920s and early 1930s. Most of these came from filmmakers; René Clair in France, Eisenstein, Pudovkin, and Alexandrov in Russia, and John Grierson in Great Britain all wrote tracts expressing a preference for asynchronous sound rather than "talking heads";[7] and as filmmakers they made films that proved the expressive possibilities of asynchronous sound. However, film scholars writing on sound have largely restricted their speculations to theories about the types

and functions of sound. Spottiswoode, Kracauer, and Burch have all cataloged different combinations of sound and image available to the filmmaker, but there have been only a few studies of sound as an element of directorial style.[8] Occasionally a scholar sensitive to sound will have valuable insights into the way sound is used in particular films.[9] Of Hitchcockian scholars, Spoto is by far the most attentive to sound, although his most interesting observations usually pertain to music rather than sounds in general.[10]

The only directors whose sound styles have attracted wider critical attention are those whose aural style is most obvious, such as Orson Welles, whose sound track is as flamboyant as his visuals; Robert Altman, whose use of multiple tracks and mumbled dialogue sequences draws attention to the noncognitive aspects of his dialogue; and Michelangelo Antonioni and Jacques Tati, whose absence of dialogue calls attention to the presence of sound effects that help describe the depersonalized modern environment.

Concerning less conspicuous sound styles, however, almost no research has been conducted. As a start, it is hard to identify idiosyncrasies when there has been little classification of the conventions of sound editing (other than a few principles set forth in filmmaking textbooks). References to the use of sound in film histories tend to stop at 1932 or 1933—just before the time when sound editing began in earnest.

An analysis of aural styles might begin by characterizing directors according to their overall approach to sound. They might be divided among the expressionists (such as Welles and Sergio Leone), who exaggerate their aural techniques, and the classicists (such as Frank Capra and John Ford), whose styles are more subdued. This latter category would include the majority of film directors who merely follow convention without giving much thought to the creative possibilities of sound. It also includes, however, a figure such as Howard Hawks, who, while he does not draw attention to his sound track, characteristically uses sound in counterpoint with his images; that is, the tension in his films often derives from the contradiction between what his characters say and what they do. As for Hitchcock, he was an expressionist who moved closer to classicism as his style evolved.

It is also possible to characterize directors according to whether

their aural styles are closed or open.[11] Directors operating in a closed mode (e.g., Hitchcock and Lang) are selective, stylized, and more in control of their material; their world is self-contained. Directors operating in an open mode (e.g., Renoir and Altman) are more realistic and less in control of their materials; there is an implication of life beyond the frame and independent of the camera. This distinction has been made in terms of visual techniques, but only minimally in terms of aural style. Thus, Renoir's open sound track is characterized by sounds that emanate from beyond the left or right edges of the frame and by what I call "deep-focus" recording that allows us to choose between listening to the characters in the foreground or those in the background. Hitchcock's sound track, by contrast, allows for less freedom. When sounds are heard from beyond the frame their intrusion does not seem accidental, as in Renoir's case, but threatening. And when Hitchcock uses deep-focus sound, he controls which sounds we attend to; background sounds contrast with or comment on foreground sounds. Major sounds rarely overlap, as they do in Renoir's films, and sound effects are sparser, more selective. When contrasting Hitchcock's closed sound track with Renoir's open one, it is interesting to observe that, while Hitchcock was experimenting with the highly artificial manipulation and distortion of sound effects in his early sound films, Renoir was experimenting with naturalistic sounds recorded on location in such films as *La Chienne* (1931) and *Toni* (1934). In his autobiography Renoir boasted, "There is not a yard of dubbed film in *La Chienne*."[12]

To appreciate Hitchcock's attitude toward sound it is necessary to understand the conventional way sound is handled. Traditionally, the film sound track is divided among three categories: dialogue, sound effects, and music. These categories reflect a literal separation of the sound elements on separate tapes or tracks that is maintained until the three tracks are combined at the final mix, where the director and several sound technicians adjust the relative volumes of each track.

Despite the studio tradition of separating the three sound tracks, Hitchcock did not conceive of them as separate entities. One distinctive element of his aural style is a continuity in his use of language, music, and sound effects that reflects his ability to con-

ceive of their combined impact before he actually hears them to-
gether. Hitchcock does not take for granted the conventional func-
tions of a given track; there is an intermingling of their functions in
many instances. In three films where Hitchcock eliminates musical
scoring, for example, he uses sound effects to much the same
atmospheric effect: wind in *Jamaica Inn* (1939), waves in *Lifeboat*
(1943), bird cries in *The Birds*. Indeed, if in *The Birds* avian noises
imitate the functions of music (instead of musical cues, bird cries
maintain the tension), in *Psycho* (1960) music (screeching violins)
imitates birds at various points. This intersection of effects extends
to Hitchcock's use of the dialogue track. Although Hitchcock
played a large part in the creation of the screenplay, he showed
less creative interest in the dialogue per se than in such noncogni-
tive forms of human expression as screaming and laughter. Their
value as sound effects is usually as important as their significance
as human utterances. Similarly, Hitchcock pays less attention to
what a character says than to how he or she says it. A person's
actual words are less significant than his definition as glib or
taciturn, voluble or silent. If human utterances sometimes function
more like sound effects, conversely, Hitchcock's sound effects may
function more like language. He often ascribes very precise mean-
ings to his sound effects. He told Truffaut: "To describe a sound
effect accurately, one has to imagine its equivalent in dialogue."[13]

Hitchcockian music, too, is interesting less as a separate entity
than for its connections with other aspects of the film. Film music
is traditionally divided between source music—that is, music that
supposedly originates from a sound source on the screen—and
scoring (sometimes called underscoring), that is, background
music unacknowledged by characters within the film itself but
accepted as a movie convention. It is both too problematic and too
misleading to analyze scoring as an integral part of Hitchcock's
aural style. The composition of the music is the aspect of
filmmaking over which directors have the least control. They can
only vaguely describe the effect they are after and specify approxi-
mately where they want music. After a cue is written, their only
option is to accept or reject it, and Hitchcock, like most directors,
rarely made a composer rewrite a cue. The main choice is one of
composer, and that choice is influenced by economics and studio

contracts as well as by the personal styles of composers. Three of Hitchcock's principal composers were Dimitri Tiomkin, who composed four Hitchcock scores: *Shadow of a Doubt* (1943), *Strangers on a Train* (1951), *I Confess* (1953), and *Dial M for Murder* (1954); Franz Waxman, who composed the scores for *Rebecca* (1940), *Suspicion* (1941), *The Paradine Case* (1947), and *Rear Window* (1954); and Bernard Herrmann, who scored the seven films from *The Trouble with Harry* (1955) to *Marnie* (1964). Herrmann was also sound consultant to the scoreless *The Birds* and the original composer for *Torn Curtain* (1966). The best source for incidents about Hitchcock's relations with and choice of composers is Taylor's biography of Hitchcock.[14]

Hitchcock showed a serious interest in the scoring for his films not just by choosing the composers but by collaborating with them to an unusual extent before and during shooting.[15] Nevertheless, it is impossible to distinguish reliably his contributions from each composer's and therefore to consider scoring as a major component of Hitchcock's aural style. Ironically, the scoring for Hitchcock's films has been the only aspect of his sound track that has received much critical attention. Several books and many articles have been written on film scoring, and Hitchcock's major composers and their contributions to his films have received generous treatment (the more important writings are listed in the bibliography). These works have emphasized the continuity of the composers' styles, of course, more than the styles of the directors for whom they wrote. (The one exception is Spoto, who discusses the Hitchcock/Herrmann collaboration as the culmination of each man's style.)[16]

Much more valid in an analysis of Hitchcock's aural style than a study of the scoring for his films is a study of his attitude toward source music. Hitchcock had an abiding interest in finding ways to incorporate music into the very heart of his plot. As shown in chapter 5, Hitchcock frequently builds his stories around musicians and songs. Thus he can manipulate the audience's familiarity with and expectations about popular music as a way of defining character and controlling our responses without having to introduce any extraneous element. Hitchcock turns a piece of music into a motif that he handles like his other recurring aural or visual im-

ages. He loves to yoke music with murder: consider the Albert Hall climax of *The Man Who Knew Too Much*, or the association of the murderers with innocent tunes in *The Shadow of a Doubt* ("The Merry Widow Waltz") and *Strangers on a Train* ("The Band Played On"). By using source music Hitchcock has control over the music because it is available before production—unlike scoring, which is written only after the rough cut of a film is assembled.

Hitchcock's incorporation of musical ideas into the thematic conception of his films is yet another example of how he uses the traditional elements of the sound track in unorthodox ways. However, if one distinctive attribute of Hitchcock's sound track is the frequent intersection of the functions of the sound effects, music, and dialogue tracks, his sound track is also distinctively contrapuntal to the visuals. That is to say, the sounds and images rarely duplicate and often contrast with one another. During a Hitchcock film we are typically looking at one thing or person while listening to another. By separating sound and image Hitchcock can thus achieve variety, denseness, tension, and, on occasion, irony. A simple example of ironic counterpoint is the opening of the trial sequence in *Murder* (1930), where Hitchcock deflates the dignity of the court proceedings by undermining the sound of a trumpet fanfare with a shot of the judge blowing his nose.

It is possible to generalize about Hitchcock's overall aural style because many elements of it remain relatively constant and distinctive. It is also possible to distinguish several different aural styles within his oeuvre. (Like most other writers, I use the word *style* to describe both the constant and the variations in Hitchcock's manner of expression.) To some extent, the various aural styles correspond with chronological periods in Hitchcock's career, and they also correspond roughly with his visual styles during those periods. It would be an oversimplification, however, to restrict any given film entirely to one category. Although Hitchcock's visual style generally involved a shift of emphasis from montage in his English films to camera movement in his American films, for example, he did not forsake his dependence on montage for suspenseful or violent sequences. Similarly, his shifts in aural style are also primarily shifts of emphasis from some techniques to others. Before

I devote one chapter each to films I consider to be characteristic of the main styles of Hitchcock's films, I would like to sketch briefly the overall evolution of his aural style.

The most important shift of style in Hitchcock's films involves a move from expressionism toward greater realism. I am using the term *expressionism* in the traditional film context, which denotes visual (or aural) distortion of time, space, or sound as a means of rendering visible (or audible) interior truths or feelings. These feelings may either be those of the director himself or be attributed to a given character. Realism is a style of filmmaking that appears to manipulate space, time, or sound less. Expressionistic techniques generally draw more attention to themselves than do realistic techniques, which are less obtrusive. From the beginning of his career until about 1966, Hitchcock became more and more interested in audience involvement. He moved toward realism in an attempt to increase audience identification through his protagonists, an emotional identification that depended to an extent on a relative invisibility of technique. Not surprisingly, the biggest shift in his career came in his move in 1939 from England to Hollywood, where the American predilection for stylistic realism matched his own interests. (In subject matter the American films are in many ways less realistic than the finely observed films about English behavior, but that is another issue.) The bigger budgets and technical expertise available to Hitchcock in American studios enabled him to switch to a style less dependent on such techniques as miniatures and editing that are more distracting, even to the untrained eye, than are full-scale sets and lengthy tracking shots. In his British films Hitchcock resorts to both aural and visual expressionistic effects in moments when he wants to reveal the feelings of his characters. In his American films Hitchcock uses sound as a way out of visual expressionism. His distortions of sound draw less attention to his style than would their visual equivalents because audiences are less likely to notice aural than visual distortions.[17]

In his American films Hitchcock generally works harder to establish connections between the audience and his characters. Whereas his British villains are likely to be overtly insane or criminal characters, in the American films the audience is forced

to identify with the evil impulses in relatively attractive and normal people. Hitchcock in Hollywood is interested in the malevolence of so-called normality and in destroying audience complacency by making the viewer complicitous with evildoers. In order to force the identification between character and viewer he has to move the audience inside the minds of his characters without resorting to distracting techniques. Thus expressionism—a film style originally developed to get inside a character's mind—is paradoxically given up by Hitchcock when he is most seriously interested in exploring the psyche.

Tom Gunning has referred to the shift from the British to the American films as "a shift from melodrama to psychodrama"—a shift in focus from external events to a character's mind.[18] Gunning's distinction implies a lessening in distancing devices in the American films. In the British melodramas Hitchcock does not hesitate to draw attention to a clever technique or to the literary, stage, or cinematic convention with which he is working. Thus, in *Blackmail* (1929) the villain stands before a chandelier that throws the shadow of a handlebar mustache across his face, and in *Secret Agent* (1936) the villain draws a mustache on his own photograph. It is as if Hitchcock wishes to lessen a slight embarrassment at working in the genre by acknowledging it. Gunning observes that in the American psychodramas events may be just as melodramatic, but the exaggerations of technique or plot are motivated within the context of the films because they are presented as the perceptions of one or another character. It is the character whose perceptions are melodramatic, not Hitchcock's, and thus he can present the most outrageous situations or characters without worrying about their verisimilitude. He can present the most exaggerated techniques as a realistic re-presentation of a character's perception.

It must be stressed that although Hitchcock became more realistic in his American period, he has always worked in a highly stylized manner. He has rarely hesitated to overstate or exaggerate effects. The red suffusions in *Marnie* are as outrageous as the cocktail shaker turning into a stabbing hand in *Blackmail*. The example of the red suffusions points out a second caveat to those who would segment Hitchcock's career too neatly—namely, that

his changes in style are not pure. He returns to or elaborates on favorite stylistic devices throughout his career. It is accurate only to speak of general trends in his work, of changes of emphasis, of experiments with specific techniques; the stylistic distinctions between the films lose their validity if the stylistic continuities are forgotten. Having made the above qualifications, however, I do think it useful to look for stylistic variations in Hitchcock's oeuvre.

Hitchcock's first and third sound films, *Blackmail* and *Murder*, reveal constant experimentation with the various uses of sound. In these films Hitchcock can be observed trying both to overcome the technical obstacles of early sound shooting and to establish his personal attitudes toward the relation between sound and picture. Most of the experiments are in the expressionistic mode, the two most famous examples being the subjective distortion of the word *knife* in *Blackmail* and the interior monologue in *Murder*. Both experiments are attempts to convey a character's thoughts and feelings. Yet at the same time both techniques draw attention to themselves as tricks and leave the audience emotionally outside the characters.

In the British films that followed Hitchcock continues off and on to experiment with expressionistic sound techniques, but with one exception the techniques tend to be bravura effects in films that are otherwise less interested in penetrating the psyches of their main characters. The exception is *Secret Agent*, the film in which Hitchcock most consistently sought to use expressionistic techniques to convey the feelings of his protagonists. *Secret Agent* is the British film in which aural techniques clearly predominated over most other considerations when Hitchcock was planning the film.

At about the point when Hitchcock settled down to make a series of widely acclaimed films at the Gaumont studios, he consolidated his treatment into what might be called his classical style—a term chosen because it implies an apparent simplicity of form, an art that conceals art. Starting in 1934 with *The Man Who Knew Too Much*, Hitchcock found ways of building aural ideas into the very conception of his screenplay so that they did not seem as obtrusive as the expressionistic techniques. Although most of the Gaumont films typify this style of filmmaking, the classical style remains a major approach for the rest of Hitchcock's career. It tends to be

used for what are variously called the lighter pictures, the thrillers, or the melodramas (depending on the writer). The British films in the classical style are almost as realistic in technique as the American films, but when Hitchcock does try to convey the feelings of a character he is more likely to revert to expressionistic techniques. In short, the Gaumont films combine a relatively invisible, classical style with occasional outbursts of expressionism. By contrast, the American films operate in a more fluid, consistent style—Hitchcock's subjective style.

Most of the American films of the 1940s and 1950s can be called subjective films because in them Hitchcock is concerned with presenting things through the distorted interpretation of a character. (In this book the term *point of view* refers to the perspective not of the director but of a given character, whose perspective may or may not be distorted. The term *subjective* as used here implies a distortion that corresponds with a character's particular interpretation of reality.) In a subjective film Hitchcock may never bother to provide an objective alternative to the way things are presented. The quintessential subjective films of the 1940s are *Rebecca*, which presents the story mostly through the eyes of the heroine until her husband's confession, two-thirds of the way through the film, and *Suspicion*, which also features the perceptions of Joan Fontaine as an impressionable, romanticizing young heroine. In the 1950s the two most subjective films are *The Wrong Man* (1956), which devotes much of its energies to conveying its hero's feelings about imprisonment, and *Rear Window* (1954), which almost literally restricts the viewer to what the hero can see from his apartment window. The most subjective film of the 1960s is *Marnie*.

Rear Window is one of four American films made between 1943 and 1954 in which Hitchcock experiments with highly restricted space. In *Lifeboat* (1943), *Rope* (1948), and *Dial M for Murder* (1954), as well as *Rear Window*, Hitchcock limits himself to a single set. Having established such stringent visual limitations, Hitchcock uses sound in a highly creative way, often depending on it to establish tension. In other films Hitchcock often creates tension between what is in frame and what is out of frame. In the single-set films he creates tension between on-set and off-set

space. People outside the room (or, in one case, the boat) are a source of either menace or salvation. In all of the single-set films but *Lifeboat* Hitchcock suggests that on-set space may be subjective whereas noises from off-set space represent reality. The use of what I call "aural intrusion" as a metaphor for the penetration of the psyche by this reality is a distinctive component of Hitchcock's style and is the subject of chapter 7.

It is possible to argue that *The Birds* (1963) is an extension of the subjective style, but I find in that film that Hitchcock moves beyond audience identification with any character, a move initiated in parts of *Vertigo* (1958) and *Psycho* (1960). In *The Birds* Hitchcock deals abstractly with fear itself, rather than with any particular manifestation of it. He does give shape to these fears in the form of birds, but the birds are less important for what they are than for the reactions they elicit. *The Birds* is especially dependent on sound because of the nonspecific quality of sound effects.

After *Marnie* (1964) Hitchcock abandons his interests in probing the individual psyche. Although in his late films—*Torn Curtain* (1966), *Topaz* (1969), *Frenzy* (1972), and *Family Plot* (1976)—he reworks and elaborates on many of his previous ideas, he takes a more casual attitude toward audience identification or box-office popularity. For instance, in an age when the audience demands an explanation for each character's motivations, Hitchcock blithely eliminates explanations for behavior and concentrates mainly on actions. He also seems to have fewer qualms about breaking the screen illusion. In the very last shot of his works—the concluding shot of *Family Plot*—the heroine, a fake clairvoyant, winks at the audience after she has fooled her boyfriend into thinking that she has some psychic ability. That wink to the audience is really made by Hitchcock, the ultimate master of illusion. He acknowledges that connection in the promotional displays for the film, which feature the master himself winking at the viewer through the heroine's crystal ball. The viewer is now a participant in the perpetration of illusion rather than in the perpetration of crime. Because Hitchcock is less interested in audience identification, it is not surprising that he also depends less on sound effects, for he is concerned with behavior, a visible phenomenon, rather than the invisible forces that control people.

Because this book deals with some stylistic elements that are constant in Hitchcock's career, others that show continuous evolution, and still others that recur intermittently, I have not chosen a strict chronological treatment for the subject. Nevertheless, the chapters do fall into a general chronological progression. Chapter 2 is a description of Hitchcock's earliest sound experiments, *Blackmail* (1929) and *Murder* (1930). In chapter 3, I jump ahead to *Secret Agent* (1936) in order to complete the discussion of Hitchcock's experiments with aural expressionism. Chapter 4 presents the first of the classical films, *The Man Who Knew Too Much* (1934), as a paradigm for all the films in the classical style that becomes an essential component of Hitchcock's repertoire. This analysis is followed by the chapter on music as motif because Hitchcock generally incorporates music and songs in a classical manner. Then the subjective films of the forties and fifties are introduced and represented in chapter 6 via *Rear Window* (1954). This chapter is logically followed by the analysis of Hitchcock's use of aural intrusion—a technique I introduce in the context of *Rear Window*. The aural intrusion technique culminates in the three single-set films, *Rope* (1948), *Dial M for Murder* (1954), and *Rear Window*, that form a subset of the subjective films. After the two chapters on aural subjectivity, I devote a chapter to *The Birds* (1963) as the film in which Hitchcock moves furthest beyond subjectivity.

Whereas Hitchcock's stylistic emphases change over the years, a number of his thematic interests remain more constant. Several ongoing aural motifs, for example, concern Hitchcock's attitudes toward the relative value of silence, screams, and language as manifestations of human feelings. Silence, in particular, takes on moral values when Hitchcock uses it for characterization. A character's reticence may be a symptom of emotional immaturity, moral paralysis, or ruthless efficiency. Hitchcock's stylistic and thematic interests intersect when he links silence with control—an association that expresses a central tension throughout his work between the need for social order and the need for personal expression. Throughout the chapters and as a final discussion I analyze Hitchcock's career-long fascination with such aural motifs as silence, screams, and inexpressive language; their recurrence em-

phasizes the continuities as well as the changes within Hitchcock's
oeuvre.

Notes

1. "The Figure in the Carpet," *Sight and Sound* 32 (Autumn 1963):164.

2. It is the assumption of this book that Hitchcock was to a great extent in creative control of his work despite the collaborative nature of filmmaking. Most film scholars would agree that Hitchcock demonstrated a distinctive, personal style as well as a technical mastery of his medium. Even the predominant argument against Hitchcock—that his moral concerns are too superficial to rank him among the most serious artists—presupposes his control over the selection, preparation, and execution of his material. To date, the most thorough discussion of Hitchcock's responsibility for his work is François Truffaut's book-length interview with the director, *Hitchcock* (New York: Simon and Schuster, 1967); originally published as *Le Cinéma selon Hitchcock* (Paris: Robert Laffont, 1966). Although it would be valuable to have still more precise knowledge about the extent of the contributions made by Hitchcock's screenwriters, technicians, producers, and the like, I do not give many details about his collaborators, for that subject would entail a book-length study in itself. Instead, I share the assumption of Hitchcock's defenders and detractors alike that Hitchcock is largely responsible for the films as we see them.

3. See, e.g., his interview with Peter Bogdanovich in *The Cinema of Alfred Hitchcock* (New York: Museum of Modern Art, 1963), p. 4.

4. Truffaut, *Hitchcock*, pp. 42–43.

5. Ibid., p. 224.

6. Mark Evans, *Soundtrack: The Music of the Movies* (New York: Hopkinson and Blake, 1975).

7. René Clair's articles, written in 1929, can be found in his *Reflections on the Cinema* (London: William Kimber, 1963); the joint Russian "Statement," which first appeared in the Leningrad magazine *Zhizn Iskusstva* on 5 August 1928, is reprinted as Appendix A of Sergei Eisenstein, *Film Form: Essays in Film Theory* and *The Film Sense*, trans. and ed. Jay Leyda (Cleveland, Ohio: World Publishing, Meridian, 1957); John Grierson summarized his opinions in "Introduction to a New Art," *Sight and Sound* 3 (Autumn 1934):101–4.

8. Raymond Spottiswoode, *A Grammar of the Film* (Berkeley, Calif.: Univ. of Calif. Press, 1950), pp. 173–93; Siegfried Kracauer, *Theory of Film: The Redemption of Physical Reality* (London: Oxford Univ. Press, 1960), pp. 102–56; Noël Burch, *Theory of Film Practice*, trans. Helen R. Lane (New York: Praeger, 1973), pp. 90–104. Burch is sensitive to the aural techniques of filmmakers such as Mizoguchi and Bresson, but only as pointers to the dialectical structures he hopes to see more fully developed in the future. The best single source of articles on sound is Rick Altman, ed., *Cinema/Sound*, *Yale French Studies* 60 (1980). The entire issue is devoted to technical, theoretical, and historical essays on sound as well as case studies of its usage in three French films.

9. Among the best examples are Lucy Fischer, "Beyond Freedom and Dignity: An

Analysis of Jacques Tati's *Playtime,*" *Sight and Sound* 45 (Autumn 1976); 236–38; Phyllis Goldfarb, "Orson Welles's Use of Sound," *Take One* 3 (July/August 1971):10–14; and Jonathan Rosenbaum, "Bresson's *Lancelot du Lac,*" *Sight and Sound* 43 (Summer 1974):128–30.

10. Donald M. Spoto, *The Art of Alfred Hitchcock* (New York: Hopkinson and Blake, 1976), and "Sound and Silence in the Films of Alfred Hitchcock," *Keynote* 4 (April 1980):12–17.

11. The terms were originated by Heinrich Wölfflin in 1915 as a dichotomy in art history. The English translation of his work is *Principles of Art History: The Problem of the Development of Style in Later Art,* trans. by M. D. Hottinger (New York: Dover, 1950). Two film writers who organize much of their argument around the distinction between open and closed forms are Louis D. Giannetti, *Understanding Movies* (Englewood Cliffs, N.J.: Prentice-Hall, 1972), and Leo Braudy, *The World in a Frame: What We See in Films* (Garden City, N.Y.: Doubleday, Anchor, 1976).

12. Jean Renoir, *My Life and My Films,* trans. Norman Denny (New York: Atheneum, 1974), p. 106.

13. Truffaut, *Hitchcock,* p. 224.

14. John Russell Taylor, *Hitch: The Life and Times of Alfred Hitchcock* (New York: Pantheon Books, 1978). According to Taylor, p. 286, Hitchcock fought to retain Herrmann's services for *Torn Curtain* but was unsatisfied with the results and allowed Universal to bring in John Addison.

15. Giannetti, *Understanding Movies,* p. 201, and Evans, *Soundtrack,* p. 144.

16. Spoto, "Sound and Silence," pp. 14–17.

17. This assumption is based on informal observation. There has been no psychological research precisely to determine whether an adult film-goer is more attentive to aural or visual information when presented with simultaneous stimuli. Some of the initial work on audio and visual perception is reviewed by Karl M. Dallenbach in a series of articles, each entitled "Attention," for the *Psychological Bulletin:* vol. 23 (1926):1–18; vol. 25 (1928):493–512; and vol. 27 (1930):497–513. In Dallenbach's day and more recently, there have been a number of experiments involving some relationship between aural and visual stimuli in a nonfilm context but none in which meaning is involved. See, e.g., Jack A. Adams and Ridgely Chambers, "Response to Simultaneous Stimulation of Two Sense Modalities," *Journal of Experimental Psychology* 63 (1962):198–206.

18. Oral communication.

2 First Experiments with Sound: *Blackmail* and *Murder*_____

Hitchcock's use of sound in *Blackmail* and *Murder* is important in three respects. As historical documents the two films overturn some accepted notions of what was technically possible in filming with immobilized cameras and uneditable sound systems. As personal documents they represent Hitchcock's first major experiments in combining sound and image in ways that would not subordinate pictures to dialogue. As films that extend Hitchcock's expressionistic interests into the sound era, they reveal Hitchcock's earliest efforts to use aural techniques to convey a character's feelings. In addition, *Blackmail* already establishes Hitchcock's predilection for integrating music and sound effects with plot and theme, and it introduces most of his favorite aural motifs. Both films are interesting historically, but *Blackmail* is the more successful work of art because its aural techniques and motifs are an integral part of a stylistic whole.

Blackmail's aesthetic integrity is all the more remarkable given the uncertain circumstances under which it was produced— circumstances that are frequently misreported in film histories. Despite its reputation, *Blackmail* was not technically the first British sound feature, although it was immediately hailed as such.[1]

Another frequent misconception about *Blackmail* is that Hitchcock had the honor of being assigned specifically to make the first sound film for Britain. In fact, the situation nearly paralleled the production of the first American full-sound feature, *Lights of New York* (1928), which Bryan Foy secretly directed as a 100 percent talkie feature and then handed to Warner Brothers before they wanted to commit themselves to a full-length talkie.[2] British studio executives were as uncommitted as their American counterparts

about converting to total synchronism. According to Rachel Low, "In April 1929, B.I.P. announced that they had a temporary sound studio fitted up with R.C.A. Phototone and that their forthcoming film *Blackmail* would have a dialogue sequence."[3] Hitchcock's assignment was to synchronize only the last reel for speech. Once again a director took a chance that studio executives would not have authorized. "It began as a silent picture, but I had made preparations so that dialogue could be added. The completed product proved a great surprise to the late John Maxwell, who was then head of the company. He had expected the dialogue to be confined to the last reel, as a 'special added attraction.' . . . I like to remember all the studio executives were pleased. They advertised it as a '99 per cent talking picture.' "[4]

It is still not certain how much Hitchcock was able to plan in advance for sound scenes. His own versions of the story vary from telling to telling. He told Truffaut that, anticipating that *Blackmail* might be releasable in full sound, he shot it silent in such a way that a minimum number of synchronized talk scenes would have to be reshot when he did indeed get permission to add sound. "We utilized the techniques of talkies, but without sound. Then, when the picture was completed, I raised objections to the part-sound version, and they gave me carte blanche to shoot some of the scenes over.[5]

That explanation differs from one he gave a reporter in 1950: "I shuffled the script a bit, saving the good scenes until the last, and then shooting them all in sound. That way, the sound sequences were spotted all through the film, like raisins in a bun, and the company didn't realize what I was doing."[6] Neither description does justice to how well the dialogue sequences are integrated into the film as a whole. To appreciate his achievement one need only compare *Blackmail* with other films to which sound was added after they were first filmed as silents. These are called "goat-gland" talkies because the addition of dialogue sequences was expected to give them a shot of new vitality. Typical of the disastrous results of adding static synchronous sound sequences to otherwise fluidly shot silent pictures is Paul Fejos's *Lonesome* (1928), which juxtaposes nonsynchronized passages of Murnauesque lyricism and

fluidity with embarrassing patches of superfluous, static dialogue. There is some unevenness but no such equivalent schizophrenia in *Blackmail*.

Hitchcock's descriptions of the filming do not explain how he was able to conceive a shooting plan that produced a film that was highly effective in the silent version that was also released and yet was also so exemplary in its use of sound that its knife sequence (discussed below) is still, over half a century later, the most often cited example in film history of the use of nonrealistic sound in a narrative film. Chabrol and Rohmer, who had both silent and sound versions available for comparison, have said that the only sequence completely different in each version is the seduction. In the silent version the artist simply approaches the girl slowly and leaps at her. The sound version replaces that approach with the more gradual excitation of the artist after he initiates the seduction with a provocative song.[7] For all of the other sequences Hitchcock was able to retain much of the silent footage.

It is in part the makeshift and transitional circumstances of the filming that allowed Hitchcock to use sound with a flexibility and creativity that distinguished it from other early sound efforts. *Blackmail* was not only a popular hit but it was immediately claimed as a *succès d'estime* for both Hitchcock and the British film industry to the extent that, as Rachel Low puts it, "for a while any criticism of the British film was expected to collapse at the mention of *Blackmail*."[8] It even won over many of the numerous film critics of the period who were still arguing that a film should be seen and not heard, that sound would kill the art of film. Admiration for *Blackmail* is expressed in nearly every theoretical essay on the possibilities of asynchronous sound written throughout the thirties by leaders of the British documentary movement.[9]

Yet, famous as it is for its use of sound, *Blackmail's* admirers have rarely mentioned any specifics except the expressionistic tours de force—the knife sequence, the overloud doorbell, or the merging screams. From a historical viewpoint, however, *Blackmail* is just as unique in its treatment of dialogue. A close look at the dialogue sequences shows that the film belies almost every truism written in standard histories about the use of sound in the transi-

tional period from 1928 to 1930. For example, whereas films of the period supposedly always showed the speaker because producers thought that the audience must see the source of sound, Hitchcock very often has the speaker offscreen. Whereas films were supposed to have been photographed in long master shots (because sound could not be cut), Hitchcock only does so three times. Whereas cameras and people were supposed to have remained immobile, Hitchcock moves his characters and his camera during synchronized sequences.

To be sure, the truisms, though not completely accurate, do describe the normal techniques of synchronized shooting in the first two years of sound. It is true that exceedingly bulky cameras were placed in stifling hot soundproof booths, sardonically called "ice boxes." It is true that multiple cameras were used because it was not possible to edit sound and picture separately. Film histories rarely acknowledge, however, that it was possible, for almost any given technique, to achieve the effects possible now.[10] The limitations were of time, money, and imagination even more than of technical capability. It was possible to move the camera (by putting the booth on wheels), to substitute voices for the characters who appeared to be speaking (as Hitchcock did in *Blackmail* by substituting Joan Barry's voice from offscreen for the thick-accented Anny Ondra's), even to edit sound after it was recorded (although this process resulted in a loss of fidelity because it required an extra loss of one generation from the original footage). In most cases primitive shooting methods were used because the more elaborate measures needed to circumvent them would have slowed down production prohibitively—unless they were restricted to cases of great need. Moreover, the primitive techniques—the mere sound and sight of people talking—so delighted audiences with their novelty that to go to any special trouble was an artistic indulgence not required commercially. If historians offer different versions of who first invented the microphone boom or put the "ice box" on wheels, that is partly because innovations in technique often occurred simultaneously in several studios (in Hollywood and England). Contrary to legend, innovations often spread overnight from studio to studio. The early directors and technicians were

discovering new technical possibilities and solutions every day in their field, and most of them openly shared their discoveries at first.

Blackmail is almost a compendium of the silent and sound styles of shooting dialogue. In the first reel, the only one to remain unsynchronized, there are two interrogations of an arrested man. The first is cut using a master shot and a few cutaways. The second makes use mostly of reverse angles of the antagonists. The phrases are articulated so clearly in the latter sequence that lips can be read and there is no need for titles. The first two synchronized scenes—a conversation between three people in the police station lobby and an argument scene at a restaurant—are also filmed primarily in master shot, with a few unsynchronized reaction and insert shots. These are the exceptions, however. Most dialogue scenes move the camera away from the speaker, either by dollying in on a detail or by panning to a listener. *(Blackmail* has several pans of up to thirty degrees in synchronized scenes. Although these are also not supposed to have been technically feasible until blimps were invented,[12] limited pans can be seen even in the first program of Vitaphone shorts publicly screened in 1926.)

Certainly, *Blackmail* has its stilted moments, especially in speech delivery. Even the better actors at the time were hampered by the need to speak distinctly for the relatively insensitive microphones. However, Hitchcock also includes several scenes where dialogue is intentionally incomprehensible—a daring device at the time. In the first-reel scene when two policemen come off duty, dialogue is added for the first time, but not synchronism, and we are supposed to get merely the gist of their conversation. Surely, the fact that one actress had to mouth the words perfectly while another delivered them offscreen affected the rhythm of the heroine's dialogue. Durgnat suggests that this accident of production added vulnerability to the girl's character: the "sparse, faint restraint of delivery expresses lostness rather than stiff upper-lip."[12] There is also a classic moment of stilted character movement parallel to the infamous barbershop sequence in *Lights of New York* (1928), in which one is able to identify the location of the microphones. The artist (Cyril Ritchard) pours a drink at one location and, while speaking, moves to the center of the room, where he

pauses artificially to wipe his hands as he delivers another line to a
concealed microphone. However, Hitchcock follows this shot with
a clever ploy. When Ritchard continues across the room Hitchcock
switches to a reverse angle of the shot so that we hear the artist
speaking as we follow behind him. John Ford in the same year *(The
Black Watch)* had also discovered the advantages of having speak-
ers walk away from the camera in order to add motion to a dialogue
sequence.

It might be argued that Hitchcock's avoidance of "talking heads"
is not a virtue, but a necessity prompted by the desire to add sound
after the silent version was made, while reshooting as little as
possible. Yet Hitchcock uses offscreen sound that is relevant to his
content. Furthermore, although he may not have worked out all the
sound details in advance, he did have to anticipate where he would
need extra shots when he was not showing the speaker. Primarily,
he appears to have concentrated on filming extra shots of the
heroine, Alice. (These shots cannot properly be called cutaways;
they are much better integrated graphically than most cutaways.)
The decision was appropriate inasmuch as most of the film is
designed to reveal her feelings. One frequent purpose of offscreen
dialogue is to contrast the girl's emotions with the unawareness of
other characters. This contrast occurs in the knife sequence, and
later when her boyfriend (Frank) and her harasser (Tracy) black-
mail and counterblackmail each other. Showing the girl while the
men's conversation continues offscreen emphasizes her emotional
exclusion from the other characters. Hitchcock also begins here a
use of nonparallel cutting to create tension between characters.[13]
For example, Hitchcock's villains often confront their victims in
public locations where nonparticipants can hear, but under cir-
cumstances in which the villain has some hold over the victim so
that he cannot outwardly object. In *Blackmail*, Tracy, having first
revealed his possession of Alice's glove to Frank and Alice, con-
tinues to threaten them by having Alice's father find him a cigar.
Hitchcock makes certain that we do not miss the significance of
this first extortion—Tracy has Frank pay for the cigar—by cutting
most of this scene to emphasize the helpless glances of the couple,
Frank's confidently neutral expression, the father's obliviousness.
The father asks the girl to climb a ladder to return the cigar box to

its shelf, and the girl leaves the frame she shared with the black-mailer. The camera stays on him long enough for him to start saying, "Pity about the poor man around the corner having died last night," and before he has finished the sentence the camera has panned over to the girl up on the ladder. She climbs down and moves toward him as he finishes speaking, and the effect of the timing of his offscreen words and her onscreen actions is to suggest his power over her, as if she is drawn back to him by his words.

If Hitchcock conquered the dialogue problem in *Blackmail*, he did not even bother to put up a fight in his next film, Sean O'Casey's *Juno and the Paycock* (1930), in which he directed the prestigious Irish Players. Hitchcock probably felt inhibited by the effort of reproducing a distinguished production of a famous play. Although the film was well received at the time, Hitchcock himself felt unenthusiastic about it because he "could see no way of narrating it in cinematic form."[14] Critical consensus has since concurred with Hitchcock's opinion that it reveals little of the director's personal style. By 1930 the technicians in charge of recording generally had dominated the entire filming process, and Durgnat suggests that Hitchcock, like most directors then, suffered from a lack of creative control: "For once Hitchcock the redoubtable technical thinker was unable to impose himself."[15]

Later in 1930, Hitchcock filmed another adaptation, *Murder*, which was based on the play *Enter Sir John* adapted from the novel of the same name by Clemence Dane. Although Hitchcock was again working on an adaptation and facing great technical limitations, *Murder* is clearly a personal work, which in every scene shows the director's efforts to work creatively with sound despite the abundance of dialogue. Because Hitchcock had to adapt *Blackmail* for sound after much of it was shot and he felt inhibited by *Juno and the Paycock*, *Murder* can be considered the first feature in which he had the freedom to experiment with the problem of avoiding "canned theater"—René Clair's derogatory term for the religiously filmed literary adaptations so prevalent at this time.

Hitchcock was working against difficult odds. He was filming simultaneous versions in German and English, and he was still facing great technical limitations. Cameras were placed in booths, and it was not yet possible to mix sound (except while shooting).

He told Truffaut, "We shot with four cameras and with a single soundtrack because we couldn't cut sound in those days."[16] The property he was filming also had disadvantages. The subject involved little action, in part because the murder takes place just before the story begins. Nor is there much suspense. As Hitchcock himself has pointed out, *Murder* is a whodunit, a film working toward an intellectual solution, rather than a suspense story provoking the emotional involvement of the spectator.[17] In short—the film is mostly talk. It concerns a famous actor (Sir John Menier) who sits on a jury that convicts an actress (Diana Baring) of killing another member of her company. Sir John becomes convinced retrospectively of her innocence, and he tries to solve the murder himself. Eventually, he finds out that the girl has been protecting her fiancé by withholding the evidence that he was a "half-caste." Hitchcock injects emotional involvement into the screenplay by developing the suggestion in the original novel that Sir John is acting more out of an unacknowledged love for the girl than for any purer motives of seeing justice triumph. However, except for a short coda, there is really only one scene in which Sir John and Diana confront each other, and his growing involvement with the girl—and consequent jealousy of the unknown man she is protecting—must be established indirectly.

The script requires a trial (which Hitchcock condenses through a complicated montage of sound and image) and jury deliberations that entail a thorough analysis of the issues. Because the deliberation scene is the longest and talkiest scene (much of the dialogue is taken verbatim from the novel), it was also the most challenging, and the viewer can sometimes feel Hitchcock straining to enliven it. One scripting solution was simply to try to make each juror come alive in the short time onscreen, a technique Hitchcock would more successfully utilize in *The Thirty-nine Steps* (1935), wherein he clearly and amusingly delineates character-types just from the nature of their questions to Mr. Memory in the opening music-hall sequence.

The deliberation scene is a first statement of three major techniques that Hitchcock would use to minimize the shooting of talking heads during the rest of his career: camera movement, non-parallel editing of dialogue, and deep-focus sound. The scene is

set up so that the jurors are seated on the outside arc of a table that
forms two thirds of a semicircle, with the foreman in the center
chair and Sir John at one extreme. At the start of the scene the
camera pans past eleven of the jurors while the foreman sum-
marizes the arguments. Later the camera pans away from the fore-
man in one direction and then swings past him and pans the other
way. In neither case does the camera movement work. The jurors
are not quite distinctive enough visually for us to learn something
new by watching them one by one. Furthermore, Hitchcock delib-
erately stops short of revealing Sir John. (If this is a game Hitch-
cock is playing with his viewers, then Hitchcock can be accused of
cheating.) There are some remarkably expressive camera move-
ments during dialogue sequences elsewhere in *Murder*, but here in
the deliberation scene they are belabored.

Much more successful is Hitchcock's nonparallel cutting of dia-
logue and image. He rarely ends a shot of a person speaking at the
precise moment that the person's dialogue ends; he more usually
cuts to a second speaker before the first has quite finished speak-
ing. In parallel cutting the simultaneous aural and visual cuts
reinforce each other so that we notice them; thus shock is generally
created through parallel cutting, whereas smoothness and con-
tinuity are created by overlapping. The nonparallel editing of aural
and visual tracks is thus a crucial general principle for the cutting
of all sound film. It is now quite common to anticipate a visual cut
by a few frames while a line of dialogue is ending, in order to avoid
the static feeling created when sound and image are cut simulta-
neously.[18] However, today's choices can be made in the cutting
room, whereas Hitchcock had to make decisions before shooting.
The preparation of the next shot took a special effort on Hitch-
cock's part because the sound and the image had to be recorded on
the same piece of film. It is possible in watching *Murder* to distin-
guish between those nonparallel transitions Hitchcock deliberately
filmed in separate shots and those in which he chose to move to
another camera's view of the same take. There is usually a change
in tone quality between different shots because the art of sound had
not advanced to the point of matching voice tone or room tone from
shot to shot. In either case, once Hitchcock has identified voices
with the faces of those who speak, he feels no need to cut back to a

speaker later in the scene. What might have been considered a
mere expedient in *Blackmail* is thus confirmed here as a deliberate
choice.

Hitchcock's experiments with nonparallel cutting anticipated by
half a decade a technique that did not become popular in the
industry until the mid-thirties, once editors were fully comfortable
with sound Moviolas, "rubber numbers," and re-recording tech-
niques.[19] The viewer can see in the films of the late thirties rival
schools of thought between editors who believed in nonparallel
cutting and those who preferred the cleaner if more static parallel
style of cutting. In 1937 Hitchcock himself wrote: "This overrun-
ning of one person's image with another person's voice is a method
peculiar to the talkies; it is one of the devices which help the
talkies to tell a story faster than a silent film could tell it, and faster
than it could be told on the stage."[20]

Murder's deliberation scene ends with a form of deep-focus
sound that completely eliminates talking heads. The camera stays
in the deliberation chambers after the jurors exit. We hear the
verdict, the death sentencing, and the defendant's last words while
we watch a janitor cleaning up after the jurors. The effect is to
lessen our interest in the reaction of the accused girl and to height-
en our awareness of the responsibility of the jurors for her fate. The
decision to stay outside of the room when a verdict is read empha-
sizes the impersonality and heartlessness of the trial, and Hitch-
cock uses the technique for similar effects as late as *Frenzy*, when
another innocent defendant is sentenced to death.

In contrast to this important visual evasion, Hitchcock's use of
aural deep focus elsewhere transforms what might have been a
pedestrian piece of exposition into the densest scene of the film. As
the police interrogate the manager and cast backstage during a
performance, we can hear and sometimes see bits and pieces of the
play being performed. All the plays and references to productions
in *Murder* are connected to the "actual" events of the film. Indeed,
a basic thematic issue is the connection between life and art and
the question of which imitates which. (There is a play within the
film called "Nothing but the Truth," and Sir John's method for
revealing the truth is to have the man he suspects as the murderer
act out a murderer's role in a supposedly fictitious play Sir John has

partially written on the assumption that the play will reveal the conscience of this particular villain.) In the backstage scene, while the police conduct their investigations, we hear clapping and laughing for the farce being presented onstage that parallels and comments on what is happening offstage. We also learn that many of the characters are playing roles in the farce that have their correlatives in the actual lives of the troupe. In *The Thirty-nine Steps*, Hitchcock also uses aural and visual deep focus to present offstage and onstage actions simultaneously. As Mr. Memory lies dying in the wings, we hear and see a chorus of female dancers onstage. In the later film, however, the deep focus is used more for contrast (the show goes on while one performer dies) than for parallels.

Whereas in later films Hitchcock would continue to use camera movement, nonparallel editing, and deep-focus techniques to enliven dialogue scenes, he soon rejected two other sound innovations that he first tried in *Murder:* a rhythmic chorus and improvised dialogue. Hitchcock uses the rhythmic chorus near the end of the deliberation scene to suggest how the other jurors pressure Sir John as the last holdout for the defendant's innocence. Hitchcock creates a sense of their steamrolling by shooting as if from Sir John's point of view and turning the jury into a chorus whose rhythm accelerates as the opposition unites. Sir John answers the objections of the various other members of the jury until a pattern starts to set in both in the cutting and in their language: their words are eventually reduced to the question: "Any answer to that, Sir John?" Hitchcock builds in phrases and shots of three as the jurors gradually gang up on the actor, and finally even the question is tripled to: "Any answer, any answer, any answer to that, Sir John?" Such contemporary directors as Lubitsch, Clair, and Mamoulian were using similar rhythmic choruses, but only in fantastic genres. Hitchcock's use of the rhythmic chorus to express a character's point of view is an unusual application of the trope. But the stylization is so extreme that there is little sense of audience identification with Sir John.

The improvised dialogue in *Murder* is a particular surprise coming from a director whose method calls for the utmost control over every element of the production, with every aspect preplanned

before shooting begins. In retrospect it is easy to understand why he was unhappy with the results: "I also experimented with improvisations in direct sound. I would explain the meaning of the scene to the actors and suggest that they make up their own dialogue. The result wasn't good; there was too much faltering. They would carefully think over what they were about to say and we didn't get the spontaneity I had hoped for. The timing was wrong and it had no rhythm."[21] One sequence that is most likely improvised is that in which the theater company first find Diana and the victim and try to explain to a policeman what they know. As Hitchcock says, the rhythm is awkward. However, as a result there is some overlapping dialogue in the sequence. (Overlapping dialogue—the merging of one character's line before a prior speaker finishes—is a sound practice that *Citizen Kane* is supposed to have popularized but that can be found in many newspaper and gangster films of the early thirties.) It feels quite naturalistic in *Murder;* in a few other scenes where characters start to speak at the same time, they actually acknowledge the overlapping, as one of them defers verbally to the other. Hitchcock used overlapping dialogue in later films—but in more controlled situations. In *Shadow of a Doubt* the mother's introduction amid the overlapping voices of her family helps characterize her lack of control over events and people.

The technique for which *Murder* is most often remembered is the interior monologue, which Hitchcock claims is the first in film history. (No one to my knowledge has disputed his claim.) In Hitchcock's career it is important as a manifestation of the director's desire to move inside a character's mind and reveal his thoughts and feelings. Hitchcock's expressionistic impulses are somewhat stymied in his English films by the limitations on technical resources, which force him to become minimally dependent on mise-en-scène. In his American period the use of lavish tracking shots somewhat furthers his wish to explore physical depths that correspond to psychological depths. Meanwhile, in the thirties he is more dependent on inexpensive means of penetrating surfaces; sound is a chief device of creating subjective experiences—a device that reaches its height of development in *Secret Agent*.

By the time Hitchcock had made *Murder* he had already experimented with his two main options for using sound subjectively: the

interior monologue, as in *Murder*'s shaving sequence, and the distortion of *exterior* sounds to suggest how they impinge on a character's consciousness, as in *Blackmail*'s knife sequence. He would eventually settle on the impingement of the exterior world as the preferred choice, and even that technique would soon become subtler, less of a stylistic flourish, less expressionistic. Ultimately, by switching from the distortion to the intrusion of exterior sounds, he would find ways of creating the same effect in the more realistic style of his American films. [22]

Both Hitchcock and his critics seem to have forgotten that *Murder* has two interior monologue scenes rather than one. The forgotten scene takes place in the heroine's jail cell. The camera moves inside Diana's cell as a small door rises like a curtain going up. Then, as the camera stays on the face of the actress, we hear her imagining the play's performance and the stage manager's giving instructions in her absence. This situation, in which a character's stream of consciousness is presented as a series of voices, prefigures the projection of voices by a person driving alone in *Psycho* and *One More Mile to Go*.[23] In the later two films the interior monologues are necessary to the characterization of the persons doing the thinking. In *Murder*, Diana's interior monologue, though fascinating historically, is gratuitous aesthetically because Hitchcock otherwise shows little interest in exploring the heroine's character or motivation. Perhaps that is why the scene has universally been forgotten.

By contrast, the interior monologue in the shaving sequence furthers Hitchcock's central point in *Murder* that Sir John is acting more out of amorous than moral motives when he becomes newly convinced about Diana's innocence and decides to find the real murderer. To prepare us for the penetration of Sir John's psyche Hitchcock gives us a series of stills that progress inward *architecturally*. The sequence is the first at Sir John's lodgings, and it begins with five establishing shots, three of doors, which not only suggest the actor's wealth and his isolation from the outside world but progressively move us into the most private part of his house, the bathroom. From there the only more interior location is within his head. The scene is photographed so that we see the back of Sir John's head as he shaves, his face in the mirror, and a radio to his

right. His lips do not move. At first he hears speech on the radio, an announcement about a police SOS that prompts him to associate the phrase "Save Our Soul" with Diana. This *intellectually* initiates the stream of consciousness. From then on the radio is used as a form of scoring (in a film that is ostensibly limited to source music). An orchestra plays the "Liebestod" from *Tristan und Isolde*, and Sir John's thoughts have been carefully timed so that Wagner's high points emphasize the *emotional* highs of the interior monologue, the love motif suggesting that Sir John's motives involve feelings for the girl that he does not yet admit to himself.[24] Herbert Marshall as Sir John delivers the monologue in his distinctive, characteristically passionate, rhythmic phrases. Sir John leaves the radio music going when he finishes shaving and moves into an adjacent room for the next scene, in which he speaks to an assistant. Because the love theme is still playing, we realize that during these transactions he is thinking more about Diana than about the business at hand.

It might be expected that interior monologues would represent Hitchcock's filmmaking at its most subjective because what we hear is a person's stream of consciousness. There is no suspicion that the thinker is editing his thoughts as there might be if he were narrating them (narration implies a listener for whom the speaker might be distorting the truth for emotional or aesthetic reasons). But oddly enough, Hitchcock's monologues usually serve as exposition (albeit of a person's thoughts). Although the monologues do represent a character's exact thoughts, they do not convey his feelings. In *Murder* we hear Sir John's thoughts about saving Diana, but it is the radio's performance of *Tristan und Isolde* that conveys the emotions. Similarly, in *Psycho* an interior monologue presents conscious thoughts while unconscious motivations are suggested through other means. As Marion drives away with stolen money, she imagines the reactions of her employees and sister when they discover the crime the following Monday. The voices are a reasonable representation of what might occur; Marion's thoughts are quite rational. But her behavior (her continuing attempt to escape after her flight has been witnessed) is irrational. Her paranoia is conveyed less by her thoughts than by the shots of rain on the windshield through which we can see successively closer

and more intense shots of her eyes. Similarly, in *Four O'Clock*
thoughts are presented through an interior monologue while feel-
ings are presented through editing and sound effects. For most of
this television film the protagonist is alone, gagged, and tied to a
pipe—while waiting for a bomb to go off. During the man's interior
monologue, the emotional intensity is conveyed most strongly
through the rhythm of the shots and the intensifying close-ups and
ticking of the clock to which the bomb is attached. Even in the
television film *Breakdown*, whose totally paralyzed hero communi-
cates to us through an interior monologue for most of its twenty-
three minutes, the most intense communication is reserved not for
language but for a tear. Hitchcock simply does not trust language
as a major way of conveying feeling; the need for more honest
means of communicating feelings is both the message and the
method of *Breakdown*. Thus, the Hitchcockian interior monologue
is paradoxically a counterpoint to rather than an expression of
feeling.

The interior monologue in *Murder* also has a visual analogue.
While Sir John is conducting his investigations he occasionally
thinks of the fine meals he is missing, and on such occasions
Hitchcock provides a shot of a table set with food. In later films
Hitchcock would avoid this holdover from silent films—the depic-
tion of a thought removed in time and place from the main action.
To be sure, Hitchcock would come to depend greatly on subjective
shots, but not on such physically displaced ones. His discarding of
the displaced visual is analogous to his discarding of the interior
monologue. Both are subjective extremes so disruptive to narrative
continuity, that although they are intellectually clear, they cut off
emotional involvement; like the rhythmic chorus, their presence
distances us emotionally, and that is not the kind of subjectivity
Hitchcock sought in the long run.

The interior monologue as a means of getting inside a character's
mind in *Murder*, then, is not altogether satisfactory on three
counts: it does not really convey underlying emotion, it does not
involve the audience, and it is grafted onto a film that is otherwise
quite different in style. By contrast, the solution of showing how
exterior sounds impinge on a character in *Blackmail* has become a
much more integral part of Hitchcock's style. Specifically, Hitch-

cock's challenge in *Blackmail* was to find techniques for externaliz-
ing the heroine's guilt. The solution, which entails stylization and
distortion, is the aural equivalent of visual expressionism. To show
that the expressionistic uses of sound in *Blackmail* are indeed
stylistically integral to the film it is necessary to examine the film in
some detail.

Blackmail's heroine is a girl, Alice, whose boyfriend, Frank, is
a Scotland Yard detective. One evening, after quarreling with
Frank in a restaurant, she leaves with another man, an artist, who
talks her into visiting his rooms. After a friendly beginning the
artist attacks Alice sexually, and in the struggle she kills him with
a knife. She wanders around London, haunted by the memory of
his upturned arm, which falls out from behind a curtain when he
dies. She is still haunted by guilt the next day when the rest of the
story takes place. Alice's boyfriend, who has been assigned as one
of the detectives on the case, finds her glove in the painter's
apartment and conceals the evidence. A blackmailer, Tracy, who
saw Alice with the artist the night before, confronts Alice and
Frank at her home with the other glove. While Frank points out
that the glove could equally well incriminate Tracy, the police
arrive to arrest the blackmailer. Tracy bolts through a window in
panic and is killed in the ensuing chase when he falls through a
roof on the British Museum. Alice finally musters the courage to
confess, but her efforts are foiled by bureaucratic delays and by
Frank; Scotland Yard remains satisfied with the assumption that
the now-dead Tracy was the murderer.

Alice is therefore responsible for two deaths, the artist's (her
stabbing of him can be interpreted either as an hysterical overreac-
tion or as justified self-defense) and Tracy's, which would have
been prevented had she confessed before his escape. Both she and
Frank are blackmailers as well as Tracy, since they have for a
while threatened to turn the tables on him if he turns in the glove.
Raymond Durgnat, who analyzes extensively the ambiguous moral
values involved in the film, concludes that assigning the relative
amount of guilt to each character is complicated and perhaps im-
possible. He rightly points out that as far as how much guilt each
feels, Frank "has too little guilt, just as she has too much."[25]

The only time an expression of the girl's guilt is witnessed by

other characters is when a knife flies out of her hand. Commentators have always treated the episode as an isolated gimmick, but the knife sequence as a whole should be seen as the culmination of a larger movement to which Hitchcock has been building since the murder. The scenes showing Alice's retreat from the artist's rooms and her subsequent wanderings through the streets have each used one or more of the elements that coalesce in the knife sequence. To recognize that preparation, one must first be aware of the specific elements of the knife sequence, which through cutting, camera work, and sound is carefully constructed to build up to its climax. The sequence occurs while Alice is eating breakfast with her parents. In the doorway leading from the breakfast parlor to the father's shop stands a gossip who is talking about the previous night's murder.[26] Alice's parents go about their business and do not pay much attention to the gossipy neighbor. Hitchcock's cutting shows that the guilt-ridden Alice is already more sensitive to the woman's speculations about the murder. As the gossip's speech becomes more graphic, Hitchcock suggests Alice's increasing sensitivity by panning from the girl to the chattering neighbor: "A good clean whack over the head with a brick is one thing. Something British about that. But knives—[the camera pans back to Alice] knives is not right. I must say I could never use a knife." At this point the camera, having ended the pan on a medium-close shot of Alice, cuts to a close-up of her. Thus Hitchcock has already emphasized the word *knife* with his camera work, first by panning on the word to Alice, then by cutting in closer when the word is repeated. The gossip continues: "Now mind you, a knife is a difficult thing to handle. . . ." From here on in her dialogue becomes almost abstract: it alternates between a blur of nonwords and the word *knife* five times. From offscreen the father says, "Alice, cut us a bit of bread, will you?" and the camera tilts down to Alice's hand approaching the knife (which looks just like the murder weapon). We hear *knife* five more times now, in the gossip's voice, at a fast pace, with the intermediate words eliminated. On the sixth repetition the word *knife* is screamed, and the actual knife seems to leap out of Alice's hand and fall to the plate.

Having begun the sequence by showing others in the room with Alice, Hitchcock then intensifies it visually by progressively clos-

ing in on her. The camera work shows cause and effect, stimulus and reflex, by tracing a path from the gossip's talking face to the girl's head and then to her hand. There is also a progression in the representation of Alice's attention. At first Alice pays attention to the gossip speaking and hears words objectively. Then, while we still hear with her objectively, the word *knife* is emphasized through visual means. Next the word is selected from the rush of words until it is isolated from its context. Finally, Hitchcock increases the volume of the word to emphasize the subjectivity of the moment, still further matching the visual intensity of the close-up with the aural intensity of the loudness.

The subjective sound in the knife sequence thus entails a combination of restricted hearing and distortion. Each of these techniques has been introduced earlier in the film in association with point of view. At the very start of the synchronized part of the film (Alice's meeting with Frank at Scotland Yard), Hitchcock calls our attention to the role sound will play by introducing a very obvious case of restricted hearing. Hitchcock makes us notice it by intentionally annoying us with it. A guard whispers something to Alice that neither we nor Frank hear. She laughs, and then Frank laughs lamely, as if to minimize his exclusion from the little game. At this point in the film the girl is behaving unreasonably about Frank's lateness for their date, and it is almost the last time we will see or hear something from Frank's viewpoint. Even here any sympathetic identification between the audience and Frank is minimal because the action is not seen from his perspective; he is as deep in the frame as the other two characters, and no subjective cutting is used. Nevertheless, we identify aurally with him because we share his frustration at not hearing the whispered joke.

The connection between restricted hearing and a character's point of view is a little stronger in a scene outside the artist's home. The artist and Alice are about to enter the front door when Tracy, who has been eavesdropping on their conversation, asks from off-screen if he may speak to the artist for a moment.[27] The immobile camera stays on the girl as the artist excuses himself to her. Since her expression is blank and the mise-en-scène very spare, there is nothing for us to do but listen with her. However, all we hear is some mumbling, a loud honk, more mumbling, and then a loud

"no!" The artist walks back into the shot and says, "That chap's nothing but a sponger. Always bothering people on the street." Thus the sound here has been presented from the girl's point of view, although if we are standing where the camera is, we would presumably be as close to the men talking as we were to Alice. Hitchcock has established a correspondence between the framing and the aural limitation of the scene. Yet, oddly enough, the effect of the aural limitation in the shot is to emphasize the visual limitation. We do not yet feel that there has been any distortion of the sound track. Hitchcock was always careful to save any extreme effect (e.g., a close-up or an overhead shot) until he needed it for maximum impact. In this case he saves subjective distortion of the soundtrack until after the murder.

Hitchcock first makes us aware that he is distorting the sound track subjectively when he exaggerates the loudness of bird chirpings to stress Alice's agitation on the morning after the murder. When the mother enters Alice's bedroom to wake her, she uncovers the cage of Alice's canary. Once the mother leaves the room, the bird's chirping is loudly insistent while the girl takes off the clothes she wore the night before and puts on fresh ones. The chirps are loudest, unnaturally so, when she is looking at herself in the mirror, the most "interior" action she performs while dressing. The sound reminds us of the tiny, birdlike jerkings that the girl made immediately after stabbing the artist. Just after the knife sequence there is another subjective distortion of sound, when a customer rings a bell as he enters the store. We are in the breakfast parlor, and yet the bell resonates much more loudly than it does elsewhere in the film. The camera is on a close-up of Alice's face to indicate that it is her point of view, once again, from which we hear.

In a sense the use of bird noises in the bedroom scene should be distinguished from the other techniques mentioned here. Whereas aural restriction and distortion of loudness are related to character point of view, the choice specifically of bird sounds has a particular meaning for Hitchcock independent of the film. This sequence marks the beginning of an ongoing association of murder and bird noises in Hitchcock's mind that accrues meaning from film to film, from *Blackmail* and *Murder* through *Sabotage* (1936), *Young and Innocent* (1937), and *Psycho*, and culminates in *The Birds*. (All of

these instances are discussed in succeeding chapters except those in *Murder* and *Young and Innocent*. In both these films the discovery of the murder victim is accompanied by bird screams.)

It should be pointed out that although Hitchcock's style is known to have been influenced by German expressionism visually, there are even expressionistic precedents from the silent period for his use of words that haunt a character. The expressionists would sometimes show visually that a word was haunting or compelling a character by having the written word float across the screen. In *The Cabinet of Dr. Caligari* (1919), the words "You must become Caligari" hover in the trees during a scene depicting how an asylum director felt compelled to assume the identity of the original Caligari he was studying. Similarly, *Dr. Mabuse, der Spieler* (1922) uses the technique in a scene in which Inspector Wenk, under the influence of Mabuse, is being compelled to commit suicide by driving off a cliff. The control word, *Melior*, which Mabuse used to hypnotize Wenk, is seen as emanating from the distance toward which Wenk is driving up the road, as if it is beckoning him onward.

In *Blackmail* the haunting by a word is the culmination of a complex interrelationship of words and images. The girl's association of her guilt with a forearm and a knife has initially been presented visually. During the murder itself there are two images of forearms. The rape and the stabbing take place behind a curtain. During the struggle, the camera tracks in to a close-up of the girl's forearm reaching out from behind the curtain and finding a bread knife on the table. Eventually, the sound of her cries and the jostlings of the curtain die down to the silence and the stillness of death. After what seems forever (but is actually a second or two), the stillness is broken by another forearm protruding from the curtain. It is upturned as if appealing for rescue. It falls to the same place where hers had found the knife. But this forearm stays there, for it is the arm of the dead man. Only then does the girl back out through the curtain, knife in hand. The visual similarity between the girl's and the man's arms has already complicated the issue of who was the attacker and who victim. Both the outstretched arm and the knife images haunt Alice on her walk through London. She sees a traffic cop's arm, and then she "sees"

Blackmail. *Visual origin of the famous "knife sequence."*

the victim's arm. She looks at a Gordon's Gin sign in moving neon lights. Not only does its slogan—"White for purity"—taunt her (her last name is White), but the moving display in lights of a cocktail being shaken turns into a knife in a hand that alternates between two positions, as if stabbing something. (Like the forearm and knife that protrude from behind the artist's curtain, the arm here is dissociated from any body; this visual disembodiment is analogous to the aural dissociation of the word "knife" from its context in the knife sequence through the blurring or elimination of the other words.) She sees a vagrant asleep with arm outstretched, but this time the cut to a close-up does not turn into a shot of the artist's forearm but remains a close-up of the vagrant's arm. She screams, and we cut to the artist's maid screaming (the two screams are merged into one) as the maid discovers the artist in the flat and

is seen from the same angle and set up as Alice confronting the bum. Thus, even the association of the knife in hand and a scream is prepared before the knife sequence.

The above cluster of interrelated audiovisual images (knife, arm, murder, scream, the word *knife*) is also related to a second cluster that associates the idea of guilt with another hand image and another sound—specifically, a pointed finger of accusation and the sound of laughter. These complex images all coalesce in the very last shot of *Blackmail*, where the two motifs converge when we see a painting of a pointing clown while we hear the sound of laughter. It is no accident that the figure is specifically a jester, for the painting evokes the Elizabethan jester, whose function was to provoke laughter while revealing truths too unpalatable to be stated without the indirection of parable or art.

The painting is first introduced in the artist's flat. It was the last painting completed by the artist before his death, and it is in part a surrogate for the man who painted it. When we and Alice first see it in his rooms it seems to represent all dirty old men. Its pointed finger suggests both that the girl is every man's victim and that she is somewhat guilty of having invited whatever is in store for her by having ascended to the artist's rooms in the first place. After the murder the painting seems to take on the role of witness as well as accuser, and the girl rips away a piece of it, although not the eyes. There is even the suggestion of a Dorian Gray analogy: although the would-be rapist himself is charming and attractive (he is played by a suave, young Cyril Ritchard), he has externalized his ugly soul into the leering jester. This painting of his true feelings is paralleled by his painting Alice as a nude figure before he persuades her to undress. The possibility that the nude painting expresses her hidden desires as well as his is suggested by the fact that she is actually holding the paintbrush while he guides her hand.

The image of the pointed finger of accusation is used not only in connection with the artist's death but elsewhere in connection with the blackmailer's. At one point, while Frank, the girl, and Tracy trade threats and counterthreats, for example, Tracy is heard from offscreen saying, "It's my word against hers," and above the girl's head in the frame—although unnoticed by her—is his forearm with a finger pointing at her. Tracy's last gesture before falling to his

death in mid-sentence is to point at Frank and say, "It's not me you want, it's him. Why his own. . . ." (Durgnat points out that there are many other hand images. Alice's implicating glove has two missing fingers. During the restaurant scene Frank has offered to give Alice nail scissors for Christmas. And all the principals in the film variously rub their hands together in gestures of guilt, nervousness, tension, or greed.)[28]

The introduction of the painting into the last shot of the film contributes to the irony of the film's conclusion. *Blackmail* ends in the same lobby where Alice first met Frank. She has just confessed to him that she stabbed the artist, and he has prevented her from telling the police. As they enter the lobby, they join the same guard who was on duty the night before when Frank left with Alice. He jokes with them about Alice's having solved the crime and about her replacing Frank at his job (yet another suggested cross-identification of characters in the film). All three laugh, and the camera dollies in on the girl's face to a close-up that excludes the two men. Her laughter is forced. She looks dismayed, as if she notices something. Hitchcock cuts to the painting of the jester. It is a closer shot than we have ever had before, however, so that we do not see the picture frame, and the jester's pointed finger aims straight at us and (according to editing logic) at the girl. While the guard jokes about having "lady detectives," Hitchcock cuts back to the girl and then to the painting, which we see is now being carried through the doors that lead into the prison area. Back to back with the jester painting is the nude caricature of the girl drawn jointly by Alice and the artist. This is the last shot of the film, and the sound beneath it is of laughter, uproarious laughter, which echoes too loudly for the occasion.

Hitchcock emphasizes the importance of the laughter by putting it last in the film—a position that makes it a comment on the whole film—and by separating it from its source—a disembodiment that renders it more cosmic. To whom is the laughter attributed? The laughter has a different meaning for each person in the lobby. Hitchcock has prepared us for this ironic tension in the two earlier episodes involving laughter. Both take place in this same lobby and involve different levels of understanding. The first instance of

laughter occurs when Frank meets Alice and the guard whispers something to the girl. As I mention above, Frank joins in the laughter of the girl and the guard even though he does not hear the joke, to minimize his feeling of being left out. The guard, who represents normality, a refusal to notice anything disturbing, is also the person who laughs a second time in the foyer. Alice arrives to confess and tells the guard she wants to see the Chief Inspector about the artist's murder. As she looks out the window, the guard comes up from behind her and says, "And I suppose you're going to tell them who did it." When she answers "Yes," he laughs at what he considers to be the absurdity of her having anything to say about the murder. The guard, of course, is the only one of the three in the final scene of the film whose laughter is completely innocent. Frank is aware of the irony of Alice's displacing him as the detective who solved the case. And Alice realizes that the laugh belongs to the jester in a sense.

The presence of the two paintings as surrogates for the artist and the girl implies that the girl will be haunted by guilt for the rest of her life. The last shot shows her surrogate being incarcerated, even if she is not. The finger of guilt has been pointed at her, and there seems no way for her to alleviate the sense of guilt that makes her so different from the more innocent girl who stood in the lobby the day before. The penultimate shot, a close-up of Alice, isolates for us her fear and discomfiture. It also identifies the last shot as a representation of her point of view. Thus, the distorted laughter is in large part a subjective echo of Alice's feelings—of her sense of exclusion from the two men, of her bitter awareness of the implications of the paintings, of her new understanding of the discrepancies between appearance (three people having a laugh together) and reality (her emotional confusion).

The interpretation of the laughter in the last scene as essentially subjective adds to our appreciation of Hitchcock's control over the film's overall structure. With this in mind, the knife sequence can be seen not only as the culmination of the scenes that preceded it but as a preparation for the final scene. Hitchcock once again, by distorting a sound, separating it from its source, and linking it to recurring visual motifs, has found an aural expression for the girl's

unrelievable guilt that haunts us as much as it does the girl. With
such an ironic ending *Blackmail* might well have been subtitled
The Last Laugh.

As I indicated in my introduction, Hitchcock typically has had
less control over the music than over the other aspects of produc-
tion. His use of music in *Blackmail* reflects his need to observe
various conventions and his desire to do something personally
creative with the music. It is complicated by the film's midstream
switch to synchronized sound, for Hitchcock had to deal both with
the silent-film conventions of scoring for live orchestra and with the
early talkie expectations that a character would perform a song in
synchronism. Manvell and Huntley have claimed that the musical
accompaniment of *Blackmail* "had already been considered on the
basis of a 'live' orchestral accompaniment in the cinemas."[29] But if
that were true it would seem unlikely that the music of Campbell
and Connely, a composer-lyricist team, would have been chosen
for the film because songs would not have been required. The
scoring may reflect an uncertainty until the last minute about the
extent to which synchronized sound would be used. At least one
reel of film, that in which a character performs a song that is
subsequently used as a motif in the scoring, could not have been
conceived for anything but a synchronized sound movie. Manvell
and Huntley's statement that "*Blackmail* offers a recorded example
of a silent film score, with only occasional, if interesting, conces-
sions to sound film technique," is certainly true of the first reel.
They accurately describe the scoring to the first reel as "an exact
version of the kind of sound that used to accompany films in the
largest West End cinemas of the late twenties. It is repetitive,
naive in content, highly atmospheric and based almost entirely on
a simple 'theme and variations' pattern."[30] Musical themes in-
troduced in the first reel do recur later in the film, associated with
similar images. (A string agitato theme identified with the image of
the spinning wheel comes back both when we see the wheel again
and during the Museum chase. There is a central theme arranged
for full orchestra that is associated with Scotland Yard, and there is
a pizzicato phrase that ascends the scale almost every time a
character climbs a flight of steps.) Nevertheless, Hitchcock did
manage to assert his personality over the scoring by controlling not

Blackmail. *Cyril Ritchard seduces Anny Ondra with a song.*

the content so much as the placement of it. Whereas it was typical of the period to use either all music or none, Hitchcock has already hinted at his future style by eliminating scoring under most dialogue sequences and by insisting on silence during most moments of tension.

Hitchcock fared ever better at incorporating the song "Miss Up-to-Date" into his overall style so that its presence is not a mere concession to popular taste. Extraneous songs were being inserted in Hollywood nonmusicals throughout 1929 and 1930, in an age that apotheosized the film that was "all singing, all dancing, all talking." The lyrics place the song in the Hollywood flapper-as-good-girl tradition of such films as *Our Dancing Daughters* (1928). Yet the lyrics are also central to the moral issues of *Blackmail*.

"Miss Up-to-Date" is sung by the artist when Alice visits his flat.
Before he physically attempts to seduce the girl, he sings and plays
the song on the piano in synchronism as she changes into a posing
costume. During the song she comes from behind the screen and
leans on the piano as he sings directly to her. He tells her that the
song is "about you, my dear." These are the lyrics, so far as they
can be made out on today's prints:

> They praise the woman of the past age
> And loathe her daughter of this fast age
> They sing a hymn of hate about Miss Up-to-Date
> And spend their spite from morn till night—
>
> They say you're wild and naughty child,
> Miss Up-to-Date
> But who but you could . . . [unintelligible]
> Pretty child, today won't bother you
> It's such a shame to break that heart of you
> Although you're a dame with a plainspoken name,
> drink a cocktail or two
> Why the alarm, there's really no harm in the
> few little things that you do
> You've a heart of gold, so let them nag and scold
> You're absolutely great, Miss Up-to-Date.

At first glance the song is simply part of a seducer's repertory; the
invitation to "drink a cocktail or two" is realized in the film's
action, and the refrain is repeated much more frenetically on the
piano by the artist as his lust grows. The lyrics, however, also
introduce the notion that art is based on reality. Like the nude that
is drawn as a caricature of the girl, the song projects an image of
how the artist envisions the girl, an interpretation of behavior that
the girl does not wish to accept. There is the suggestion that the
girl's extreme reaction to the artist's advances is prompted by the
unacceptable image of herself that he has revealed to her.

The use of the song also makes sense in terms of the artist's
characterization. Cyril Ritchard has been cast for his deceptively
charming appearance, and his attempt to seduce the girl first
through song rather than force is consistent with his other behavior.

After the murder his song is used to underscore the girl's sense of guilt. Following the silence of the murder, an orchestrated version of the tune returns dirgelike to the sound track, in a minor key and at half tempo. Throughout most of the girl's flight the tune haunts the sound track, just as the images of the arm and the knife haunt the visuals. Although the scoring is not actually a projection of her thoughts as are the subjective shots of her visual hallucinations, the music is nevertheless, as scoring often will be for the rest of the sound era, an extension of her emotional state, especially when it is heard in a piano version. The melody continues throughout her trek through London and finally is wiped out, as it were, by the scream that ends the sequence. The fact that the music associated with the artist is connected with his more appealing nature makes its repetition all the more accusatory, like the outstretched arm. It is probably no accident that at the very end of the film, when the artist's painting is being carried into the prison, the orchestral arrangement that swells over the logo is the last line of "Miss Up-to-Date," adding further irony to an already ambiguous ending.

"Miss Up-to-Date" is not the only song in the film. During the restaurant scene the main tune played under the quarrel that precipitates the girl's leaving with another man (the artist) is "Girl of My Dreams," a love song sung by a man whose girl has left him. Although the source is not shown, the music is presumably being played live because we hear clapping between numbers. In keeping with Hitchcock's mischievous humor is another tune, which the blackmailer whistles after he has conned the couple into providing him with a free breakfast: "The Best Things in Life are Free." Moreover, Tracy's whistling is no random effect. Two other men whistle: the artist, while he pours Alice a drink, and the detective, while he searches the artist's flat. The effect of the parallel actions among the three characters is to suggest that there may be a moral parallel among them as well.

I have mentioned two instances in which Hitchcock has suggested that art mirrors life: Alice finds her guilt reflected in both the artist's song and his paintings. Again, this is no isolated motif. Hitchcock frequently draws on art to comment on life. In some cases, such as the above, he stresses the close connections between life and art. In others, he contrasts the timelessness of art

with the ephemerality of human existence. In *Blackmail* Hitchcock develops these issues in terms not only of music and painting but of architecture, sculpture, and even motion pictures. The film's climax is a chase through the British Museum. Hitchcock emphasizes three aspects of the Museum: its size, its sense of entrapment, and one Egyptian sculpture, all three of which comment on man's fate. When the blackmailer first enters the building, the shots are angled so as to make him look insignificant next to the imposing columns of the facade. Interior shots are chosen for their geometric and mazelike quality. A high-angle shot of the reading room, especially, with its spokelike diagonal passages leading to a series of concentric circles, identifies the idea of entrapment with the recurring images of circles that range from the film's first shot of a spinning wheel (on a police van) to the dome of the Museum. The one display in the Museum singled out specifically is an enormous stone face of Nefertiti, past which the blackmailer drops on a rope that seems as slender as his chances of escape. Larger-than-life sculptures of heads—the Statue of Liberty and Mount Rushmore—also witness the descent of characters in the finales of *Saboteur* (1942) and *North by Northwest* (1959). The sight here of the implacable visage of the aged stone queen is directly preceded by a shot of the face of a very anxious Alice. Indeed, the entire chase in the Museum is intercut with shots of Alice back home, as she decides to write a confession note to Scotland Yard that would free Tracy if she were to act in time. The crosscutting therefore functions partly for suspense. Moreover, it reminds us that it is she whom the police should be chasing—and that if Tracy is caught, he will surely tell this to the police. However, the juxtaposition of the girl's face with that of the queen also suggests that Alice is tampering in a godlike manner with the fate of another human being.[31]

All three of Hitchcock's favorite aural motifs (silence, screams, disdain for language) appear as early as *Blackmail*, in varying degrees of cohesion with the rest of the film. One motif—the disdain for language—seems almost gratuitous.[32] It can be seen in a short comic-relief sequence in which the artist's maid reports the murder to the police. The episode, a comedy of miscommunication between maid and policeman, is shot as a phone call with the

woman on the top left of the screen and the policeman on the right bottom:

Policeman: Who did you say it was?

Woman: Mr. Crew.

Policeman: Mr. Who?

Woman: No, Mr. Crew, I tell you. It's 'orrible.

Policeman: All right, don't you worry. I'll send someone around right away. What number did you say—seven or eleven?

Woman: Thirty-one.

Policeman: Thirty-one.

Woman: What?

Policeman: Thirty-one, I said.

Woman: No, no! Thirty-*one*.

There is little other evidence in the film to suggest that this is a serious statement on the inadequacy of language. At any rate, the sequence is less significant for its meaning than as an example of the freedom with which Hitchcock could treat language in an era when dialogue was usually considered sacred.

On the other hand, Hitchcock's treatment of silence is central to the moral issues of *Blackmail*. One of Hitchcock's major themes in the sound era is that a character's silence—that is, not speaking—can be a symptom of moral paralysis.[33] Alice, Frank, and Tracy all exhibit this behavior to some extent. Alice's delay in not reporting the murder is responsible for Tracy's death, and Frank is at least as guilty because he tries to prevent her from speaking. Indeed, Alice and Frank are frequently at odds about when she should talk and

when she should be quiet. In their first scene together Alice
punishes Frank for being late by giving him the "silent treatment."
When Frank later confronts her with the implicating glove, the girl
grabs his hands but is unable to speak. Finally, Frank yells out in
frustration, "For God's sake, say something!" During the confron-
tation between the blackmailer and the couple, when Frank black-
mails Tracy in turn, Hitchcock emphasizes the girl's silence by
showing her face while we hear the men talking offscreen. Tracy
sees that she is having a struggle of conscience and tells Frank,
"Why don't you let Alice speak?" Frank answers, "I know what I'm
doing. She'll speak at the right moment" and tells the girl, "For
God's sake be quiet." When Alice finally goes to Scotland Yard
with her confession he tries to prevent her from telling anyone but
him. Her delaying tactics in saying "I'd better say now what I have
to say; I'd rather not wait" are sufficiently long enough to allow a
phone to ring that will effectively prevent her telling the police.
Frank crumples Alice's confession note (or possibly the application
to see the inspector) and puts it in the same pocket where he had
previously concealed the glove. Again, the concealment of this
written confession plus the suppression of her oral confession,
together with the image of the paintings being imprisoned, suggest
that Alice will live uncomfortably with her suppressed secret un-
less she finds some appropriate way of letting her guilt surface.

One way guilt surfaces is through a scream, and that is the
meaning of Alice's second scream in *Blackmail*. More often a
Hitchcockian scream is a cry for help, as is Alice's first scream.
This earlier scream is prepared for when Alice, shortly after arriv-
ing at the artist's flat, looks out the window and sees a bobby across
the street, walking his beat. She turns back toward the room look-
ing reassured; by implication, help is within earshot if she must
call for it. When the artist later attacks her, she cries out in
protest. As she calls, "Don't! Let me go, let me go!" Hitchcock cuts
to the same shot used earlier of the bobby seen through the win-
dow, which may be, as Durgnat suggests, a wry comment on the
fact that the bobby is too far away to help but a threat to her once
she has stabbed the artist.[34] In subsequent films Hitchcock will
elaborate on the pessimistic implication here that a scream for help

is likely to go unanswered. He will emphasize the exterior shot that shows the scream as either unheard or ignored.

Alice's scream is actually so weak as to suggest an ambivalence about her desire to be rescued. Hitchcock saves her loud scream for the cry of horror she emits when she sees the sleeping beggar with his arm outstretched. The second scream works both structurally and psychologically. It is a necessary release of emotions for the girl, who has not uttered a sound since the murder. The sound track has been dominated by variations on the artist's song in the scoring, and now the sound track picks up her first conscious aural expression of her guilt for what she has done. Because Hitchcock thinks that conscious acknowledgment of one's darker nature and deeds is necessary for one's psychological well-being (although he does not believe that simply identifying traumatic youthful experiences alleviates their effects),[35] this scream is to be taken as a cathartic first step for the girl's recovery of her mental stability; it certainly is for the film's viewers, who also have had no release for their tensions.

The girl's scream is merged into the scream of the maid, to whom Hitchcock cuts as she discovers the artist's corpse. I consider this transition to be a case of ineffective expressionism; the gimmick draws attention to itself without justification. Otherwise, *Blackmail*'s aural techniques derive organically from its meaning. Not until *Secret Agent* would Hitchcock once again find a vehicle appropriate for extensive experimentation with the use of expressionistic sound. By 1936 re-recording practices were quite sophisticated. Therefore, much of the impetus to use sound creatively in *Secret Agent* must have come not (as in *Blackmail*) from the challenge of overcoming stringent technical limitations but from a wish to explore the new range of expressive possibilities available with technically sophisticated equipment.

Notes

1. Actually, the distinction belongs to the undistinguished *The Clue of the New Pin*, a film made by British Lion for British Phototone in response to quota production legislation. (A quota system was established in 1927 to ensure that British theaters would show a

reasonable proportion of their own films and not depend on American imports.) Little notice was paid to the film, which was presented at a trade show in March, 1929, four months before *Blackmail*'s premiere. Rachel Low speculates that it excited little attention "because it was on disc and technically rather unsatisfactory." See her *The History of the British Film: Volume 4, 1918–1928* (London: Allen and Unwin, 1971), p. 194.

2. Interview of Bryan Foy by James G. Stewart, presented at the Eastman House "Symposium on the Coming of Sound to the American Film, 1925–1940," Rochester, October 1973.

3. Low, *History*, p. 191. The reference to Photo*tone* must be a mistake on the part of the author because that is a sound-on-disc system and she says elsewhere in her book that B.I.P. adopted sound-on-film. The print itself identifies its recording system as R.C.A. Photo*phone*, a sound-on-film process that, although poorer in sound quality than disc systems, had advantages in distribution and projection and therefore took hold in British studios.

4. Ibid.

5. François Truffaut, *Hitchcock* (New York: Simon and Schuster, 1967; originally published as *Le Cinéma selon Hitchcock* (Paris: Robert Laffont, 1966), p. 46.

6. "New York Close Up," *New York Herald Tribune*, 26 February 1950, p. 18.

7. Eric Rohmer and Claude Chabrol, *Hitchcock* (Paris: Editions Universitaires, 1957), p. 30.

8. Low, *History*, p. 192.

9. See, e.g., Grierson, "Introduction to a New Art," *Sight and Sound* 3 (Autumn 1934):102.

10. An impressive and useful exception to the inaccurate histories of technological developments is Barry Salt, "Film Style and Technology in the Thirties," *Film Quarterly* 30 (Fall 1976):19–32.

11. Salt, in "Film Style," p. 25, is the one writer who does note that cameras inside soundproof booths could pan about thirty degrees left or right.

12. Raymond Durgnat, *The Strange Case of Alfred Hitchcock; or, The Plain Man's Hitchcock* (Cambridge, Mass.: MIT Press, 1974), p. 103.

13. *Nonparallel cut* is a term used by some sound editors to indicate that the sound is edited either before or after a transition from one shot to the next. The disjunction can be a matter of a few frames or of several seconds.

14. Truffaut, *Hitchcock*, p. 48.

15. Durgnat, *The Strange Case*, p. 107.

16. Truffaut, *Hitchcock*, p. 55.

17. Ibid., p. 52.

18. Salt, in "Film Style," p. 20, observes experimentation with this editing practice in films from the beginning of the thirties.

19. "Rubber numbering" is the edge numbering of sound and picture tracks so that synchronism can be easily established later. Salt, in "Film Style," pp. 28–30, shows how these various developments permitted new editing freedom, and he argues that they also are responsible for the decrease in the "Average Shot Lengths" of Hollywood films in the mid-thirties.

20. "Direction," in *Footnotes to the Film*, ed. by Charles Davy (London: Lovat Dickson and Thompson, 1937); reprinted in *Focus on Hitchcock*, ed. Albert J. LaValley (Englewood Cliffs, N.J.: Prentice-Hall, 1972), p. 36.

21. Truffaut, *Hitchcock*, p. 53. George Perry cites as improvised the scene in which a stage manager and his wife breakfast with Sir John, in *The Films of Alfred Hitchcock* (London: Studio Vista, 1965), p. 35.

22. See chapter 7 on aural intrusion.

23. *One More Mile to Go* is one of the twenty television films that Hitchcock personally directed between 1955 and 1962, mostly for his series "Alfred Hitchcock Presents." In 1968, Jack Edmund Nolan indexed the films and argued persuasively that they should be considered as part of Hitchcock's personal oeuvre because they continue the stylistic and thematic interests of his feature films. See his "Hitchcock's TV Films," *Film Fan Monthly* 84 (June 1968):3–6. Of the four television films I mention, three are twenty-three-minute films produced for "Alfred Hitchcock Presents": *Breakdown* (13 November 1955), *Back for Christmas* (4 March 1956), and *One More Mile to Go* (3 April 1957); the fifty-two-minute *Four O'Clock* was made for NBC's "Suspicion" series and shown on 30 September 1957.

24. Because there was no postdubbing to speak of in 1930, Hitchcock created the monologue by shooting to the accompaniment of a prerecorded phonograph and Marshall's speech and a live orchestra behind the set. See Donald Spoto, "Sound and Silence in the Films of Alfred Hitchcock," *Keynote* 4 (11 April 1980): 14.

25. Durgnat, *The Strange Case*, p. 90.

26. It is appropriate that the gossip, whose function in life is to publicize private matters, is always stationed by the doorway that serves as a threshold between the public part of the family residence, the shop, and the family's home.

27. Eavesdropping is the aural equivalent of voyeurism for Hitchcock and is just as morally dubious. Hitchcock may use it to characterize a villain *(Blackmail*, the British version of *The Man Who Knew Too Much, The Lady Vanishes, Rebecca)* or a heroine who is too timid *(Jamaica Inn* [1939], *Rebecca, Suspicion)*. The director plays with the audience's complicity as eavesdroppers when we strain to overhear verdicts *(Murder, Notorious, Frenzy)*, domineering mothers *(Notorious, Psycho)*, confessions *(I Confess)*, and quarrels *(Rear Window)*. Eavesdropping is overtly dealt with in *Easy Virtue* (1927), *The Skin Game* (1931), *Sabotage* (1936), *Mr. and Mrs. Smith* (1941), and *Marnie*.

28. Durgnat, *The Strange Case*, p. 92.

29. Roger Manvell and John Huntley, *The Technique of Film Music* (New York: Hastings House, Communications Arts Books, 1957), p. 27.

30. Ibid., p. 28.

31. Although the various parallels between life and art are central to the meaning of the film, the first connection is introduced somewhat whimsically in terms of motion pictures. During the restaurant scene the couple argues about a film that Frank wants to see and that does not interest Alice. It is entitled *Fingerprint* and is therefore about him, a detective. He claims that a film about Scotland Yard can't be realistic. However, Hitchcock through Alice takes a jab at both movie directing and realism by having her retort that "I heard they've got a real criminal to direct it, just to be on the safe side."

32. Maurice Yacowar has written that "in this film, speech brings confusion and isolation

rather than clarity and community," but the format of Yacowar's survey does not allow him room to develop his argument. See his "Hitchcock: The Best of the Earliest," *Take One* 5 (21 May 1976):42.

33. John Belton has suggested that "all of Hitchcock's films concern themselves with paralysis of one kind or another," in "Hitchcock in Britain," *The Thousand Eyes* 2 (Winter 1979):5–9.

34. Durgnat, *The Strange Case*, p. 93.

35. Interview by Richard Schickel for the WNET television series "The Men Who Made the Movies," 1973; published in Richard Schickel, *The Men Who Made the Movies* (New York: Atheneum, 1975), p. 275.

3 Expressionism at Its Height: Secret Agent

Of all Hitchcock's films of the thirties, *Secret Agent* (1936) is the one in which he experiments with sound most obviously and most continually. In fact, in this film the celebrated Hitchcockian wit more often finds expression in aural than in visual ideas. Some of the aural tours de force that various writers have noted, if only in passing, include a sustained organ chord produced by a murdered organist, the use of a fire alarm to create a diversionary panic in a chocolate factory, and the whining and howling of a telepathic dog who senses that his master, far off on a mountain, is being murdered. To be sure, such effects do share the tendency of expressionistic devices to draw attention to themselves. What the writers have not noticed, however, is that these set pieces are more than isolated bravura effects; they are an organic part of a profound exploration of the possibilities of subjective sound. As in *Blackmail*, the hero and heroine passively allow the murder of an innocent man, and Hitchcock once more uses aural expressionism to convey their sense of guilt. Hitchcock's experiments in *Secret Agent* with nonliteral and even subliminal sound effects push far beyond the usual limits of narrative film. Yet none of these experiments have received any critical attention to date.

There is a unifying concept that links style and theme in *Secret Agent*: the way chaos can overwhelm apparent order. In metaphorical terms, this concept might be expressed as "discord overwhelming apparent harmony," and, indeed, in *Secret Agent* the musical metaphor comes to life. Music is by definition the ordering (spatially for harmony and temporally for rhythm) of what would otherwise be random sounds. For Hitchcock the breakdown of social order is best expressed subjectively through an individual's perception; he exposes a character to chaos in order to penetrate

his psyche—and, by extension, ours.[1] The key to *Secret Agent* lies
in the connections Hitchcock establishes between these two kinds
of order—musical and psychological. He establishes these connec-
tions through a series of "shifts": music becomes noise, and noise
becomes a subjective extension of a person's feelings.

From the very beginning of the film, music helps Hitchcock
express the undermining of social order. The opening shot, framed
in perfect symmetry, shows visitors assembled around a bier. The
scoring is an exaggeratedly. stately march. When the guests leave,
the framing becomes asymmetrical. The one-armed soldier in
charge upends the empty coffin and, to leering music that under-
scores his disrespect, lights a cigarette from one of the holy can-
dles. In the next scene we learn that the man who is supposed to
have died has been officially "buried" by the British secret service
so that he may actually assume the identity of a writer named
Ashenden. Under his new identity the writer is to travel to Switzer-
land in order to locate and kill an enemy spy—one who is playing a
crucial role for England's enemies in the Middle East (the year is
1916). Assigned to Ashenden (John Gielgud) are two assistants, a
fake wife, Elsa (Madeleine Carroll), and a professional assassin
with a fake title, the General (Peter Lorre).

The three spies are first united in the couple's hotel bathroom,
and it is here that Hitchcock plants the initial conjunction of music
and chaos. The General, a compulsive womanizer, annoyed be-
cause he has not been assigned a beautiful "wife" as well, throws a
temper tantrum, tearing apart everything in the bathroom, includ-
ing his own clothing, except for one thing: a record player, which is
inexplicably sitting on the toilet. The next day Ashenden and the
General visit a rural church to hear from an organist the name of
the agent whom they are pursuing. The sounds of distant cowbells
and church bells accompany Hitchcock's establishing shots of the
mountain village. As the two men enter the church, however, they
are greeted by a loud, sustained, discordant sound, which adds
immeasurably to the suspense as they wait for the signal, which, as
things turn out, they never receive from the organist. It is the eerie
sound of organ notes. (Technically, the word *chord* would be a
misnomer because the intervals are too close to form any sort of
harmony.) The two men creep up behind the organist, whose hand

Secret Agent. *John Gielgud, Peter Lorre, and dead organist. A posthumous conversion of music to noise.*

is creating the noise, and he falls over as soon as they touch him. As he does so, his hand strikes a second register and produces a second nonchord before finally slipping off the keyboard altogether. Oddly enough, it is the resulting sudden silence that provides the aural emphasis for the fact of his death. The eerie dissonance of the sustained organ sound, although actually caused by his death, adds more to our feeling of suspense than of death, since we at first do not know its source. It is also a characteristically Hitchcockian way that an organist might "register" his death. In the director's world, people often live and die by using objects as extensions of their professional identities: a photographer blinds an attacker with a flashbulb, and a carousel attendant falls, when shot, onto a lever that sends the carousel out of control. As for the organist, if a triad represents order, the non-

chord played here stands for chaos. It is the organist's way of
signaling posthumously that murder has entered the cathedral, or,
in this case, a humble village church.

In *Secret Agent*, therefore, almost from the start, music is poten-
tially noise, and the same transformation is repeated in the very
next scene. While Ashenden and the General are searching the
dead organist, they hear footsteps and climb the belfry to hide.
They are trapped in the church tower for hours as its huge bells toll
out the news of the organist's death (or is it tolling out a signal to
the enemy?). Hitchcock emphasizes the intensity of the noise by
tracking in to an extreme close-up of a mouth speaking into an ear
as the two men try to communicate. When the men get back to
town, the General's first words are: "Me still blind on this ear." The
words suggest that their subjection to painfully loud noise has been
a punishment—either from the gods (the church bells) or from the
enemy—for their sins (the major issue of the film is the morality of
killing even when one is under orders from one's country).

Whereas in the church scene the heroes are victimized by loud
noise, when they later gain the upper hand they put loud noise to
work for them. Ashenden and the General visit a chocolate factory,
one that they have learned also serves as the spy headquarters. The
scene is accompanied throughout by the deafening roar of ma-
chines, which Spoto suggests may symbolize "the inevitable grind-
ing of 'the wheels of fate.'"[2] When they see police come to arrest
them, the two take advantage of the noise by using it as an excuse
to whisper to one another a plan whereby the General fakes a
diversionary seizure while Ashenden pulls a fire-alarm signal. The
crowd of assembly-line workers is suddenly turned into a panicking
stampede, and this temporarily prevents the would-be arresters of
Ashenden and the General from entering the building. Thus the
transformation of order to chaos has been used to their advantage.
By showing them using the method (chaos) of the enemy, Hitch-
cock implicates the ostensible good side by suggesting that it is not
much better than its enemy, an issue that has been raised earlier in
the film when the heroes mistakenly kill the wrong man. Hitch-
cock's use of loud noise in the factory scene has a contrapuntal
value as well. Its stridency provides an ominous warning that the
order and friendliness of the chocolate factory are only apparent.

Paradoxically, the use of a loud but steady sound also allows Hitchcock to shoot in silent-film style and thus revert to the visual method of story telling that he favors.

It is important to distinguish in this film between what is done in pantomime and what is openly spoken. When the heroes formulate their plan under the cover of factory noise, their attempt to communicate appears to us as pantomime. Once again Hitchcock associates silence—not speaking—with moral paralysis. The film explores the alternating willingness and reluctance of the two main characters (Elsa and Ashenden) to kill in the line of duty. A major indication of a character's acknowledgment of moral responsibility for his actions is his ability to actually refer to his work as "killing" as opposed to evading his responsibility by circumlocution. For instance, when Ashenden is first given his orders he asks what to do with the spy once he is located. His superior—who significantly has no name; he is just called "R"—avoids saying "kill him" outright; instead, he looks up at the sound of a bomb dropping and comments, "That sounded just like a pistol shot, didn't it?" (However, the equation of the two sounds implies that the gunshot will be a retaliation for this bombing of London and somewhat mitigates the evil of the killing by suggesting that it is justified self-defense for a country under attack.)

In Elsa's case, moral paralysis is also expressed through oral ellipsis. Her initial callousness about killing is indicated by the indirectness with which she refers to the task. Ashenden asks her why she has become a spy; she answers, "Excitement, big risks, danger, perhaps even a little . . ."—but instead of saying the word "killing" she pantomimes the rest of the sentence by mimicking the action of pulling a trigger. Similarly, when Ashenden tells her at a casino the next day that Caypor, the charming Englishman who has just joined their party, is the spy they have been seeking, her reaction is the elliptical: "Do you mean we shall have to . . . how thrilling!" Hitchcock's staging of this scene—the faces of Ashenden and Elsa are out of focus in the foreground as she speaks, and we can hear and see the alleged spy in the middle ground—also emphasizes her insensitivity because the intended victim is within the frame. Later in the evening, Ashenden, appalled by Elsa's callousness, tries to impress on her the seriousness of what they are

doing by finally giving the proper name to their task. When she complains about her less active role in the plans, he says, "Can I tell you something? We aren't hunting a fox but a man. An oldish man with a wife. Oh, I know it's war and it's our job to do it. But that doesn't prevent it from being murder, does it? Simple murder." They look at their intended victim, who gives a friendly wave as the scene ends with an iris-out on him—an important visual effect that links this scene with the way his death is witnessed in the next scene, through a telescope.

The death of Caypor is filmed partly as pantomime. Ashenden and the General climb a mountain with Caypor; their intention is to push him off at a treacherous point. Ashenden changes his mind en route, but the professional assassin insists on carrying out orders. The murder itself is seen from Ashenden's point of view, through a telescope in an observatory half a mile down the trail. Yet the couple acknowledge later that, even though they were "long-range assassins," they were guilty along with the General. Thus, killing by indirection is condemned along with speaking by indirection.

Hitchcock stresses the enormity of the murder through a brilliant combination of crosscutting and sound. It is in the murder sequence that he initiates a series of shifts that transform a dog's howl into a subjective expression of guilt. The scene on the mountain is crosscut with one taking place in Caypor's hotel room, where Caypor's German wife is giving Elsa a language lesson. By the door sits a wirehaired dachshund, which Hitchcock, with characteristic clarity, has carefully identified with Caypor. Both times that Ashenden and the audience meet Caypor he is introduced via his dog (the first time, Ashenden trips over his leash; the second time, the dog escapes into the casino to find his master). Hitchcock equates the innocence of man and pet by having Elsa say of Caypor, when she learns he is the spy, "But he looks so harmless," just before Caypor tells a casino official, "But anyone can see this dog is harmless." As the murder takes place, the dog sits by the hotel-room door, whining in anguish and pawing at it as if to get out. Editing his sound track with a freedom he would never again allow himself, Hitchcock continues the sound of the dog's whining even after he cuts to the mountain. The effect suggests that the dog has a telepathic sense of its master's danger; we begin to feel as if we,

too, should be sympathetic to Caypor; although we do not yet know that he is innocent, movie (and melodrama) convention has taught us to trust animal instincts. The first two times Hitchcock cross-cuts, the dog sound is overlapped with shots of Caypor alone in the frame. Having earlier identified the dog with the man, Hitchcock now identifies the sound of the dog with its owner. (Overlapping sound for a few frames is common in films, but Hitchcock overlaps here for whole shots. Furthermore, he will later introduce the whine without "justifying" it with the presence—even in a previous shot—of the dog. Thus Hitchcock is editing sound here with a freedom that had only been used in musicals and the quasi-musicals of Lubitsch and Clair, where nonrealistic sound editing did not jar with the fantasy of the genre.)

Just about the time that Ashenden is deciding not to carry out the murder Hitchcock allows the whining to continue under shots in which Ashenden and the General appear, so that the whine now becomes associated with Ashenden's guilty conscience. This association is made on a conscious level back in the hotel room, where Elsa, knowing full well why the dog is upset, is tormented by the dog's anguish. We do not actually see Caypor going over the cliff; but we hear a sound that suggests his descent. After showing (through the iris of a telescope) the General putting his arm up to Caypor's shoulder, Hitchcock cuts to Ashenden at the observatory saying, "Look out, Caypor, for God's sake!" As he calls out we hear a heartrending howl from the dog, a slow, descending howl that continues under the next shot: the mountain with only one figure on it and a cloud shadow passing over it. The howl continues under a series of shots in the hotel room, the last of which is a close-up of Elsa. The baying is richly evocative. Its length and descent provide an aural objective correlative for Caypor's unseen fall. Its tone is suitably mournful to represent our own emotions at the time. It becomes associated with the guilt felt by Ashenden and Elsa. And it seems like nature's protest against the wrong perpetrated. Although I would not go so far as Durgnat, who said that "the inter-connection of the animal, the musical and the telepathic at the point of death, *must* represent climactic transcendence within the Orphic rites,"[3] the resonance of classical myth surely envelops the sequence. This strong aural image will reach a haunting climax in

the following scene where a howl and a whine are heard just after Ashenden and Elsa discover that they have killed the wrong man.

The scene following Caypor's death—one in which Ashenden, Elsa, and the General meet at a dockside café where folksingers and folkdancers entertain—climaxes the first half of the film by uniting the major separate images and sounds of the previous scenes. In the murder sequence both couples, Caypor and wife and Ashenden and Elsa, are physically separated. The café scene opens with a close-up of an amorous-looking couple staring into each other's eyes, in contrast to Elsa and Ashenden who sit adjacently but uncommunicatively. (They remain emotionally apart until they argue, reunite, and kiss after a steamer ride. This kiss is filmed under an arched bridge, which architecturally reunites them, just as the sound of distant bells—music that remains music—consecrates their avowals.) The murder sequence ended with a second, shorter howl of the dog, and the café scene starts with the singing of peasants, two sounds that merge later in the scene. The scene also pulls together all the circular images that have been gradually associated with the couple's guilt until now. Furthermore, the scene establishes and resolves the connection between the complex of aural images (those which shift from music to noise) with the complex of circular images as it shifts from an objective to a subjective mode, in order to convey Elsa's feelings of guilt.

The scene opens with the entertainers singing a pleasant folk tune. As the General arrives (from the Caypor inquest) the number ends, so that the audience's clapping at his entrance can be taken as an ironic form of approval for the General's performance as a killer. The General gives Ashenden a telegram to decode, and while Ashenden is away from his seat the entertainers perform what is evidently a local custom, in which the singers spin coins in bowls for accompaniment while they perform a peculiar kind of yodeling in slow chords. Through a combination of dollies-in, cutting between the coins and Elsa, and framing, Hitchcock identifies the moment with Elsa's feelings. Elsa is becoming mesmerized by the spinning (although she cannot literally see it) and the ringing of the coins. Hitchcock often uses spirals or circles (in *The Lady*

Vanishes, for example) to indicate states of delirium. From the beginning of the film the English spies have asked themselves whether they are acting out of patriotic or materialistic motives. Coins stress the mercenary possibility at this point; Elsa not only hears the ringing coins but watches the General flip a coin into the bodice of a girl he has just met (he later bribes her for espionage secrets). Ashenden returns to the table with the decoded message that they have killed an innocent man. By this time the chorus's yodeling has come to sound as much like a dog's howling as it does like singing. Music has been transformed into the specific noise that has already been associated with the heroes' feelings of guilt (through a series of transfers from dog to master to murderers). The shifts from music to noise and from noise to subjective expression form a single continuum.

After Ashenden is seated, Elsa reads the decoded message that they have killed the wrong man. She puts her hands to her head and says, "But the button!" (Caypor was mistakenly identified as the spy because his jacket had buttons identical to one found in the hand of the murdered organist.) To express Elsa's shock Hitchcock augments both the audio and the visual tracks. He raises the loudness of the sound track to an almost painful level (noise is once again a form of punishment), and he creates a montage of spinning images. Over the now-familiar shot of a coin spinning in a bowl he superimposes the image of a spinning button, a shot of multiple rows of buttons, and a few frames of clapping hands. The circular images, besides creating a geometrical suggestion of Elsa's delirium, also evoke earlier shots of a roulette table (at which Caypor was identified by his button) and the two iris shots of Caypor. In the tradition of German expressionist films, Hitchcock uses iris shots in *Secret Agent* to connect the victim's entrapment with the perpetrator's voyeurism. Ashenden has watched the death they perpetrated if not executed, and, as in *Psycho* and *Rear Window*, Hitchcock implies that his voyeurism is only one step removed from murder. Thus, all the major aural and visual motifs in *Secret Agent* coalesce in the delirium sequence. At the same time, the characters have been brought to their lowest psychological state. It is characteristic of Hitchcock that the moment when all the film's

stylistic elements come together is also the moment when his characters fall apart. Paradoxically, the greatest stylistic order is required to convey a sense of moral breakdown.

There is one component of the sound track during the café scene that requires separate discussion from the others because its usage is unique in the film and, to my knowledge, in Hitchcock's career. It is the sound of a dog whining, which Hitchcock adds to the track under the sounds of the ringing coins and the yodeling-howling while Ashenden sits down at the table. The whining is a more radical use of sound than the howling in two ways. First, the howling has a realistic basis in the scene where it occurs; deliberately ambiguous, the sound can be attributed to the yodelers even though it resembles howling. By contrast, the whining allows only one interpretation; it is the distinctive sound made by Caypor's dog during the murder sequence, and it clearly has no literal source in the café scene. Second, whereas the howling is a noticeable component of the sound track, the whining is apparently not meant to be registered consciously but more or less subliminally.[4] Even though the whining is not consciously discerned by the viewer, its inclusion furthers Hitchcock's expressionistic aims. In a film that has already established the subjective nature of the sound track, Hitchcock here introduces a sound completely divorced from any literal source and solely for the emotional value of its associations.

The deliriously loud sound of ringing is abruptly replaced by that of the General laughing at the discovery that they have killed the wrong man. As in *Blackmail*, Hitchcock uses laughter to emphasize the disparity of awareness between the heroine and the man who is laughing. The callousness of the General's response evidently brings Elsa to her senses, and so, in direct contrast to *Blackmail*, the sound track shifts from subjective to objective with the introduction of the laughter.

The General's laughter is also entirely in keeping with his characterization throughout the rest of the film. Durgnat helpfully points out that the villain's part here, as in *North by Northwest*, is divided among various characters.[5] If Marvin (the real enemy spy, played by Robert Young) seems charming, or at least innocuous, Peter Lorre's General represents the sleazy and mercenary aspect of espionage. He likes killing to excess just as he likes women to

excess. Indeed, he confuses sex and death (just as he confuses hearing and seeing when he complains "Me still blind on this ear"). He is introduced in the film through the sound of a woman's scream at secret-service headquarters in London during the bombing. When "R" and Ashenden first hear the scream, they assume that it is a maid's response to the bombs, but she is more afraid of sexual attack from the General. She runs out of the basement shelter crying, "I'd rather be upstairs with a bomb than downstairs with the General." The General also elicits screams from his German girlfriend each time he throws a coin down her bodice. Sex and death are also interchanged on a verbal level when Ashenden asks "R" if the General is a "lady-killer." "Not only ladies," answers "R."

The General's laughter at death, his combination of sexual and murderous behavior, is finally an obviously immoral extreme of the more ambiguous moral universe of Elsa and Ashenden. Hitchcock first indicates that they have entered that *socially* dangerous world by creating literal transformations of sound—the transformation of organ chord to discord, of church bells to noise. When he wishes to indicate that his characters are now caught up *morally* and *emotionally* in an ambiguous universe, he does so by using sounds for which there are no literal or objective sources. Thus, through the expressionistic use of sound, Hitchcock begins *Secret Agent* with the same penetration of psychic complacency that frequently marks his best work.

It might be expected that the scenes following the café episode would reverse the direction of the earlier scenes, that the moral regeneration of the heroes would be matched by the reassertion of order on the sound track. Hitchcock suggests this possibility in the shift from the subjectivity of Elsa's aural delirium to the reality of the General's laughter. After the café scene, the only remaining subjective use of sound occurs when train wheels "tell" Elsa: "Save Ashenden, Save Ashenden!" This shift from noise to speech neatly reverses the earlier mental shift from human expression (yodeling) to noise (howling). Yet these reversals only hint at an aesthetic resolution, which in fact never comes. Hitchcock never resolves the film except on the most superficial level: the actions of the characters become dictated more by narrative requirements

than by moral imperatives. The moral dilemma is not worked out in terms of the characters' choices but is simply evaded by the expedient of ending the film with a train crash that conveniently kills the real spy and absolves the heroes of that responsibility.[6] There is nothing the matter per se with an unresolved ending. In many of Hitchcock's films an ending that leaves the audience feeling disturbed or unsettled reflects Hitchcock's vision of a world of moral ambiguity and complexity.[7] In the best of these films, however, Hitchcock has found a formal solution to convey that ambiguity (e.g., the sound of laughter in *Blackmail*, the image of birds on a porch in *The Birds*). In *Secret Agent* Hitchcock never consummates the implications of his aural expressionism.

Hitchcock's other films of the thirties are characteristically more realistic than *Secret Agent*, with only occasional forays into aural or visual expressionism. The expressionistic techniques are generally quite noticeable. As a result what is conveyed is less the feelings themselves than the idea of the feelings. A typical example occurs in *The Thirty-nine Steps*, just after a woman spy dies in Robert Donat's room, revealing her secret mission to him with her last breath. The woman has transferred to Donat both her knowledge and her paranoia. A triple repetition of her words and a superimposition of her face accompanies Donat's realization that he cannot escape the burden of his new knowledge. Yet the technique is less expressive of his feelings than is the cutting of the sequence.

The Lady Vanishes (1938) includes two aural ideas used earlier in *Secret Agent*, but the differences are significant. The first apparent parallel is a delirium sequence. Suffered by the heroine after a blow on the head, the delirium is comprised of a combination of spinning images and loud noises. At this point, however, neither the images nor the noises that make up the montage have any resonance as developed motifs. From here on in train noises continue to express the heroine's confusion when she is forced to doubt her senses (the enemy conspires to convince her that she never saw the lady she thinks has vanished). However, the subjective distortions have physical explanations rather than emotional causes attributable to an initial weakness of character. A brief expository scene that suggests her to be somewhat superficial does not justify or determine the nature of her punishment. The second apparent

parallel, a shift from music to noise, occurs when the dancing and singing of some peasants is perceived by the heroine in the room below as stomping and cacophony. Hitchcock even makes the shift explicit: the hero complains, "You dare call it noise—the ancient music with which your peasant ancestors celebrated every wedding for countless generations. . . ."[8] The explicit treatment hints at the difference between the handling of the same idea in the two films. It is no longer an expressionistic element but an acknowledged part of the story line. Such handling places it firmly in the classical style discussed in chapters 4 and 5.

Notes

1. The descent of Hitchcock's protagonists into chaos and their subsequent struggles to escape as an archetypal pattern in Hitchcock's American films is analyzed by Robin Wood throughout his *Hitchcock's Films* (London: A. Zwemmer; Cranbury, N.J.: A. S. Barnes, 1965, rev. 1969). References below are to the 1969 edition. It will be obvious to readers familiar with Wood's seminal work that my study is greatly indebted to Wood's thematic analysis.

2. Donald M. Spoto, *The Art of Alfred Hitchcock* (New York: Hopkinson and Blake, 1976), p. 53. A more obvious function of the noise is that it blocks out from the viewer the unnecessary dialogue between the heroes and the people giving them a tour of the factory. In *North by Northwest* Hitchcock similarly uses motor noise to drown out unnecessary exposition. By blocking out with airplane noise a federal agent's explanation to the hero of all that has occurred—information already provided to the viewer—Hitchcock has impossibly reduced the explanation to a matter of a few seconds. It is one of the rare instances when sound rather than editing can be used to condense screen time.

3. Raymond Durgnat, *The Strange Case of Alfred Hitchcock: or The Plain Man's Hitchcock* (Cambridge, Mass.: MIT Press, 1974), p. 134. Italics mine.

4. I am using the term *subliminal* in the sense that the stimulus functions outside the viewer's area of conscious awareness, not in the sense that the stimulus is inadequate to produce perception. The term must be defined loosely because it has not been scientifically ascertained what is subconsciously registered from a sound track. I can only report that my repeated experiments have shown that even film scholars told to pay close attention to the scene will not notice the dog sounds amid the other sounds on the busy track, whereas even subjects who have not seen the rest of the film, if told to *listen* specifically to the one shot in which the sounds occur, will invariably report the presence of the whining, even though they have no reason to expect it in such a context. By contrast, a film student or scholar is easily capable of identifying the four superimposed images that appear a minute later in the scene. The implication of this comparison between a viewer's ability to perceive clearly a relatively dense visual field but not discriminate among equally dense aural images is that filmmakers

must be—and in many cases are—aware of this imbalance in our perceptual sensitivity, of our discriminating of visual information over the sound track. When writers refer to subliminal visual images, they are referring to the insertion of images for less than the four frames or so that most viewers need to consciously register their perception of an image. By contrast, I believe that with sound the idea of subliminal perception should be identified with simultaneously rather than sequentially dense stimuli. In a sense, the use of subliminal sounds is frequent and normal, considering that the average commercial film has dozens of passages in which the composite sound track at a given point comprises twenty or more separate layers of sound, most of which are not meant to be identified as discrete elements by the listener. These sounds are usually built up from noises natural to the location. Hitchcock's introduction of the dog sounds, which have earlier been associated with the couple's guilt, is qualitatively, though not quantitatively, different from the layering of sounds we are not supposed to notice in other films.

5. Durgnat, *The Strange Case*, p. 133.

6. After the train crash there is a short coda accompanied by typical newsreel march music. It is a montage of newsreel footage, newspaper headlines claiming victory in the Middle East, and a postcard to "R" from Elsa and Ashenden. Over the message—"Home safely, but never again, Mr. and Mrs. Ashenden"—appears a superimposition of their smiling faces.

7. Wood, in *Hitchcock's Films*, pp. 22–26, defends this "'nasty taste' phenomenon" in depth.

8. It is relevant that the music annoying the heroine is wedding music, for at this point the heroine is headed for a marriage with a man she does not love.

4 Consolidation of a Classical Style: *The Man Who Knew Too Much* (1934)

In a generally favorable contemporary review of *The Man Who Knew Too Much* (1934), Forsyth Hardy observed that "with *Murder* in mind, the surprise of the film is the absence of any expressive use of sound."[1] If by "expressive" sound Hardy is referring to virtuoso effects, then he is right; there is nothing equivalent to the choric chanting in *Murder* or the knife sequence in *Blackmail*. However, Hitchcock is still very much experimenting with sound in *The Man Who Knew Too Much*—in less obvious ways. With this film Hitchcock finds a successful formula that will enable him to develop his concerns with the deeper impulses of human behavior without resorting to noticeable expressionistic devices. It is the first film in the classical style that will characterize such films as *Young and Innocent* (1937), *The Lady Vanishes* (1938), *Foreign Correspondent* (1940), and *Mr. and Mrs. Smith* (1941).[2]

The classical method requires Hitchcock to manipulate his sounds within a realistic context. On the stylistic level this means that he has to provide a literal pretext for any exaggerated use of sound. On the thematic level, the method requires the incorporation of the aural effects into the plot itself, so that they are so obvious and so essential that they do not jar with the style of the rest of the film.

One means of amplifying a sound with a literal source is to find a plausible second sound that provides an aural correlative for the original sound. This substitution technique is akin to the use of "objects as visual correlatives" that Andrew Sarris has observed in Hitchcock's films.[3] In *The Man Who Knew Too Much*, vases serve this function during a shootout at the spies' hideout at Wapping. The director wants to show that the spies are gradually being

overcome by the police who are firing at them through the windows, but he does not want to eliminate his few spies too soon lest he also eliminate the suspense. He therefore uses vases, which line the room's shelves, as a visual substitute for and aural extension of the destruction being sustained. Hitchcock presumably does not want to actually depict the violence of the spies' deaths; not only does Hitchcock prefer implication, but also Hollywood's gangster films had created a revulsion in England against excessive violence. He was able to suggest the impact of the bullets by showing the shattering and toppling of vases (just as Howard Hawks had shown Gaffney's murder through indirection in *Scarface* two years earlier by having the camera follow a bowling ball released by the murdered man to its target, where a last pin wavers and finally topples). Similarly, the sounds of gunshots from down the street, even if realistic (at this time sound-effects recordists had to find substitutes for the sounds of shots because recording the real sound would have blown out their sensitive equipment), were multiplied and amplified by the sounds of numerous vases shattering and crashing to the floor. In much the same way, Hitchcock uses crockery during a donnybrook in *Young and Innocent* and balloons during a birthday party in *The Birds* to intensify the effects of destruction.

The other way to manipulate sounds within realistic limitations is to carefully control the use of ambient noise, that is, the sounds that might occur naturally in the background of a given location. Background noises can be juggled quite extensively before the audience will notice them. Hitchcock was fond of saying that a "decisive factor" in *The Man Who Knew Too Much* was "the contrast between the snowy Alps and the congested streets of London," which he told Truffaut was a "visual concept [that] had to be embodied in the film.⁴ For the transition between the Swiss and the British scenes Hitchcock dissolves from snowy mountains to a night shot of Piccadilly Circus and from the jingle of sleigh bells to the noise of traffic. Otherwise, he barely indicates any visual congestion of London. He depends much more on sound for ambience.

For instance, when the film's two heroes, Lawrence and Clive, first arrive at Wapping, the sound track is busy with boat whistles, hand-organ music, car horns, and traffic, but we see little activity.

(Of course, this is the more economic way of creating ambience in a tightly budgeted studio.) As the men walk upstairs and wait outside a dentist's office that is a front for espionage activities, Hitchcock keeps up the level of ambient noise. However, while we wait outside with Lawrence once Clive has gone into the office with an unsavory-looking dentist, Hitchcock eliminates all but a few token exterior noises, to focus our concentration on the closed door. Our expectations are rewarded with a scream (Clive's), which confirms our fears about both assassins and dentists. (An earlier association between the assassin and dentistry is suggested when Lawrence's daughter observes that she does not like the assassin because he uses too much brilliantine and has too many teeth.) It is important to the film that Wapping is the kind of seamy location in which a scream goes unheeded. The plausibility of its going unnoticed by the outside world has been increased by the introduction of that world as a noisy location.

In Hitchcock's American remake of *The Man Who Knew Too Much* (1956), it is the first setting (in this version, Marrakesh) that is noisy and London that is quiet.[5] Hitchcock emphasizes the congestion of Marrakesh by staging the murder of the spy in the marketplace. Contrasted with the noisy setting is the placidity of the Jimmy Stewart character—Hitchcock has specifically described his character as "an earnest and quiet man."[6] The manipulation of the ambient noise to underline this contrast is done with great care. For instance, there is a scene in a police station in which Stewart and his wife talk with a police officer. The shots alternate between the couple's view of the policeman, which includes a view through the window of the busy city, and the policeman's view of the couple, who are sitting across from him before a blank wall. Although the ambient noise should theoretically not vary, in fact, Hitchcock raises the traffic noise when we see the city and lowers it significantly when we are looking at Stewart. I have described this detail to distinguish between the early and later appearances of the classical style. The manipulation of ambient noise is already present in the 1934 film, but in relatively crude form. Later versions of Hitchcock's techniques are almost always more refined.

If the technical aspects of the classical style are superior in the

second version, however, those thematic aspects which the films share are already fully developed in the first. That is to say, Hitchcock has so neatly incorporated his thematic elements into the plot and characterization that they are all but invisible to the viewer who does not want to look for them. The point where the themes all coalesce is the famous Albert Hall sequence, in which a diplomat is to be assassinated. The spies plan to have the sound of the assassin's gunshot at the concert hall be masked by the sound of cymbals crashing, so that the structural climax of the film corresponds with the musical climax of a dramatic cantata being performed. At the concert is a woman, Mrs. Lawrence, who knows about the plot but has been warned that her ,intervention would mean the death of her kidnapped daughter. Thus, her last-second scream, which saves the diplomat, is also the thematic climax of a film whose moral dilemma has been a couple's choice between the life of their daughter and that of a famous diplomat, between the family and the state, between love and duty. The choice between screaming and remaining silent is related to one of the film's major concerns: the contrast between silence and oral expression that differentiates the spies from the heroes of the film. Furthermore, the concert sequence creates a conjunction of music and murder, the one a sign of order, the other a sign of chaos. The silence-versus-expression antinomy operates on an individual level. The music-versus-murder antinomy operates on a social level. These two antinomies merge at the concert sequence, which poses in concrete terms the central tension of this and other Hitchcock films: the problem of how to reconcile the need for social order with the need for personal expression. As my analysis will show, on the social level Hitchcock is more or less on the side of control; on the personal level he is more or less on the side of expression.

The silence-versus-expression motif is developed through contrasts of characters. *The Man Who Knew Too Much* is the first of Hitchcock's films to suggest that for criminals to be effective they must work quietly, a concept that is most fully and literally developed in *Family Plot*, where the kidnappers always remain mute in their dealings with lawmen. In both films silence is associated with single-minded dedication to one's task. Noise and talking reveal espionage activities and must be avoided at all costs. The

spies would not have known that the Lawrences "knew too much" in the first place if Lawrence had not talked too loudly about it in a hotel hall in Saint Moritz. Even shooting is to be avoided if possible. The spies battle Lawrence and Clive in their church with chairs rather than guns because they do not want the police to hear. During the brawl the woman spy tells the organist to play a hymn to cover up the sound of the scuffle. The spies engage in the final shoot-out with the police only because their hideout has been discovered. Thus it is altogether appropriate that their assassination attempt involves their concealing a gunshot under the sound of crashing cymbals. Similarly, it is appropriate that their kidnapping involves keeping the Lawrences quiet. Despite the film's title, it is not the Lawrences' knowing too much, so much as their telling anyone, that concerns the spies. The idea of "keeping your mouth shut" is literalized by Hitchcock, who has Lawrence tell Clive to do precisely that after Clive has had his tooth extracted in the cause of their search for the daughter.

The most efficient, and the quietest, character in *The Man Who Knew Too Much* is the woman spy, who even after being shot, dies without a sound, and who spends a good deal of time trying to keep her brother, Abbott, the spy ringleader, from not getting sidetracked from his work. Talking too much is Abbott's fatal flaw. It is also what gives him (as played by Peter Lorre) his personality because it humanizes him. He likes to chat, to make puns, and to laugh. He is so identified by his musical Swiss watch that, when Lawrence is searching for him in the hideout-church, his presence can be revealed by the sound of the watch chiming while he is still offscreen.

Keeping quiet involves controlling one's emotions. Abbott tells Lawrence, "You should learn to control your fatherly feelings and not drop things on the floor" and challenges the father not to give away his feelings when he is reunited with his daughter in the spies' hideout. That reunion sequence is matched later against the scene of the woman spy's death, in which Abbott cannot entirely suppress his despair.

In previous chapters I have suggested that silence is a symptom of moral paralysis; in *The Man Who Knew Too Much* it is also a sign of emotional paralysis. For Hitchcock implies that always keeping

quiet requires the unhealthy suppression of emotions. Unlike the
spies, the Lawrences are talkers. Volubility is a sign of emotional
life, of spontaneity, of irrepressibility. In the second scene of the
film, the skeet-shooting finals between Mrs. Lawrence and Ramon,
who, it will turn out, is the spies' assassin, the Lawrence daughter
spoils her mother's shot by talking too much. The mother remarks,
"Let that be a lesson to you not to have children." Like most
jokers, she is partly serious, although her actions for the rest of the
film show that she prefers life, and having a daughter, to winning.
(She does win in the "contest" that involves a life, rather than just
winning an artificial game.) A moment later it is the mother who is
shushed by the crowd for talking too much (as she is saying that she
will "disown the child" if she loses), and the assassin wins the
championship. There is a structural connection linking the first two
confrontations between these two sharpshooter-antagonists. At the
skeet-shooting match the daughter's speaking makes the mother
miss a shot. At Albert Hall the mother's screaming makes the
assassin miss.

Thus, the concert sequence, which is usually considered merely
a clever device for producing suspense, is related to the tension in
the rest of the film between keeping quiet and revealing one's
feelings. (More obviously, the concert sequence is also a confronta-
tion between the good and evil forces.) At the concert the mother is
torn between two forms of behavior—one trained, one instinctual.
The audience sympathizes with both. One choice is not to disturb a
concert, not to make a fool of oneself in public—a behavior pattern
that has been instilled in us from an early age. The other choice is
the impulse to cry out at a moment of danger. When the mother
screams in the nick of time to prevent the assassination, she is not
so much going against maternal instinct (by risking the life of her
child) as responding to the more immediate instinct of wanting to
save the ambassador's life. Thus, her behavior here is one and the
same healthy expression of emotion as her daughter's talking at the
shooting match, and both are opposed to the unnatural repression
of emotion typical of the spies.

The two screams elicited by the spies at different points in the
film provide a measure of the extent to which anarchic forces have
intruded into civilization. The spies' threat moves from an isolated

room in a seamy suburb to an Albert Hall concert at the political and cultural center of British society. If a scream goes unheeded when emitted from a slum dentist's office, it is altogether conspicuous and inappropriate at a concert, and that is why it is an effective means for Mrs. Lawrence to save a diplomat's life.

The whole notion of staging the film's climax at a concert is particularly useful because Hitchcock can work with the concept of musical order in two ways, stylistic and thematic. A comparison of the role of music in both versions of the film reveals once again that, while both thoroughly develop the thematic associations of music, the second is a decided improvement on the first in its stylistic use of music. Hitchcock has said that "the first version is the work of a talented amateur and the second was made by a professional.[7] He was, as usual, assessing his films only according to their craftsmanship, and in that area he is certainly right. In both films the stylistic function of the music is to create suspense. Music is such a useful tool for Hitchcock because a piece of music has its own structure, a preestablished order against which he can time the struggles of his characters.

Truffaut and Hitchcock together have quite thoroughly analyzed the improvements in the second version of the concert sequence itself.[8] They have not so thoroughly discussed the preparation for the sequence, however. In the British version of the film Hitchcock gives us little chance to hear the musical phrase during which the shot will be fired. A considerable portion of the piece ("The Storm Cloud Cantata" by Arthur Benjamin) is played under the opening titles, but it stops short, just before the last four notes that comprise the crucial phrase. The four notes in isolation are first heard just before the concert, as Abbott plays them for the assassin (really for the audience, of course) on a record player. The American version is much more sophisticated aurally and visually in acquainting the audience with the music so that the suspense can be milked. Just a look at the scene in which the spies play the record reveals the added clarity of Hitchcock's later version—a clarity evidently based on a greater self-awareness of the elements of his own style. In the later film the spies provide the context of the musical phrase, and they play the record twice. In the first version the playing of the record is photographed in deep focus, so

that we may watch the expressions of the father and daughter in the center and depth of the image, with Abbott and the assassin less conspicuously located on either side of the frame and nearer the camera. In the second version Hitchcock simplifies the shot (the three spies in it are all looking at the phonograph; the hostages are not seen), thereby forcing us to pay closer attention to the music. There is no emotional distraction.

Formal considerations aside, Hitchcock established with the first *Man Who Knew Too Much* the thematic role that classical music would usually play from then on in his films; the concert is a staid ritual of refined society. During the film's violent confrontations the spies use music to cover their activities. Their first assassination is that of a British spy in Saint Moritz who is shot while he is dancing with Mrs. Lawrence. Hitchcock does not emphasize the point, but this assassination, too, is concealed by music. The gunshot occurs on a musical beat, and the sound heard is not of a bullet but of window glass breaking. Even the victim himself looks down with surprise, after not noticing for a moment that he is wounded. As is noted above, the spies try to cover the noise of the brawl in their church with music. At the end of the hymn, the organist plays a solemn amen. Church music is, of course, even more staid than choral music, and so we experience a frisson of pleasure when Lawrence earlier gets the chance to "naughtily" sing false words to a hymn while he is trying to warn Clive of their danger. (It is the same antiauthoritarian pleasure we get out of seeing grown men and women fighting in church.) Their disregard for the normal lyrics of the hymn may be seen as a foreshadowing, like the daughter's talking during the match, of the mother's "naughty," antisocial scream during the concert. The disrespect for music by the so-called moral forces in the film is continued, in a minor way, even during the final shoot-out, when two policemen, commandeering one citizen's parlor, use his piano as a barricade, after the first policeman has scolded his younger partner for playing a few notes on the piano by saying, "This is a scrap, not a . . . concert."

The evil forces cover their activities with a front of respectability (religious and cultural). By contrast, the good side has to be disrespectful to cultural institutions to preserve them. The conjunction

The Man Who Knew Too Much. *James Stewart at Albert Hall.*
"A scream may be more civilized than a cantata."

of music and murder is one of Hitchcock's many ways of showing
that evil lurks very near the surface of respectability. Just as the
attachment of Mrs. Lawrence's knitting to the coat of someone
about to be killed juxtaposes "the domestic and the sinister,"[9] so
the interruption of music by assassinations suggests that domestic
and national security are very fragile illusions—as tenuous as a
thread of yarn that breaks when a man dies; that security and
control are gained at the cost of repressing natural instincts; and
that a scream may be more civilized than a cantata.

Notes

1. "Films of the Quarter," *Cinema Quarterly* 3 (Winter 1935): 119.
2. Films that combine classical and subjective techniques in varying proportions include
The Thirty-nine Steps (1935), *Sabotage* (1936), *Saboteur* (1942), *Lifeboat* (1943), *Dial M for
Murder* (1954), *To Catch a Thief* (1955), and *The Man Who Knew Too Much* (1956).

3. Andrew Sarris, *The American Cinema* (New York: E. P. Dutton, 1968), p. 58.

4. François Truffaut, *Hitchcock* (New York: Simon and Schuster, 1967; originally published as *Le Cinéma selon Hitchcock* [Paris: Robert Laffont, 1966]), p. 61.

5. In the American version the characterizations of the heroes are more complex, and there is an added subjective component. See below, chapter 9, p. 163.

6. Truffaut, *Hitchcock*, p. 170.

7. Ibid., p. 65.

8. Ibid., pp. 63–65.

9. Raymond Durgnat, *The Strange Case of Alfred Hitchcock or The Plain Man's Hitchcock* (Cambridge, Mass.: MIT Press, 1974), p. 123.

5 Music and Murder⎯⎯⎯⎯⎯⎯⎯⎯⎯

Appearing most often in the form of song, music is an essential component of the story in over half of Hitchcock's sound films. As in *The Man Who Knew Too Much,* the most distinctive aspect of Hitchcock's music is its frequent incorporation into the very conception of the film. Eight of his protagonists are, in fact, musicians: a composer in *Waltzes from Vienna* (1933), women singers in both *Stage Fright* (1950) and the American version of *The Man Who Knew Too Much* (1956), a bass player in *The Wrong Man* (1956), a pianist in *Rope* (1948), a drummer in *Young and Innocent* (1937), and a music teacher and a musicologist in *The Lady Vanishes* (1938). (It is interesting to note that Hitchcock himself makes several appearances in his films carrying a musical instrument and that his favorite analogue for filmmaking is orchestration.) Aside from its personal relevance, Hitchcock's dependence on music, classical or popular, is also the logical outgrowth of his search for plot devices that are suggestive but that derive naturally from a situation, so that any symbolic or metaphorical value they might have is not so obtrusive as to stop the flow of action or reduce audience involvement. This formula is, of course, part of Hitchcock's classical approach to style, and so it is not surprising that it is particularly the British films in which songs abound—songs play an important role in every one of the Gaumont films.

Hitchcock expressed his desire to integrate musical and visual concepts as long ago as 1933, in an interview for *Cinema Quarterly.*[1] His discussion focused mainly on his just-completed film, *Waltzes from Vienna* (1933). The film, released in America as *Strauss's Great Waltz* and now unavailable here for viewing, is Hitchcock's only musical (excluding the musical number for Marlene Dietrich in *Stage Fright*). In the interview Hitchcock reveals a fascination with the possibilities of editing film and music together. His remarks seem influenced by the work of Lubitsch, Mamoulian,

Strangers on a Train. *One of Hitchcock's cameo appearances with a musical instrument.*

and Clair, who in their early musicals had sought to make the music integral with the film.[2] Hitchcock speaks with disdain of those musicals which merely "interpolate 'numbers' rather than employ music." In his film "the music had to inspire the action." Therefore, he "arranged the cutting to match the rhythm of the music. . . . In the slow passages the cutting is slow, when the music quickens the mood of the melody is followed by the quick cutting." The influence of other narrative filmmakers is obvious in Hitchcock's description of the following scene in which Strauss, a young baker, conceives a tune at work. "There the action—composed of simple things like bakers kneading dough and rolls falling into baskets—moves in time with the music which is forming in the young man's brain."[3] This derivation of the music from the activity of workers sounds especially similar to the opening scene of Mamoulian's *Love Me Tonight* (1932). Mamoulian's musical leads into Maurice Chevalier's singing of "The Song of Paris" as

if the song springs forth from the orchestration provided by the rhythmic waking activities of the city—sweeping, hammering, rug beating, and the like.

Hitchcock's discussion during Watts's interview ranges far beyond the specific needs of a musical to express a general view of the relation of film and music: "The basis of the cinema's appeal is emotional. Music's appeal is to a great extent emotional, too. To neglect music, I think, is to surrender, wilfully or not, a chance of progress in film-making." He feels so strongly about the potential value of music that he thinks every film should have a completed musical score before it goes into production. But the music should not, he says, overpower the film: "I might argue that I do not want the audience to listen consciously to the music at all. It might be achieving its desired effect without the audience being aware of how that effect was achieved."[4]

Hitchcock mentions two purposes for background music, both of which he adhered to throughout his career. One is "atmospheric": "To create excitement. To heighten tensity. In a scene of action, for instance, when the aim is to build up to a physical climax, music adds excitement just as effectively as cutting." His example from *Waltzes from Vienna* shows how music can eliminate the need for crosscutting. "There is a dialogue scene between a young man and a woman. It is a quiet, tender scene. But the woman's husband is on his way. The *obvious* [italics added] way to get suspense is to cut every now and then to glimpses of the husband travelling towards the house. In the silent days, when the villain was coming, you always had the orchestra playing quickening music. You *felt* the menace. Well, you can still have that and keep the sense of the talk-scene going as well. And the result is that you don't need to insist pictorially on the husband's approach. I think I used about six feet of film out of the three hundred feet used in the sequences to flash to the husband. The feeling of approaching climax can be suggested by the music."[5] Hitchcock has a sure sense here of the redundancy of "mickey-mousing," of having the music merely imitate the action, and he has boldly chosen the musical rather than the visual means of maintaining suspense. It is also interesting to note that in 1933 Hitchcock considers cutting to be more "obvious"—read clichéd—than music as a means of creating suspense.

The fact that he has to argue that music be used subtly suggests that the general attitude toward scoring is as yet unsettled in 1933. For his own part, Hitchcock's comments about music seem to reflect a personal ambivalence at the time about whether cinematic style should be obtrusive.

The other musical function Hitchcock mentions in the interview is a "psychological" use of music "to express the unspoken." The example he gives might be described as contrapuntal to the visuals: "Two people may be saying one thing and thinking something very different. Their looks match their words, but not their thoughts. They may be talking politely and quietly, but there may be a storm coming. You cannot express the mood of that situation by word and photograph. But I think you could get at the underlying idea with the right background music."[6]

The psychological and atmospheric functions of music are two of the ways in which Hitchcock has continued to use scoring and source music. Unlike weaker directors, he did not have to resort to scoring as a cover-up for ineffective, sagging sequences or for unmatched transitions. The one practice mentioned in the interview that he did not observe was having the score composed before shooting began. That was an impractical suggestion for narrative films, because it would have required shooting to be timed to precise tenths of seconds. But he did encourage composers to attend preproduction meetings.[7] More important, he achieved the same control with his strategy of incorporating familiar music into the story line.

One of the hallmarks of Hitchcock's treatment of music in his classical style is his use of familiar music to define a character or his social milieu. He does so either by linking a character with a given tune or by implying something about the character's expressed attitude toward a piece of music. In the latter case there is usually a dichotomy in Hitchcock's use of music as motif: classical compositions are usually treated as a product of cultural refinement—often overrefinement—whereas popular music is treated as a more natural expression of emotion. The implication that classical music is less in touch with genuine feelings reaches its extreme with the reference to Mozart in *Vertigo*. As Robin Wood has argued, Mozart's music is "clearly identified with the

superficial externality of Midge's world."[8] In Scottie's opening scene with Midge, he asks her to turn off a Mozart recording. Later, a Mozart symphony is played as a musical cure for Scottie when he is emotionally paralyzed after the supposed death of Madeleine. Realizing that Scottie is still in love with the mysterious Madeleine, Midge acknowledges defeat by telling the doctor, "I don't think Mozart's going to help at all": a poignant line that, as Wood says, "conveys her sense not only of Mozart's inadequacy but of her own."[9]

The association of classical music with social refinement creates a surprising paradox: whereas it can represent a civilization being threatened, it is often heard in conjunction with the villains who pose that threat. Hitchcock usually characterizes his villains as cultured and well-mannered and then proceeds to expose the superficiality of their refinement. The Peter Lorre character in the earlier *Man Who Knew Too Much* both appreciates good music and quotes Shakespeare. Like many of Hitchcock's villains of the thirties and forties, he is vaguely German, his outward refinement perhaps representing a sly poke at the cultural pretensions of the Nazis. Ultimately, this convention of the cultured, upper-class villain dates back to Victorian melodrama, where it delighted the largely lower-class audience.

Piano playing in Hitchcock's films is usually a comment on class. Two of his wealthiest women characters, Mrs. Paradine in *The Paradine Case* and Melanie in *The Birds*, play romantic pieces at the piano. In *Murder*, when Hitchcock introduces the home of a stage manager and his wife by showing their daughter mangling a piano sonatina, he is poking fun at their bourgeois pretensions.

The contrast between the usual roles of classical and popular music becomes quite clear when they appear in the same film. In the second version of *The Man Who Knew Too Much* the concert piece is nearly death-dealing and a popular song is life-saving. "Che sera, sera," the song that Doris Day sings to save her son's life (her kidnapped son locates her through her voice) was written specifically for the film. Oddly enough, her actions contradict the very lyrics she sings. The words of the chorus recommend fatalistic passivity: "Che sera, sera, whatever will be will be/The future's not ours to see, what will be will be." Yet the heroine is more

Strangers on a Train. *Farley Granger and Laura Elliot. Sounds in a record shop underscore the quarrel.*

successfully and actively engaged in saving both her son and society (or, at least, one statesman), than anyone else in the film.

Notorious (1946) also counterposes "stuffy" and sentimental music. Again, classical music helps define the highly civilized facade that the Nazi spies wish to maintain. The introductory shots of their headquarters, the Sebastian home, are accompanied by the sounds of a Chopin-like prelude, which is presumably being played somewhere in the house, although not on the grand piano that is a prominent part of the decor. The waltzes played later at their formal party are also meant to feel too sedate; they work contrapuntally in mood to our nervousness about the life-and-death maneuvers that Alicia and Devlin are making. Indeed, when Alicia seeks an excuse to leave her husband at one point, she tells him that she is bored with the "stuffy" waltzes being played and that she will ask the band to play some Brazilian music. At the earlier

party of the film (which Alicia hosts in Florida), Alicia also ex-
presses an affinity for more popular music when she chooses a
sentimental fox-trot for the record player. Devlin asks her why she
likes the song, and she answers, "Because it's a lot of hooey.
There's nothing like a love song to give you a good laugh." How-
ever, Alicia turns out to be quite sentimental once she falls in love.
She must spend the rest of the film waiting for Devlin to discard his
own cynicism and to trust and express his love for her. This senti-
mental attachment of a heroine to a love song prefigures its more
extensive development in *Rear Window* (see chapter 6). There, too,
the heroine expresses her admiration for a love song less ap-
preciated by a cynical man who at first does not fully return her
love. In both cases the man's initial unresponsiveness to the love
song symptomizes his emotional paralysis.

Hitchcock's favoring of low-brow over high-brow music can be
taken as evidence of the anti-intellectuality that so offends Charles
Thomas Samuels in Hitchcock's work.[10] Yet, as the above exam-
ples show, it is less musical taste than moral and psychological
questions that are at stake. Intellectuality and respectability are
condemned only when they are masks for emotional cowardice or
outright evil. It is, of course, precisely the point of Hitchcock's
persona and his aesthetic to do the reverse: his artistic and moral
concerns are often disguised by the trappings of a popular genre
(e.g., "the thriller").

Songs are extraordinarily useful for Hitchcock because he can
exploit both their direct emotional quality and the indirect associa-
tions brought to familiar songs by the audience. When he uses
songs in his classical style, he usually emphasizes their associative
qualities. As representatives of a culture they provide a shorthand
reference to that culture. For instance, songs have patriotic associ-
ations in *Lifeboat*, *The Lady Vanishes*, and *Foreign Correspondent*,
and childhood associations in *The Birds* and *Marnie*. When Hitch-
cock wants to exploit the more direct, emotional qualities of a song,
he usually establishes a meaning for that song in terms of one
character. For instance, songs transmit or reflect a character's guilt
in *Blackmail*, *Secret Agent*, *Sabotage*, *Young and Innocent*,
Shadow of a Doubt, *Stage Fright*, and *Strangers on a Train*.

Typical of the classical treatment of music is *Lifeboat*, which

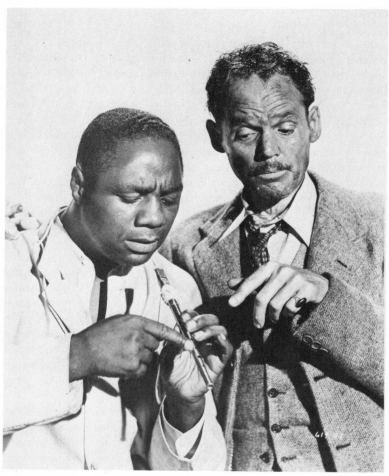

Lifeboat. *Canada Lee and Henry Hull. Chauvinistic values are attached to tunes.*

deals with the chauvinistic values attached to songs. The film's struggle between one German and a boatful of Allies is echoed by a conflict between the songs "Du, du liegst mir im Herzen" and "Don't Sit under the Apple Tree." At first the Brooklyn cab driver, Gus Smith, objects when the Nazi, Willy, sings the German folk tune; Smith counters with the American tune. After the German saves Smith's life by amputating his gangrenous leg, however, the Americans join in when Willy sings German songs.

In *The Lady Vanishes,* Hitchcock deals explicitly with the indigenous quality of folk tunes. Its hero, Gil, is a musicologist dedicated to preserving the musical heritage of the country of Bandrica in which the film starts. He is seen constantly with the folk dancers whose art he is recording for posterity. Hitchcock uses the dancers as a butt of humor—by catching them in awkward positions. However, Gil's profession is not much worked into the thematic material of the film; it simply helps establish the innocent and indigenous qualities of folk tunes—and his own innocent, awkward sincerity as well. These qualities are also initially attributed to the tune that becomes the film's "MacGuffin." "MacGuffin" is Hitchcock's term for the relatively meaningless plot device that supplies a pretext for the action—e.g., the secret plans in a spy thriller. The vanishing lady of the title is a governess and music teacher working as a spy to carry a message to the British government; the message is encoded within a tune. When the governess first hears the tune, she says of Bandrica, "Do you hear that music? Everyone sings here, the people are just like happy children with laughter on their lips and music in their hearts." Yet in the very next scene Hitchcock once again mingles music with murder. The tune is sung by a man who is strangled as soon as he finishes his serenade. Before the governess can convey the tune to the British secret service it is the cause of a number of other deaths as well.

In *Foreign Correspondent* the East European spies torture an Allied diplomat by repeating an American swing record ad nauseam. To judge from the film, Hitchcock seems to have taken a mischievous pleasure in seeing something so innocuous as a popular record being used as an instrument of political torture. Undoubtedly, he enjoyed irritating his audience along with the diplomat in the process.

Marnie. *Louise Latham and Tippi Hedren. The children's chant, "Mother, Mother, I am ill," echoes Marnie's problems.*

Two of Hitchcock's sixties films use children's songs to mingle the sinister with the innocent. In *The Birds* the vicious attack of the birds on the school children of Bodega Bay is prepared for in a sequence in which the birds amass outside a schoolhouse while we listen to the children singing. The song is carefully chosen—the verse is an accumulative story, which lengthens in lines from verse to verse, just as the birds are accumulating. Each chorus ends with the words "now, now, now" to heighten the suspense about when the birds will attack. *Marnie* uses as a motif the childhood chant that begins: "Mother, Mother, I am ill/Send for the doctor over the hill." We first hear the lines repeated by children outside Marnie's childhood home. She repeats several of the lines while "free associating" for her husband as he plays amateur psychiatrist. The

film ends with Marnie and her husband driving away from her childhood home past children singing the same rhyme. Besides referring to both Marnie's illness and her mother's central role in her problems, the use of a child's chant is particularly appropriate because the film explores the traumatic effects of an experience she had at the age of five. The movement of the film is to get Marnie back into a childhood state so that she can remember and exorcise the effects of that experience.

In *Young and Innocent* Hitchcock emphasizes the rhythmic aspects of song. As in several other films the climax involves the disruption of a piece of music. This time, however, the disruption is a rhythmic manifestation of a villain's guilt rather than a hero's temporary adoption of a villain's antisocial behavior. In the film's final scene the heroine, Erica, seeks to clear a friend, Robert, who is wrongly accused of murder, by finding a man who can be identified by an eye twitch. She and the vagrant helping her sit at a *thé dansant* in a crowded hotel ballroom at the far end of the room from the band. While the band plays (and the bandleader sings) the popular tune "The Drummer Man," the camera swoops in one dramatic shot from the couple's end of the ballroom to the band's end and into a close-up of the drummer's twitching eyes. However, although Hitchcock has let the audience in on the secret, there is little chance that Erica will spot the twitcher, who has actually committed the murder of which Robert stands accused. When Erica and her partner dance past the band, the drummer turns his back to the dancers (he has recognized the vagrant) and improvises on the xylophone, a digression from the musical arrangement for which the bandleader will scold him. It is a foreshadowing of his more radical divergence from the score later on.

Guilt in Hitchcock's world will usually manifest itself through a person's lack of control. In the drummer's case the eye twitch, an obvious symptom of his guilt—Douchet calls the tic a "visual disharmony"[11]—becomes harder and harder to suppress. (Ironically, the musician whose function is to keep the beat cannot control the rhythms of his own body.) During a break the drummer downs a handful of pills to tranquilize his too-nervous system. However, when the band resumes playing "Drummer Man," he is unable to maintain the beat. His drumming gets wilder and wilder

until the dancers notice as well as the bandleader, and eventually he collapses. Before he dies—presumably of a heart attack brought on by the pills—he confesses, with a mad, melodramatic laugh, to the murder of which Robert is accused. There is no equivalent scene or character in the original novel (Josephine Tey's *A Shilling for Candles*), which attributes the murder to another character. Hitchcock first gives his villain an eye twitch as an external manifestation of his guilt on the very night of the crime. Then he has the villain assume a musician's role so that his guilt can be translated into an aural metaphor for being out of step with the rest of society. (A visual equivalent of this asynchronism can be found in *Strangers on a Train*. There the villain looks straight ahead at his victim from the bleachers during a tennis game while all the other spectators rotate their heads back and forth in a unified rhythm as they watch the ball.) Hitchcock adds a characteristic offbeat touch, as it were, by aurally extending the drummer's death—the drummer's body produces several extra loud cymbal and bass-drum crashes as he collapses onto his instruments. The drummer thus creates noise instead of music just as the dying organist did with his last chord in *Secret Agent*.

Twenty years after *Young and Innocent* Hitchcock again associated guilt with the loss of rhythm in *The Wrong Man*. Oddly enough, it is the later film that posits the idea only in an intellectual manner rather than weaving it into the very fabric of the film. *The Wrong Man* involves the disruption of order in the very routine life of bass player Emmanuel Balestrero, when he is falsely accused of another man's crimes. On the day before his arrest Balestrero intercedes in a quarrel between his two sons caused when one son's harmonica playing disrupts the other's piano practice. The father tells the young pianist, "Don't let anything throw you off the beat. You do well till you get mad and hit the piano." The comment is a clue to the father's character. After his arrest it is only his inner strength—his ability not to get thrown off the beat—that enables him to endure his ignominious imprisonment and trial. By contrast, his more vulnerable wife accepts in her imagination the guilt of which the husband is accused and thereby becomes psychotic. Of course, the film is a semidocumentary one, based on an actual case in which the hero was indeed a musician who might

have used a musical figure of speech. However, the father's comment is consistent with Hitchcock's concerns in other films, and, furthermore, the quarrel between the sons is one of the few wholly fabricated episodes in the film. It exists only to develop Balestrero's character—to show that he is a good father and to allow him to say the above lines, which explain his inner source of strength.

The Hitchcock musician who does get thrown off the beat by guilt is Philip, the weaker murderer in *Rope*. In the play from which the film is adapted, Philip's piano playing is almost incidental. In the film version Philip is about to make his professional debut, and his ability to conceal his guilt—to control his emotions—is equated with his ability to continue playing a piece of music. (Significantly in this film based on continuous camera movement, his piece and the music for the credits is an arrangement of Francis Poulenc's "Perpetual Movement no. 1.") The man who suspects his guilt tries to force Philip's confession by operating a metronome faster and faster. Its "presto" ticking, which presumably echoes Philip's heartbeat, forces Philip to abandon his playing in distress and yell, "I can't play with that thing."

Stage Fright uses song lyrics to reflect a character's guilt. It is no accident that Marlene Dietrich is singing "Je vois la vie en rose" as a bloodstained dress is held up before her to force a public expression of her guilt. The lyrics, in fact, refer to more than the literal idea of seeing bloodstains. The song relates to the film's central concern with how one perceives the world. It is being sung by a chanteuse who has been so abused by people that she treats them in kind. Her foil is the very innocent Eve, a prelapsarian heroine who still perceives the world, like the speaker in the song, through the rose-colored glasses of love. She is so misled by her supposed love for a man that she is blinded to the fact that he is obviously in cahoots with the murderer. Thus, the song is not simply a pun on *red* as rosy or bloody; it refers to two ways of perceiving the world—both of them distorted extremes—one too naive and the other too cynical.

I would categorize as classical in style all the examples mentioned so far of music or song as motif. That is to say, regardless of its thematic or expressive function, the music in each case has a raison d'être on the plot level. In a more subjective vein, there are

Stage Fright. *Marlene Dietrich as chanteuse. Her songs are thematically appropriate.*

occasions when Hitchcock uses songs to get inside the feelings of a central character, but these are not so frequent as might be expected. I discount, for example, the song exposing the guilt of the drummer in *Young and Innocent* or the chanteuse in *Stage Fright* because there has been little consistent prior interest in penetrating either character's feelings of guilt before the introduction of the song. Only in *Blackmail, Secret Agent, Sabotage, Shadow of a Doubt,* and *Strangers on a Train* does Hitchcock really use song as a major conveyor of guilt, and in these cases the device is too conspicuous to be considered subjective.

I have already discussed the way Hitchcock uses songs to express guilt in *Blackmail* and *Secret Agent.* In *Sabotage* he uses "Who Killed Cock Robin?"—the title song of a cartoon—as a



mirror of one person's guilt and the stimulus of another's. The Disney cartoon, which was released shortly before *Sabotage*, is heard by Mrs. Verloc when she steps into her husband's movie theater between the scene in which her husband confesses that he has inadvertently killed his wife's kid brother and the scene in which she stabs her husband in revenge. The part of the cartoon that we and she actually see is the sequence in which Cock Robin is slain. The audience's response is to laugh at the killing; the wife, who had smiled at first, frowns at their callousness. Hitchcock leaves it ambiguous whether we are to see the cartoon as a healthy escape from oppressive realities or as a stimulus for a murder. Certainly, the question repeatedly put by the chorus of birds—"Who, who, who, who killed Cock Robin?"—is meant to haunt the wife; we hear it repeatedly as we watch her walk back into the private rooms. Furthermore, the association of birds with the boy's murder has been well prepared. Verloc gives the boy two birds, the saboteurs' bomb is hidden in a bird cage, and the code for the explosion is "the birds will sing."[12] Like the song "Miss Up-to-Date" in *Blackmail*, "Who Killed Cock Robin?" specifically haunts a woman who stabs a man. In both cases the song contributes to the central moral ambiguity: the suggestion that the woman is both victim and murderer.

In these examples of songs that reflect or inspire guilt, the song is usually performed in just one section of the film. In two of Hitchcock's films the songs become recurring motifs associated with murderers. "The Band Played On" is associated with Bruno in *Strangers on a Train*, and "The Merry Widow Waltz" is associated with Uncle Charles in *Shadow of a Doubt*. In both cases the songs are chosen for their associations with the Gay Nineties period and are then linked to rather likable villains. Hitchcock undermines the innocence of the songs by showing that the surface charm of the villains masks two of the least repentant of his entire stable of villains.

In *Shadow of a Doubt*, Uncle Charles is even known as the Merry Widow Murderer. The transfer of the waltz from the uncle's head to his niece's is a metaphor for the uncle's corruption of the girl's innocence; he exposes her to his vicious vision of the world. (Actually, the uncle's character is itself a metaphor for the darker

Shadow of a Doubt. *Teresa Wright greets Joseph Cotten. The mental transfer of a tune is a metaphor for the corruption of innocence.*

side of the girl's own nature. Hitchcock conveys this relationship by giving them psychic affinities, by shooting them as mirror images of each other, and by giving the girl the name of Charlie.) The repetition of the waltz with a concurrent dissolve to a vignette of ballroom dancers (dressed in nineties fashions) occurs three times after the opening titles marks the film's major transitions. As Gavin Lambert has pointed out, "The waltz gradually becomes less charming and more sinister, like Uncle Charlie himself."[13]

The tune becomes a symbol of the evil that young Charlie tries to prevent her uncle from spreading to the rest of her family and to the Santa Rosa community. After its introduction under the opening titles it is sometimes obvious and sometimes woven unobtrusively into the scoring. For example, when Uncle Charles arrives by train

at Santa Rosa, the notes of the waltz do battle in the underscoring with a second melody that has an Americana theme comprising bits of folk tunes. Thus through music Uncle Charles is already felt as antagonistic to American values. (Hitchcock was very much interested in having the town of Santa Rosa represent small-town America; he shot on location and emphasized such institutions as banks and churches in the mise-en-scène.)

The first of the three crucial waltz-plus-dancers transitions occurs when Charlie notices initials on a ring that her uncle has just presented to her in a marriagelike ceremony. (This ring becomes a symbol first for her acceptance of the uncle and then for her struggle against him.) Once Charlie has symbolically married her uncle in the kitchen, his song seems to be transferred to her as well. "I can't get that tune out of my head," she complains at dinner. "I think tunes jump from head to head." The second time we see and hear the dancers and the song is at a library, where Charlie checks the initials on the ring against a news story naming the victim of the last Merry Widow Murder. At this point Charlie realizes that her uncle is probably the murderer. She determines to prevent that knowledge from spreading. When her mother absentmindedly hums the tune the next day, Charlie begs her, "Please remember, don't hum that tune." The waltz and image last recur after the niece kills her uncle in self-defense during a struggle aboard a train. She has won her life-and-death battle with her uncle, but she must carry the burden of his guilt with her forever. Moreover, she herself, through having kept silent about her uncle's identity, is guilty of the death of another suspect, who was killed during a police chase.

In *Strangers on a Train* Hitchcock connects the seemingly innocuous "The Band Played On" with the strangling of the hero's wife, Miriam, by the villain, Bruno. (The tune was retained from the original novel, where it is played by a carousel. It was already a favorite property at the film's studio, Warner Brothers, and provided the title for that studio's *Strawberry Blonde*.) The song is first heard while Bruno is watching his intended victim and her two male friends as they ride a carousel at a fairground. To emphasize the song, Hitchcock has the three riders actually sing the lyrics of the carousel music. The significant line is the refrain, "And the

band played on." It may be associated with the imperviousness of the world to the death of Miriam and, by implication, to death in general. The band does indeed play on while Miriam is strangled— during the murder the carousel plays this very tune. The band plays on while a man discovers her body, and it plays on while he yells for help. To emphasize his impotence, Hitchcock cuts to a high-angle shot of a Ferris wheel from which are heard many cries of help from people playing at being in danger. And the band plays on. The next time we hear the tune is at a party in Washington, D.C., which Bruno attends uninvited. He pretends to choke a strange woman but nearly does strangle her when he spots the hero's sister, who reminds him of Miriam. As Bruno falls into a swoon in which he begins to reenact the strangling, Hitchcock helps us to share that experience by playing the same tune once more.

As he did in *Shadow of a Doubt*, Hitchcock uses the key song to mark three crucial moments of *Strangers on a Train*. Again, the third appearance of the song marks a life-and-death struggle between the hero and the villain from whom he is trying to defend his family and social milieu. While we wait with Bruno until the sun sets so that the final confrontation can arise, the carousel plays "Ain't She Sweet," "Baby Face," and "Ain't We Got Fun." At the climax, however, it reverts to "The Band Played On." The climactic struggle takes place on a carousel gone out of control. As the carousel accelerates so does the music, so that once again Hitchcock is using music to suggest order (a spinning merry-go-round) turning into chaos (the merry-go-round eventually spins off its track). It will be recalled that in *Secret Agent* Hitchcock also combines circular images (coins spinning in bowls) with music turned into chaos (the sound of yodelers) when he wants to show chaos overwhelming his characters. In *Shadow of a Doubt*, the circular image of waltzers accompanies the music gone delirious.

Strangers on a Train is different from *Shadow of a Doubt* and *Secret Agent*, however, in that the song is never transferred to a hero or heroine. In the latter two films Hitchcock uses music as a device to indicate that the heroine feels overwhelmed by evil and guilt—the sound and visual effects communicate a moral delirium through physical means. In *Strangers on a Train* the song is never

transferred along with the guilt from villain to hero. This keeping of the song association with Bruno is perhaps indicative of the central structural differences between the three films. Although intellectually *Strangers on a Train* is the Hitchcock film that treats most explicitly the idea of the transference of guilt, that guilt is barely identified *emotionally* with the hero. (Although Guy exhibits an initial guilt on learning of his wife's murder, Bruno's progressive intrusion into Guy's life is not commensurate with an increasing feeling of guilt on Guy's part. Nor do I think that Guy gains in self-awareness as the film progresses.) By contrast, the point of view and sympathies of *Secret Agent* and *Shadow of a Doubt* are closer to the heroine's than to the villain's. Even so, the delirium sequences are so expressionistic as to lessen some of the audience identification. (I would, however, still call *Shadow of a Doubt* a subjective, rather than an expressionistic, film because it otherwise conveys the heroine's feelings in subtler ways.) Not until *Rear Window* would Hitchcock find a vehicle that allowed him to present things subjectively throughout the film without recourse to distracting bravura effects, and in that film music plays its most important role.

Notes

1. Steven Watts, "Alfred Hitchcock on Music in Films," *Cinema Quarterly* 2 (Winter 1933–34):80–83.

2. Their earliest musicals are Lubitsch's *The Love Parade* (1929), Mamoulian's *Love Me Tonight* (1932), and Clair's *Sous les Toits de Paris* (1930), *Le Million* (1931), and *A Nous la Liberté* (1931). The British documentary unit, which was also interested in the integration of music and editing, did not begin its famous experiments with sound until early in 1934. See John Grierson, "The G.P.O. Gets Sound," *Cinema Quarterly* 2 (Summer 1934):215.

3. Watts, "Alfred Hitchcock," pp. 81–83.

4. Ibid.

5. Ibid., pp. 81–82.

6. Ibid., p. 82.

7. Louis D. Giannetti, "Sound," in *Understanding Movies* (Englewood Cliffs, N.J.: Prentice-Hall, 1972), p. 116.

8. Robin Wood, *Hitchcock's Films* (London: A. Zwemmer; Cranbury, N.J.: A. S. Barnes, 1965, rev. 1969), p. 83.

9. Ibid., p. 84.

10. "Hitchcock," *American Scholar* 39 (Spring 1970):295.

11. Jean Douchet, *Alfred Hitchcock* (Paris: Cahiers de l'Herne, 1967), p. 21.

12. For a further discussion of the role of birds in *Sabotage,* see Donald M. Spoto, *The Art of Alfred Hitchcock* (New York: Hopkinson and Blake, 1976), p. 61.

13. "Hitchcock and the Art of Suspense," *American Film* 1 (January/February 1976):22.

6　The Subjective Film: *Rear Window*_____

The dramatic locus of most Hitchcock films made between 1940 and 1964 is the mind. Hitchcock is less interested in external reality than in how it is perceived.[1] Thus the chief stylistic tactic of the subjective films is also their major point: to show how easily a character—and the viewer for whom he is a surrogate—can misinterpret events according to his own preconceptions. Hence, the insecure heroine of *Rebecca* interprets her husband's silence about his former wife as a sign of still-cherished love; the suggestible wife in *Suspicion* interprets her husband's inexplicable behavior as a desire to kill her; the naive heroine of *Stage Fright* supplies rosy explanations for the odd behavior of the man she loves; the romanticizing heroine of *I Confess* makes a false confession of adultery; and in *Vertigo* a man half in love with easeful death falls in love with a waking dream.[2]

The most persuasive way of demonstrating the seductiveness of such misinterpretations is to let the viewer make the same mistake. Having been seduced into adopting a character's point of view that is later exposed as illusion, we should then be able both to sympathize with the character's weakness and to recognize it in ourselves. Thus the most persuasive of Hitchcock's subjective films are also the most realistic in style; Hitchcock would otherwise destroy the illusion by drawing attention to his style. He himself may maintain an aesthetic distance by adding levels of irony, but he requires our total identification at times so that we will acknowledge the existence of our darker natures before we render any moral judgments.

Rear Window (1954) is the film that quintessentially presents a subjective point of view within an apparently realistic style. The single obvious distortion is the overloud sound of some approach-

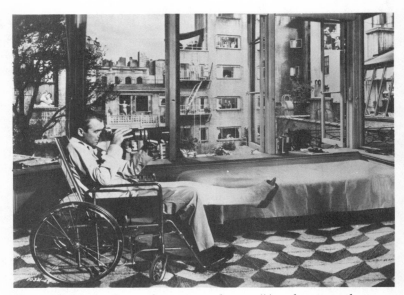

Rear Window. *James Stewart on the set. "An almost total separation of what we see from what we hear."*

ing footsteps in the second-to-last sequence of the film. Only at the end of the film do we realize that we have shared the hero's dangerously distorted perception of events (it is mere accident that in one case his assumption is correct); and we are forced to reinterpret everything that has gone before (including our complicity in the hero's voyeurism) in a new light.

An ideal way to manipulate sound without distorting it is to dissociate it from its source. In *Rear Window* Hitchcock is able to maintain an almost total separation of what we see from what we hear. The result is a rich sound track that is both realistic in style and yet perhaps the most asynchronous and subjective of Hitchcock's career. The film is one of Hitchcock's experiments with the use of a single location. The set is limited to a courtyard in New York City. By a window in one apartment sits L. B. Jeffries (called

"Jeff"), confined to a wheelchair with a cast on his leg. The visuals are restricted to one room of the convalescent's apartment and whatever he can see from his window. The sounds are seemingly almost as limited; they can come from within Jeff's own apartment, can emanate from other apartments, or can drift over from the next street, which we can barely glimpse through an alleyway. The sound of a boat whistle or siren may occasionally extend the aural boundaries a bit further than the visual ones. Yet we can rarely distinguish what Jeff's neighbors are saying unless they step onto their fire escapes; all we can normally hear from the neighbors' apartments is the music they play or listen to.

The viewer spends most of the film watching with Jeff as he spies on the activities of his neighbors as seen through their individual windows. Thus the world outside Jeff's apartment is presented as a series of pantomimes. Dialogue is reserved mainly for Jeff's comments on what he sees or for conversations he has with visitors to his apartment. With the exception of those scenes which are filmed within Jeff's apartment, then, there is a split between the world "in here," which is heard but not seen, and the world "out there," which is seen but not heard. The thrust of the film's structure will be to reverse this situation. Let me first consider the worlds as originally distinct and separate.

Less than one-tenth of the time that we are looking at Jeff's neighbors does the dominant sound emanate from the particular window under surveillance. Hitchcock was always a proponent of asynchronous sound; he considered it redundant to show the source of dialogue or sound effects. In *Blackmail* he could avoid talking heads because the stifling conventions of filming dialogue had not yet established themselves. In his forties films he got further from this ideal with his somewhat overproduced, dialogue-heavy talkies. Later in his career he came up with vehicles that eliminated the need for excessively long dialogue sequences. *Psycho* and *Vertigo*, for instance, have relatively little dialogue. *Rear Window*, too, includes many sequences with no dialogue. When characters do speak, their words often provide an added rather than a redundant dimension. What Jeff says to a visitor, for instance, usually applies both to the person he is addressing and to the neighbor he, and we, are watching at the time. The reverse also occurs. On some occa-

sions, when Jeff can be lured away from his window watching to participate in discussions with his visitors, sounds from outside may comment on the situation in his apartment.

For the most part, the sounds from outside comprise traffic noise, which plays a minor role, and music, which in *Rear Window* plays a role as important as the dialogue and the visuals. To ignore the music is to eliminate an ironic component essential to the vision of the film. Hitchcock can be unusually free with the music because throughout the film New York City is supposedly undergoing a heat wave, so that all the courtyard windows are wide open. Hitchcock thus is free to use any or all sounds that might plausibly emanate from any of the dozens of windows facing the courtyard.

One can make a case that all the music in the film is source music, although the source is not always identified. Even the title music, arranged in a jazz idiom by Franz Waxman, is provided with a source, if we care to attribute one to it. As the title sequence ends the camera pans to a radio; the music comes to an end and is replaced by a commercial, which a composer, whose radio this is, turns off. From here on in the source of the music is usually, but not always, attributable to a specific window. Yet the music is timed as carefully as scoring; that is to say, it is timed as precisely to the actions of the characters as music written specifically for a film sequence. For instance, when Jeff scratches an itchy leg with a Chinese backscratcher, the music, which presumably emanates from some neighboring apartment window, underscores his feelings by shifting from a nervous sound to a soothing one at the precise moment of relief.

The ambiguity of whether we are listening to source music or music scored specifically for the film is appropriate to the thematic material of *Rear Window* and relates to the way we respond to the film visually. One of the major, unresolvable issues that Hitchcock dramatizes in the film is the audience's innate voyeurism. We are implicated in Jeff's voyeurism because we, too, cannot refrain from spying on his neighbors; that is, we cannot distinguish whether we are watching the neighbors because Jeff does so or because we are voyeuristic ourselves. This breaking down of the distinction between our actual behavior and our movie-going behavior is analogous to the blurring of the distinction between source music (which

presumably has some independent existence—and thus corre- sponds to our innate voyeurism) and scoring (which is a product of the movie-making art and is once removed from reality—and thus corresponds to our movie-going voyeurism).

It is important that we have a sense of the music as source music, because thereby we necessarily associate it with the court- yard. The result is that both the music and the noise help integrate the sense of space in the courtyard. This integration counteracts the effect of the film's editing and mise-en-scène, both of which tend to isolate the neighbors from one another. The set design isolates them by placing each in his separate window. The cutting reinforces that separation when Hitchcock creates transitions from window to window through reaction shots rather than camera move- ment; for instance, a typical transitional sequence would be a cut from one neighbor in a window to Jeff's face and then to another neighbor in a different window. There is at times some panning between neighbors, and this camera movement helps create a sense of continuity in the courtyard. The tension between separa- tion and continuity in human lives is central to the film, which, as we shall see, expresses in physical terms the metaphysical idea that no person can remain isolated emotionally from other people.

As I have said, the neighbors under surveillance at any given time are rarely the main source of whatever is on the sound track. This aural dissociation emphasizes the idea of the courtyard as microcosm. Regardless of what we are watching, the sound track makes us aware of a larger sphere of activity. In addition, there is often a contrast between the courtyard sounds and Jeff's comments in the foreground. The use of aural deep focus here exemplifies Hitchcock's closed style as opposed to the open style I ascribed in the introduction to Renoir and Altman.[3] Even when Hitchcock has a busy sound track, it is still much more selective than the sound track of a thirties film by Jean Renoir or of almost any Robert Altman work. Renoir and Altman use sound more "demo- cratically," in the sense that André Bazin applied the word to visual deep focus, which does not emphasize any element at the expense of any other simultaneously presented. We are not meant to feel that all of Jeff's neighbors or all sounds are equally impor- tant but that they are presented only as they pertain to Jeff or his

Rear Window. *Hitchcock keeping time for the composer.*

perceptions. One can compare, for example, the use of cacophony in Renoir's *The Rules of the Game* (1939) with its presence in *Rear Window*. In the Renoir film a key scene takes place in a corridor of la Chesnaye's chateau as his guests retire for the first night of their visit. Like Hitchcock's courtyard, Renoir's corridor, with its guests making their moves in and out of their rooms across a checkered floor, is a social microcosm. We hear fragments of conversations, and at times one guest even walks around or is heard from his (offscreen) room playing random notes on a hunting horn. There is no predominant sound, but rather a sense of babble, in this and other similar scenes of the film. By contrast, Hitchcock starts each morning scene of *Rear Window* with a cacophonous sound track comprised of a woman singing scales, dogs barking, traffic noise, and the like. However, these transitional scenes last less than a minute, and the rest of the time Hitchcock prefers to let one sound predominate, usually a piece of source music that is heard not in fragments but from beginning to end. Whereas Renoir's corridor scenes have a unity of space (the above scene is shot in one extensive take) and a multiplicity of sounds, Hitchcock's courtyard scenes usually have a unity of sound (one song at a time) and a multiplicity of spaces (each separate apartment window).

The main function of Hitchcock's aural deep focus is irony. He achieves a depth of meaning that derives from the juxtaposition of one sound against various images. To be more specific, a given song takes on a new and frequently different meaning as it is associated with each neighbor, as well as with Jeff's own situation. For example, the first night's activities are accompanied by the song "Lover," the source of which is unspecified. Its first line— "Lover, when you're near me"—has ironic references to at least three couples. The first is a couple sharing a mattress on a fire escape. The second is Jeff and his fiancée, who has just walked out on him after a quarrel. The third is Thorwald and his wife; it is her perpetual nearness—she is an invalid—that presumably drives him to murder her later the same night.

A second song that refers to several situations is "Waiting for my true love to appear." It is being played at the party of the composer, who lives in the apartment adjacent to Jeff's. The lyrics apply equally well to Jeff, whose fiancée has not yet shown up for

her evening visit, and a character referred to as Miss Lonelyhearts, who eventually gives up "waiting" and goes to a restaurant to pick up a man. By the time Miss Lonelyhearts returns from the restaurant, the composer's guests are singing "Mona Lisa," a song obviously associated with Jeff's girlfriend, whose name is Lisa. Similarly, Miss Lonelyheart's name (it is Jeff who so dubs her) is linked to the lyrics with the line "Is it only 'cause you're lonely?" Soon the man makes unwelcome advances toward Miss Lonelyhearts. Hitchcock emphasizes the association of the song with her situation by timing the song to end as she throws the man out of her apartment.

One of the most telling songs in the film is a recording played the first evening by Miss Lonelyhearts, which begins, "To see you is to love you, and I see you everywhere." This first line raises the central issue of biased perception. Miss Lonelyhearts has put this romantically crooned song on the record player as part of the setting for a drama she enacts with an imagined dinner guest, for whom she has prepared a candle-lit place setting. However, once she has drunk a toast with her "guest," she sees through her own illusions and breaks down in tears. By contrast, it is Jeff who does not see the truth of his own dissembling behavior. The phrase "I see you everywhere" is the clue to his all-consuming involvement in his neighbors' lives. He interprets every neighbor's situation as a projection of his own fears about marrying Lisa.[4] He assumes that the composer's unhappiness is the result of marital troubles; he sympathizes more than he consciously admits with Thorwald's desire to rid himself of a presumably nagging wife; he scowls disapprovingly at a bride's seemingly insatiable sexual demands. Jeff's preference for a world of illusion is shown by his returning a silent toast to the unthreatening Miss Lonelyhearts across the way rather than face—literally—his own dinner partner, Lisa, who is pouring champagne at the time. Jeff will not see Lisa's finer qualities until she enters his preferred courtyard world; he will finally fall in love with her only when she enters Thorwald's apartment and stands in a window enacting her own pantomime.

It is at the point when Jeff watches Lisa in Thorwald's bedroom window that the film's most important song, "Lisa," is first heard all the way through, its completion marking Jeff's realization that he loves Lisa. Hitchcock spoke to Truffaut about this song: "You

remember that one of the characters in the yard was a musician. Well, I wanted to show how a popular song is composed by gradually developing it throughout the film until, in the final scene, it is played on a recording with a full orchestral accompaniment. Well, it didn't work out the way I wanted it to, and I was quite disappointed."[5] Two years later Hitchcock was a bit more specific about his dissatisfaction: "I was a little disappointed at the lack of a structure in the title song. I had a motion picture songwriter when I should have chosen a popular songwriter."[6] It is hard to tell what Hitchcock would have considered a stronger structure. He may possibly have had in mind a song in which the various parts are more distinctive; Waxman develops the middle third of the song simply by elaborating on the principal theme after transposing it into another key. Judging from Hitchcock's use of songs in other films, he probably was looking for the immediacy and clarity of popular music.

In neither of the above interviews does Hitchcock give away the full significance of the song; its creation is made analogous to both the creation of a love relationship and the creation of the movie. Although we do not know until the last notes of the film that its title is "Lisa," the tune is carefully associated with the fiancée and the progress of her relationship with Jeff. The first time we hear part of the song, the notes arise from a cacophony of morning sounds in the courtyard as we are looking at a photograph of Lisa on the cover of a national magazine. (Just before we see the magazine cover we see a negative of the photograph, so that the unfinished song is linked with photography in an unfinished state.) Lisa stops to admire the tune every time it is played. When she first hears it, she says that it "sounds almost as if it were being written especially for us" (which, of course, it is, on one level). Jeff, characteristically deflating her romantic intentions, says, "No wonder he's having so much trouble with it." Later that evening the composer drunkenly returns to his apartment and knocks the music sheets off the piano, presumably while suffering from a creative block. His discouraged mood parallels the setback in the couple's relationship, for Lisa has just stalked out of the apartment after quarreling with Jeff. By the next evening the couple have temporarily reconciled their problems. Lisa is humming the song when Jeff's detective friend dis-

covers her intention to stay the night with Jeff—a major step forward in their relationship; and she hums along with it again when she first believes Jeff's story that Thorwald has murdered his wife—the second major advance in Jeff's approval of her. At this point the song stops, while Lisa says, "Tell me everything you saw"; the sound track thus underscores with sudden silence the importance of her finally believing in Jeff's interpretations of the actions he has been watching in Thorwald's apartment.

Most important, the same song is playing when Lisa enters Thorwald's apartment. It is being rehearsed by a small combo and is heard from start to finish for the first time. Because this scene is the riskiest part of the action so far in the film, one might expect that Hitchcock would prefer scoring that heightens the tension, but instead we hear the song in its most wistful arrangement; as Lisa enters the apartment, it is being played with romantic vibrato on a harmonica. The effect of the song here is to unite the ideas of romance and danger, two inseparable emotions in Jeff's mind, and to allow him to fall in love with Lisa. His main worry had apparently been that Lisa was too soft to accompany him on his assignments as a professional photographer of physically and politically dangerous situations. Now that Lisa appears to welcome danger, he realizes that she can fit into his world—a world that during his convalescence has been represented by his projections and interpretations of danger in his own backyard.

A second drama reaches its climax while the song is heard at this point. Directly below Thorwald's apartment is that of Miss Lonelyhearts. While Lisa breaks into Thorwald's home, Miss Lonelyhearts prepares to commit suicide with an overdose of sleeping pills. (Indeed, when Jeff dials the phone to call the police, he is intending to save Miss Lonelyhearts. He gets sidetracked, however, by Lisa's danger.) Both Lisa and Miss Lonelyhearts have presumably heard the "Lisa" theme before, but at this point it supposedly sounds strikingly beautiful. Miss Lonelyhearts puts down her glass and pills and walks to her picture window; the beauty of the music dissuades her from killing herself. Meanwhile, Lisa, in Thorwald's identically laid-out apartment on the floor directly above, also approaches the window and stands in the same position in the window frame as Miss Lonelyhearts below her. Lisa,

too, is struck by the music's beauty, but, ironically, rather than save her life, it endangers her; Thorwald arrives home while she pauses to enjoy the music.

During the codalike ending of the film, the song will be heard once more; this time it is arranged for male vocalist and full orchestra, and the composer is playing the new record for Miss Lonelyhearts, who is in his apartment. She tells him that he will never know how much the song meant to her. Parallel to this blossoming friendship in the background is that of Jeff and Lisa in the foreground. Although the happy ending for their love story is somewhat qualified, the primary clue to the state of the couple's relationship is, as Robin Wood argues, that Jeff has turned his back to the window and presumably his face to reality.[7] The last word of the song is "Lisa," and the camera ends on Lisa—the film, the song, and the various relationships in this apartment and those in the courtyard all having been resolved for the time being, on the same happy note, as it were.

Throughout the film, therefore, Hitchcock does not use "Lisa" simply as a gimmick to motivate the action but to raise the issue of the value of art. It is appropriate that the composer is writing a song, a form of music roughly analogous to a Hitchcock movie because it is a popular rather than an elite art form. Hitchcock's ambivalence about his own work is reflected in his treatment of the composer's behavior and of the various responses to the song. For instance, Hitchcock poses the problem of whether his own motivations as a filmmaker are commercial or artistic when he has Lisa ask Jeff, "Where does a man get the inspiration to write a song like that?" Jeff answers, "He gets it from the landlady twice a month," whereas Lisa wishes that she could be "creative like the composer." The film makes a strong statement about the positive value of the song by having it save the life of Miss Lonelyhearts, just when Jeff forgets about her predicament. Its development, as I have shown, also accompanies the growth of two relationships.

If the moral assessment of song is positive in *Rear Window*, however, the treatment of photography is deliberately more ambiguous. As critics have shown, there is clearly a reason that Jeff is a photographer. His profession links him to the filmmaker, and his behavior during the movie links him to the film-goer.[8] As a

viewer-surrogate, Jeff passively watches actions take place in little frames that he responds to but does not affect. His behavior is not altruistic; it helps neither Mrs. Thorwald nor Miss Lonelyhearts. Rather, it is voyeuristic; he escalates from the use of the naked eye to binoculars and finally to a telephoto lens. However, the telephoto lens is a part of his camera, a fact that suggests that photographers and filmmakers are not only voyeuristic themselves but that their work caters to the voyeurism of the audience. I do not propose to settle here the complex issues raised in *Rear Window* about the psychology and morality of filmmaking and film-going.[9] Rather, I have wished to indicate how Hitchcock uses music to develop the argument.

Actually, a distinction should be made between the arts themselves and the act of creation. The composer is at his worst when he is unable to work. When suffering a creative setback he comes home drunk and destructive. Jeff is seen at his worst throughout the film because he is not able to get out and actively take pictures. In a sense his neurotic voyeurism can be seen less as an extension of his photographic work than as the result of the denial of that creative outlet. In fact, Hitchcock separates the dancer from the dance, as it were. The composer writes the song out of creative impulses; he does not knowingly stop a suicide or promote a romance. Similarly, a photograph or a film has a value separate from the factors that went into its creation. The very fact that the song arises out of the cacophony that begins *Rear Window* and is heard in final form at the same time the film itself ends suggests that their simultaneous completion marks a corresponding transformation of the chaos of life into the order of art.

So far my discussion of *Rear Window* has concerned the essentially static situation of the first two-thirds of the film, which maintains the separation between Jeff and his neighbors and between dialogue and pantomime. However, that separation is eventually destroyed; indeed, it is the interpenetration of the two worlds that results in Jeff's shift from passive voyeurism to emotional involvement, the "therapeutic" experience that Robin Wood finds at the heart of the film.[10] Wood rightly puts that shift in terms that explain why the film's setting is ultimately a psychological one: "The Hitchcockian hero typically lives in a small enclosed world of his

own fabrication, at once a protection and a prison, artificial and unrealistic, into which the "real" chaos erupts, demanding to be faced."[11] By the end of the film not only have Jeff's emissaries (his nurse and his girlfriend) invaded Thorwald's apartment, but Thorwald has invaded Jeff's. Reality, in the form of Thorwald, has intruded on Jeff's private world. The nonthreatening two-dimensional character has left his movie-screen-like frame and joined his viewer's world. When Jeff hears Thorwald approaching in his hallway he turns out the lights in his apartment. Thorwald turns out the hall light, enters the apartment, and confronts Jeff in the darkness. As Wood demonstrates, because of the parallels established between Jeff and Thorwald, "the scene carries overtones of a confrontation with a *doppelganger:* . . . we have to accept [Thorwald] as representative of potentialities in Jefferies and, by extension, in all of us."[12]

Wood's contention that Thorwald is Jeff's alter ego can be supported not only by the structure of the film but also by the reversals in the sound pattern. When Jeff first notices Thorwald, he can see but not hear him. At the end of the film he can hear but not see him. Sight is associated with security in Jeff's mind, sound with menace.[13] All the interactions that lead to the confrontation of Thorwald and Jeff involve an increase in aural communication and a lessening of visual communication. A detailed look at the climatic events in the film will show a shift from visual to aural evidence.

Jeff's first suspicions that Thorwald has killed his wife are based purely on visual and circumstantial evidence. Through Thorwald's window Jeff sees only what appears to be bickering, some suspicious nocturnal activities, and, finally, the absence of the wife. Jeff must supply an interpretation of their behavior. This is not the first or last time that Hitchcock will film an argument through a window. His television short *One More Mile to Go*, for example, begins with an exterior tracking shot up to the picture window of a quarreling couple. The camera does not cut inside until immediately after the husband has struck and killed his wife with a poker. The effect, in both instances, of filming so that we can see but not hear the quarrel is to universalize it; Hitchcock leaves it for each viewer to supply the particulars of the fight from his imagination. Fighting

between spouses is universal; to specify the issue would eliminate audience identification. The effect of filming all the neighbors in *Rear Window* in pantomime is not to reduce their value as characters but to render them as archetypes, with which we, and Jeff, can all identify. Later in *Rear Window*, when Jeff switches to telephoto lenses to watch the Thorwalds, we can actually hear the sounds of their voices; the visual magnification of the image is accompanied by aural magnification. Yet we still cannot make out their actual words; we can only hear their angry tones, and so the argument remains abstract.

With no verbal proof of murder, the only possible aural evidence is one scream, but its source remains unidentified. During the first night, which we retrospectively fix as the time of the crime, a scream and a crash are heard while the camera is panning across some darkened windows, with the camera movement presumably representing Jeff's viewpoint. The camera does a double take, as it were, stopping on a window of a corner building, as if to imply that it is the location of the source of the sound.

Thorwald cannot be heard, so Jeff supplies words and motivations for him, narrating what he takes to be Thorwald's thoughts. He has Lisa push under Thorwald's door an anonymous note that reads, "What have you done with her?" When he sees Thorwald's reactions, he says excitedly, "You did it, Thorwald, you did it!" However, Hitchcock makes Thorwald's reactions neutral enough to make us wonder if Jeff is not reading too much into Thorwald's behavior. Next, Jeff escalates from sending a silent note to making telephone contact with Thorwald. As he watches Thorwald contemplating whether to answer the ringing phone, he again puts thoughts into Thorwald's head: "You're curious, Thorwald . . ." he begins. When Thorwald answers the phone, Jeff poses as a blackmailer and tells Thorwald to meet him at a hotel (so that Lisa and the nurse can have time to dig for evidence in Thorwald's garden). The fact that we can hear Thorwald ourselves and that he is frightened enough to be willing to meet with the blackmailer gives us more objective evidence that Jeff's interpretations of Thorwald's actions are justified. Thorwald returns while Lisa is in his apartment and catches Lisa sending pantomimed signals to Jeff. Now the tables are turned. Jeff becomes Thorwald's victim. First, as Jeff

did to him, Thorwald simply looks at Jeff—he stares out his window, following the direction implied by Lisa's gestures. Next, having figured out Jeff's name from his mailbox, as Lisa had Thorwald's, he phones Jeff. Jeff answers, thinking that it is his friend Tom, and by mentioning Thorwald's name, he confirms Thorwald's suspicions aurally, just as Thorwald had confirmed Jeff's suspicions when Jeff phoned him. Thorwald hangs up without speaking.

A moment later Jeff hears a door crashing shut in his own corridor. Thorwald's footsteps are long, slow, exaggerated, reverberated—in short, expressionistic—to convey a sense of their impact on Jeff. (We have never heard the approaching footsteps of Jeff's previous visitors as they walked down the same corridor.) Hitchcock here observes the dictum of the horror movie that an unseen threat is more terrifying than a visible one—a convention he develops furthest in *The Birds*. Thorwald enters the apartment and stands in the dark by the door, confronting his harrasser, Jeff. "What do you want from me?" he asks. Now it is Thorwald who is talking and Jeff who is silent, for Jeff has no good explanation for why he has spied on his neighbor. Jeff pops four successive flashbulbs in Thorwald's eyes, temporarily blinding him. The result for a moment returns Jeff to his original advantage; he can see Thorwald but Thorwald cannot see him. Jeff is stalling for time, and, sure enough, he has just enough time before Thorwald's attack to scream for help from Lisa and the policemen who have just arrived at Thorwald's apartment. They do not arrive in time to prevent Thorwald from throwing Jeff out of his window, but they do manage to break Jeff's fall to the ground.

Jeff's scream for help is a crucial sound reversal in the film. Lisa had screamed for help to Jeff from Thorwald's apartment. Now it is Jeff who screams to Lisa for help while she is at Thorwald's apartment. This cry for help is essential to the theme of *Rear Window*. As Wood has said, Jeff's apartment is no longer a place of protection but a place of vulnerability. The penetration of his room by Thorwald is actually the penetration of his emotionally detached psyche by dangerous reality. With the scream Jeff is acknowledging that he needs help from others, that he is not self-reliant, that we are all part of a universe and must depend on one another.

If we read the actions of the film as all leading to Jeff's confron-

tation with Thorwald and his cry for help, it is possible to consider
the entire sound track as a subjective extension of Jeff's feelings.
The sounds gradually become more and more focused. During the
opening titles of the film we are presented with a relatively random
selection of sounds, from neighbors chatting to cats meowing. As
Jeff becomes more and more preoccupied with Thorwald's affairs,
the sounds become more and more selective. Just as he concen-
trates his telephoto lens more and more on Thorwald, so he concen-
trates his aural attention on relevant sounds. They are selected and
magnified in proportion to his interests. Only when Jeff is on our
end of the telephone do we hear the speaker on the other end.[14]
Even the traffic noise may reflect his feelings. When Jeff concen-
trates on what goes on within his own apartment, we hear relatively
little noise from outside. However, when Lisa walks out angrily on
him, for example, there is a loud rumbling noise that may physi-
cally be attributed to a truck going by on the next street but that
emotionally works to suggest Jeff's disturbance as he sits and
thinks in his upset state. When he watches Lisa and the nurse
digging in Thorwald's garden plot, there is no sound of music in the
courtyard. The courtyard itself is at this point a safe place, whereas
the street from which Thorwald will return is a threat. Therefore,
the sound track concentrates on street noise, not courtyard noise.
Even the songs that emanate from windows may only be those
which are relevant to Jeff's interests (although he misses the ironic
component). In the sense that Thorwald shifts from visual non-
threat to aural threat, the loudness of Thorwald's footsteps is appro-
priate. If the whole film is seen as a progression from the presenta-
tion of random noises and random windows to a concentration on
the neighbor who psychologically threatens Jeff and the footsteps
that bring terror to him, then they are the logical culmination of the
stylistic choices of the film. Subjectivity has looked and sounded
realistic; now reality looks and sounds distorted; the intrusion of
reality on Jeff is conveyed paradoxically through an expressionistic
technique. As a result Hitchcock undermines audience
identification with Jeff just at the point when he is most threatened.
The patently unreal sound forces this emotional withdrawal just
before Thorwald enters the room, so that the viewer can see him not
as a monster but as a somewhat bewildered victim of Jeff's harass-

ment. (Soon, we even see the results of Jeff's blinding flashes from Thorwald's point of view.) The sudden shift to an expressionistic presentation of Jeff's subjectivity creates an emotional distance that encourages the viewer to judge Jeff's behavior and to recognize retrospectively the subjectivity (and therefore the culpability) of Jeff's earlier perceptions as well.

Notes

1. John Belton persuasively defends Hitchcock's "perceptual approach to cinematic narrative" during this period in "Hitchcock: The Mechanics of Perception," *Cambridge Phoenix*, 16 October 1969. Belton finds "a disparity of perception which culminates in a psychological breakdown of one or more of his characters" in *Rebecca, Suspicion, The Paradine Case, Dial M for Murder, The Wrong Man, Under Capricorn, Vertigo,* and *Marnie;* the "use of objects to illustrate changes in perception" in *Shadow of a Doubt* and *Strangers on a Train;* "change or loss of identity" associated with misperception in *Spellbound, To Catch a Thief, North by Northwest, Psycho,* and *Vertigo;* and the mise-en-scène as a subjective projection of the world in *Rear Window, The Birds,* and *Marnie*. To these titles I would add *Notorious, I Confess,* and the later *Man Who Knew Too Much* for a complete list of films made in the subjective style. I would not include *The Birds* for reasons to be explained in chapter 8.

2. The identification of Scottie's love for Madeleine with his death yearning is made by Robin Wood in *Hitchcock's Films* (London: A. Zwemmer; Cranbury, N.J.: A. S. Barnes, 1965, rev. 1969), p. 80.

3. I defined *aural deep focus* in chapter 1 as the interplay between sounds made by foreground and background sources, to keep the term analogous with the visual definition of deep focus. In *Rear Window* the term could be extended to include any juxtaposition of background and foreground noises regardless of whether the sources are visible or not because the relation between foreground and background is both clear and constant.

4. Wood, *Hitchcock's Films*, p. 64.

5. François Truffaut, *Hitchcock* (New York: Simon and Schuster, 1967; originally published as *Le Cinéma selon Hitchcock* [Paris: Robert Laffont, 1966]), p. 160.

6. Alfred Hitchcock, *"Rear Window," Take One* 2 (November/December 1968):18.

7. Wood, *Hitchcock's Films*, p. 15. Eric Rohmer and Claude Chabrol in *Hitchcock* (Paris: Editions Universitaires, 1957), p. 131, had argued that there was no improvement in the relationship.

8. Rohmer and Chabrol, *Hitchcock*, p. 126.

9. A condemnation of Jeff's voyeurism can be found in Jean Douchet, "Hitch et son public," *Cahiers du Cinéma*, no. 113 (November 1960), pp. 7–15. A defense can be found in Raymond Durgnat, *The Strange Case of Alfred Hitchcock: or The Plain Man's Hitchcock* (Cambridge, Mass.: MIT Press, 1974), pp. 235–44. Peter Wollen suggests that Hitchcockian voyeurism—and he sees spying as an aspect of voyeurism—invites Freudian analy-

sis that goes beyond "the 'psychology of perception'" to the "rhetoric of the unconscious": "Hitchcock's Vision," *Cinema*, no. 3 (June 1969), pp. 2–4.

10. Wood, *Hitchcock's Films*, p. 63.

11. Ibid., p. 68.

12. Ibid., p. 67.

13. I am speaking here only of sound Jeff notes consciously. He rarely acknowledges the presence of the music. His fiancée points out the song "Lisa" to him, and he does indeed feel threatened by it until he comes to accept the woman with whom it is associated.

14. Actually, after Jeff hands the phone over to his friend once, we do hear the caller's first three words: "Lieutenant Doyle, Sir?"

7 Aural Intrusion and the Single-Set Films

The equation of menace in *Rear Window* with the sound of an unseen invader is the culmination of Hitchcock's experiments with a technique that can be called aural intrusion. This use of offscreen noise to threaten an onscreen character is a frequent and distinctive component of Hitchcock's style. The technique provides a realistic metaphor for the penetration of the psyche. Hence, it is particularly useful in the subjective films, in which Hitchcock wants to concentrate on mental events while eliminating expressionistic distractions.

Aural intrusion can range from the penetration of a person's voice from just outside the frame to the noisy assault on a room or building by one or more invaders. The boundaries, whatever their scope, demarcate an interior space from an exterior one. The spaces may or may not be literalized (a room literally exists for the characters; a frame does not), but ultimately they are psychological; the interior space represents subjective perception, which is threatened by reality from outside. The aural-intrusion technique is prominent in the single-set films *(Lifeboat, Rope, Dial M for Murder, Rear Window)*, which, with their deliberate visual restriction, depend greatly on the tension between inside and outside space.

An early example of aural intrusion can be found in the use of the frame as a private space in *Murder*. The voice of an offscreen character can seem like an invasion of that space when it is occupied by one person lost in thought. Invasion of the frame occurs when Sir John, while searching Diana Baring's rooms for clues that would indicate her innocence, finds a photograph of himself. The shot of him staring in silence at the picture is a loosely framed close-up. Suddenly, we hear from offscreen the voice of his assis-

tant, Markham, saying, "Lot more places to go to, Sir John." Markham's words not only intrude on Sir John's privacy but also characterize Markham as efficient but insensitive. The shot can be compared to a later one in which Sir John stares at a broken basin that may be important evidence. Here again he stares in silence, but Markham's head is allowed to stay in the corner of the frame, so that his saying the same line ("Lot more places to go to, Sir John") is not so startling. Here his words merely indicate that he is blind to the importance of a clue. The shift of emphasis makes sense because the moment is not so personal for Sir John.

Thirty-four years later, in *Marnie*, Hitchcock again interrupts an intensely private moment with a surprise voice from offscreen. In this case the technique is more crucial because the intrusion helps define the relationship between the film's two central figures. In this scene we watch Marnie trying to steal money from her husband's office safe. She is unable to make her hands grasp the money. After she loses the struggle, she and we are surprised to hear from offscreen the voice of her husband saying, "I'll take you home, Marnie." His intrusion here on a personal psychological struggle supports the growing evidence that his relation to Marnie is one of voyeur as well as authority figure. The audience, having thought it was alone with Marnie, shares her resentment at his intrusion.

Aural intrusion also defines a husband-wife relationship in the television short *Back for Christmas*. It is the story of a meek man who murders his domineering wife, only to have her ultimately defeat him after her death. (Before dying she orders a wine cellar dug for her husband without his knowledge. As a result her body will be dug up from the cellar where he had interred it, and he will be caught.) The wife's dominance is suggested by her introduction into the film as a disembodied voice. As the movie opens we are watching the husband digging in the cellar, but we hear the wife call him from upstairs. The proprietary and domineering tone of her "Oh, Herbert" instantly makes us side with the meek man. Knowing that this is a Hitchcock film, we can deduce from this first scene that the man is probably digging a grave for his wife. In fact, Hitchcock, assuming our familiarity with his work, expects us to make that deduction. Similarly, he depends on the cliché of the

nagging wife for instant character description; it provides a useful kind of shorthand for a twenty-three-minute film. Moreover, the wife must be a cliché in order for us to sympathize with the murderous husband. Hitchcock bases our sympathy for him on the inescapable presence of the woman, a presence created more aurally than visually.

In some films the aural intrusion represents not so much an invasion of privacy as of security. Hitchcock uses the technique to destroy audience and character complacency by creating (or maintaining) insecurity through sound during moments of apparent (that is, visual) serenity. In such cases the sound may be mechanical, but it is more often human. Hitchcock's villains are often aural intruders; after all, his villains are tangible evidence that evil is always lurking among us. In *The Lady Vanishes*, for example, the leader of the spies, Dr. Hartz, is often heard before he appears on screen. This is typified by his first entrance. In that scene the heroine, conversing with the hero in a train corridor, tells him, "There must be some explanation" to the odd events of the past few minutes. Suddenly, she is answered by "There is," followed by the entrance of the "doctor" into the frame. Similarly, he sneaks up on the couple in a train compartment while they are unwrapping the bandages that conceal the missing lady he has kidnapped. Again, Hitchcock reveals the villain's presence aurally before cutting to him. Like the husband in *Marnie*, his characterization as an aural intruder identifies him as a sneak and a spy as well as an authority figure. More important, it makes us paranoid about eavesdroppers for the rest of the film.

In most cases aural intrusion suggests a power relationship between intruder and victim. In the last shot of *Notorious*, for example, Alex Sebastian, trying to escape from his home because his colleagues there know that he has inadvertently betrayed them, is abandoned by Alicia and Devlin, who drive off, leaving him at the end of the sidewalk. A close-up of Sebastian's head fills most of the frame, blocking out the doorway where his colleagues stand watching. Ordinarily, the graphic dominance of his head would also suggest a dominance over his colleagues, but Hitchcock subverts that expectation. From the unseen background blocked by Sebastian's head we hear, "Alex, will you come in, please. I wish to talk

to you," and Alex must walk back up his sidewalk into the arms of his executioners. There is a slight reverberation added to the speaker's voice, just enough to give extra authority to it. This sequence is consistent with the characterization of the Nazis as killers hiding behind a genteel facade. The Nazis are informing a person in very polite phrases that he is about to be done away with. Once Sebastian walks back inside his home our aural sense of doom is confirmed graphically; he is first trapped in two dimensions by the door frame and finally in the third dimension when the door closes between him and us.

The front door of the Sebastian home plays an important role in emphasizing the boundary between the film's interior and exterior spaces. *Notorious* is one of many films in which a home or room sets off one character from the rest of the world. That interior space is often a metaphor for the essential isolation of the character, an isolation that Robin Wood defines as both protective and imprisoning.[1] Usually, as in *Rear Window*, a shift occurs; the room that at first seems protective eventually becomes a trap. The invaded room is thus central to the Hitchcockian attempt to penetrate our complacency, particularly within domestic situations. In *Rear Window* the hero must helplessly wait as the villain enters the apartment from which the hero had safely spied on him. In *Shadow of a Doubt* a murderous uncle displaces a niece from her own bedroom and eventually tries to kill her. Finally, in the television film *Four O'Clock* a man planning to murder his wife is tied up next to his own bomb. In each case the outside world that is at first the source of threat then becomes the source of salvation. The victim must communicate with the outside world to save his life. In *Rear Window* this aural communication involves a scream for help to the policemen and fiancée across a courtyard. In *Shadow of a Doubt* it involves a telephone call. As the heroine makes frantic phone calls to a detective, Hitchcock photographs her through a banister, to emphasize her feeling of entrapment in her own house. Lastly, in *Four O'Clock* the protagonist grunts and strains in order to make himself heard despite a gag on his mouth. Hitchcock teases him with telephone rings and door bells that he cannot answer.

Indeed, the telephone call is a major aural intruder, offering either threats or salvation from outside. In *The Thirty-nine Steps* a

telephone ring jars the hero just after a strange woman has died on his bed with a knife in her back. The ringing is felt, by hero and viewer alike, as a threat from outside, marking him as a sitting target if he remains in his room. The telephone is the chief link with the outside world in *Dial M for Murder*. Husband and wife are aurally linked through it during the attempted strangling of the wife (by a killer hired by the husband): the husband is forced to overhear his wife's painful struggling. After killing her would-be attacker, the wife is relieved to find, and depend on, her husband on the other end of the line. She does not know, of course, that he is the very person who seeks her death. The telephone also rings during a rape/strangling in *Frenzy*. However, this victim does not save herself; with each unanswered ring her chances for rescue diminish.

Another aural indication of the unlikelihood of rescue is a door slam. In both *The Wrong Man* and *Frenzy*, when the hero is unjustly thrown into jail, Hitchcock emphasizes and finalizes his feelings of incarceration by heightening the effect of the cell door slamming through extra volume and reverberation. Hitchcock often claimed that his own fear of imprisonment went back to his early childhood when his father sent him to jail for several hours (or several minutes—the story varies) as a deterrent to naughtiness. The story may well be apocryphal, but the way Hitchcock described it is significant: "I always thought it was the clang of the door which was the potent thing—the sound and the solidity of that closing cell door and the bolt."[2] Spoto observes that in *Topaz* "the closing doors suggest not only the separation between nations . . . but also the estrangement between individuals. At some point in the film, every major character loudly slams a door; everyone is shut out of everyone's life, at least for a time."[3]

Aural intrusion is an essential technique of the single-set films, which are all experiments with unified space. *Dial M for Murder* and *Rope* are both adaptations of plays, but the spatial orientation is quite different in each; *Dial M for Murder* is an experiment with 3-D, and *Rope* is an exercise in perpetual camera movement. Hitchcock starts *Rope* by cutting from the exterior to the interior of an apartment just after a victim screams, and thereafter Hitchcock stays within the apartment, cutting only at reel changes. (As V. F.

Perkins notes, whereas Hitchcock disguises the ten-minute camera changeovers, he cuts to a new setup every twenty minutes for the projector changeovers.[4]) After an initial moment of traffic noise inserted when the murderers first open their curtains, there is no more sound from the street until the end of the film, when an approaching police siren foretells the doom of the two murderers who have been hiding a corpse in their apartment.[5] With the final intrusion of outside noise the apartment that has shielded their crime suddenly becomes their trap. The shift to outside noise signals a shift from subjectivity to external reality: the restriction during most of the film to sounds within the apartment matches the murderers' sense of insularity, the occasional door bells and telephone rings signal the major threats to their security, and the final wail of a siren brings them into the larger world of retribution.

At the end of the film the man who discovers the corpse repudiates his indirect role in the murder by opening an apartment window and firing three shots. Rising voices from passersby on the street below indicate that the police will be called, and soon we hear the wail of a siren, which eventually crescendoes to a deafening intensity. The importance of these sounds to Hitchcock's meaning is indicated by the painstaking efforts he made to obtain the effects. He insisted that the comments of the passersby be recorded from a microphone six stories above them, and he refused to use the standard police siren available from the studio's sound library. He told Truffaut:

> I asked them, "How are you going to give the impression of distance?" and they answered, "We'll make it soft at first, and then we'll bring it up loud." But I didn't want it done that way. I made them get an ambulance with a siren. We placed a microphone at the studio gate and sent the ambulance two miles away and that's the way we made the soundtrack.[6]

In *Dial M for Murder* outside noises are essential throughout much of the film. Just beyond the upstage door is a rarely seen foyer where several crucial actions take place.[7] From it we hear the sound of footsteps, which alternately bring rescuers or murderers. To obtain final proof of guilt several characters must listen to

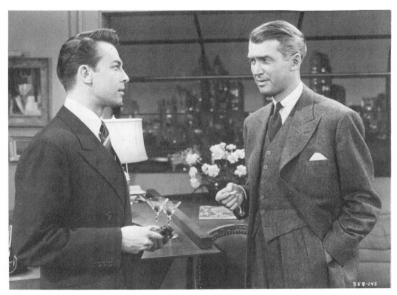

Rope*. James Stewart and John Dall. The final wail of a siren will bring the larger world of retribution.*

discover which suspect knows that an apartment key is hidden in the foyer. The unseen foyer also figures prominently in the play, but a stage production could not have been so selective about the relative loudness of footfall as various characters approach. Phone calls, are, as I have suggested, another medium of salvation or threat in this film. These were inherited from the stage play as well, but Hitchcock characteristically shoots the film in such a way as to emphasize the significance of the phone as a link to the outside world. The difference is that in a play it is nearly impossible to establish point of view if there is more than one character onstage, whereas on film Hitchcock can, and does, connect sounds with the perceptions of a given character at a given time.[8]

Although *Dial M for Murder* was filmed in 3-D, exaggerated thrustings toward or away from the audience are kept to a minimum

(two shots), and the added depth is used only in very subtle ways. (The film was released in a flat print version in most of the country and not seen as photographed until spring 1980.) Indeed, the film was shot on a set that more or less preserved the missing wall and proscenium arch feeling of the stage. In 3-D, however, actions downstage protrude into the audience and actions upstage recede, and this exaggerates the distance of the foyer, which lies behind an upstage door. The most conspicuous three-dimensional effect is the heroine's grasping toward the audience for help while she is being strangled (her outstretched arm finds a pair of scissors). The other extreme on this axis would be the foyer and what lies beyond. It would seem that when Hitchcock is using techniques that make us most identify with his victim, he uses the depth axis—reaching into the audience or forcing us to listen with a character to what is happening beyond the door. For more neutral effects he sticks to the less-threatening, less-involving cross-screen axis. In effect, what he has done is to use one axis in the film for point-of-view identification techniques and the other for less-involving moments. The mise-en-scène is more of a psychological space in the former case, more of a theatrical one in the latter.

At the climax of the film Hitchcock moves out visually into the foyer while the detective who has solved the murder narrates the telltale actions of the husband, Tony, as he hunts for a key. (The second exaggerated 3-D effect is saved for the moment when that key is produced.) At this point we are far from point-of-view shooting. Indeed, the effect of having Tony go through his actions as the detective narrates them is to make Tony somewhat puppetlike; his behavior seems controlled by the omniscient detective. The film's ending places it outside the dominant Hitchcock tradition in which we share a character's point of view. Instead, the last sequence operates within the conventions of the detective-thriller genre to which the play and most detective novels belong, in which the solutions are all explained by a mastermind detective. In this genre there is less emphasis on character identification and sympathy than on the deductive brilliance of the sleuth.

Unlike *Rope, Rear Window*, and parts of *Dial M for Murder, Lifeboat* is not a subjective film. Its single setting—passengers adrift in a dinghy—is just as metaphorical but has more to do with

the concept of social microcosm than with subjective perception. There is, of course, a pervasive tension between the interior and exterior space, because the basic question is whether the passengers will cross paths with another vessel. When the passengers finally do hear a noise from a distant source, its potential as either threat or salvation is rendered with an ambiguity on the sound track. The passengers hear a rumbling, which they at first take to be thunder (a positive sound because they are dying of thirst and would welcome rain), but which turns out to be the guns of an enemy ship.

Although the boat as a whole is not a subjective space, aural intrusion nevertheless is a major aesthetic resource of the film and is essential to its thematic development. In this case the interior and exterior spaces are not constant but are redefined throughout the film, along with point of view. The challenge is to suggest feelings of privacy. Hitchcock creates that sense of private conversations or private thoughts by photographing a person or couple against the sky or water rather than from across the boat and simultaneously eliminating any other conversations in the boat. To bring the couple back psychologically into the milieu of the boat he simply reverses the camera angle. This reversal is usually motivated by the intrusion of sounds from other passengers. When Hitchcock wants simply to bring his passengers back into the action, he keeps these intrusions subtle; when he wants to emphasize the loss of privacy, he makes the intrusions noticeable. The alternation between moments of relative intimacy and moments of shared experience is central to Hitchcock's concern in *Lifeboat* with the tension between the formation of love relationships and the interdependency of a small group of people—and, by extension, of a group of nations.

The subjective space in *Lifeboat* has no literal setting; it is only a cinematic idea temporarily defined through a combination of framing, cutting, and the aural intrusion that ends it. This aural intrusion into subjective space that is temporary and nonliteral is typical of films shot in the classical style; most often that space is defined by the frame. In the expressionistic films the spatial territory invaded by sounds is usually the mind itself; hence the knife sequence in *Blackmail* and the delirium sequence in *Secret Agent*.

In the subjective films, interior and exterior spaces are defined by the setting; the area susceptible of intrusion is usually a room, a building, or a vehicle. The clearest example of the car as subjective territory is the sequence in *Psycho* showing Marion driving from Phoenix toward California. Leo Braudy has discussed the subjectivity of the sequence in terms of audience identification. We remain inside the car with Marion, hearing the voices she imagines and seeing a policeman through her guilty eyes. Braudy observes that when an offscreen voice yells "Hey!" as she drives away from a car lot, we assume incorrectly along with her that it must be the policeman calling after her because "Hitchcock has given us that guilty, almost paranoid state of mind that converts all outside itself into images of potential evil."[9] Later in *Psycho* and in much of *The Birds*, however, there is no longer anyone to identify with. Our paranoia goes far beyond our fears for a given character. By the time of *The Birds* the whole world is a target for aural intruders.

Notes

1. Robin Wood, *Hitchcock's Films* (London: A. Zwemmer; Cranbury, N.J.: A. S. Barnes, 1965, rev. 1969), p. 68.

2. Richard Schickel, *The Men Who Made the Movies* (New York: Atheneum, 1975), p. 275.

3. Donald M. Spoto, *The Art of Alfred Hitchcock* (New York: Hopkinson and Blake, 1976), p. 432.

4. *"Rope," Movie*, no. 7 (February 1963), p. 11.

5. Spoto, in *The Art of Alfred Hitchcock*, p. 215, observes that in the four James Stewart films *(Rope, The Man Who Knew Too Much, Rear Window,* and *Vertigo)* "outside noises . . . are constantly heard in the background" and that they represent "the outside world . . . trying to break through his increasingly sealed life of fancy."

6. François Truffaut, *Hitchcock* (New York: Simon and Schuster, 1967; originally published as *Le Cinéma selon Hitchcock* [Paris: Robert Laffont, 1966]) p. 135.

7. In his perceptive comparison of the stage and screen versions of *Dial M for Murder,* Peter Bordonaro says that the "entry foyer" of the stage play is eliminated in the film, so that the front door opens directly into the living room. See his *"Dial M for Murder:* A Play by Frederick Knott/A Film by Alfred Hitchcock," *Sight and Sound* 45 (Summer 1976):176. The foyer to which I am referring here is common to the entire building but serves the same purpose.

8. Bordonaro, ibid., argues persuasively that Hitchcock has altered the play's simplistic

designation of evil husband and innocent wife by making the husband more sympathetic (he acts more out of sexual jealousy than greed) and the wife more guilty (of sexual infidelity). Our sympathies vary along with the points of view.

9. Leo Braudy, "Hitchcock, Truffaut, and the Irresponsible Audience," *Film Quarterly* 21 (Summer 1968):25.

8 Beyond Subjectivity: *The Birds*___

The Birds (1963)—together with *Secret Agent* and *Rear Window*—
is one of the three Hitchcock films in which sound is most impor-
tant. Hitchcock's emphasis on sound effects is indicated by the fact
that he forgoes background music in *The Birds* for the first time
since *Lifeboat* twenty years earlier.[1] (In both cases, the starkness of
the scoreless sound track emphasizes the vulnerability of a human
community in a hostile natural environment.) *The Birds* is also
Hitchcock's most stylized sound track—it is composed from a con-
stant interplay of natural sounds and computer-generated bird
noises. The particular emphasis on the sound track at this point in
Hitchcock's career would seem to have resulted from two converg-
ing developments, one technical, one personal.

The technical development was the new sophistication of elec-
tronic sound. Hitchcock told Truffaut in his discussion of *The
Birds*, "Until now we've worked with natural sounds, but now,
thanks to electronic sound, I'm not only going to indicate the sound
we want but also the style and the nature of each sound."[2] Such an
interest in new technical challenges was, of course, characteristic
of the director who immediately experimented with synchronized
sound, elaborate camera movement, and 3-D as soon as each be-
came available to him. Indeed, the challenge of mastering a new
technology has provided a major creative stimulus for Hitchcock in
many films.

The personal development involves Hitchcock's interest from
about 1958 to 1963 in going beyond point-of-view shots identified
with a given character, an interest begun in *Vertigo*, developed in
Psycho, and culminating in *The Birds*. In these three films, which
to varying degrees might be called the "extrasubjective" films, the
director sought most seriously to touch directly the fears of the
audience.[3] They are his least detached, most unsettling and haunt-
ing films. *(North by Northwest*, which Hitchcock directed between

Vertigo and *Psycho*, is darker in mood than the earlier espionage thrillers it resembles, but it is still a romantic comedy.) The extrasubjective films introduce terror through the experience of a character with whom we identify, but then Hitchcock removes the surrogate and we experience the sensation more directly. (The reverse occurs in *Vertigo*, where the very opening title designs induce dizziness before the first sequence attaches the sensation to the hero's vertigo.) Hitchcock himself has said that "in *Psycho* there is no identification with the characters. There wasn't time to develop them and there was no need to. The audience goes through the paroxysms in the film without consciousness of Vera Miles or John Gavin. They're just characters that *lead* the audience through the final part of the picture, I wasn't interested in them. And you know, nobody ever mentions that they were ever in the film."[4] Hitchcock's comment is somewhat overstated. Although there is no single character to whom we remain emotionally attached for the whole film, at one point or another we share the subjective experiences of almost every major character. Similarly, in *The Birds*, as Mike Prokosch has argued, "the principal characters have no monopoly on audience identification."[5] Hitchcock gives us a heroine, however shallow, and then a family with whom to experience the film. However, as William S. Pechter has pointed out, their "suffering is incommensurate with the provocation. . . . The theme *is* the audience" and our reaction to the film.[6] The characters may or may not have escaped the birds at the end of the film, but the audience is left behind, in a world where the birds, which represent any terrifying, uncontrollable forces, have prevailed.

When Hitchcock aims toward direct audience involvement, he often shifts from a dependence on visual techniques to a greater dependence on aural techniques. In *Vertigo* the emphasis is still visual; the sensation of vertigo is created more specifically through computer-generated designs for the titles and later through shots that combine tracking out with zooming forward. To be sure, Herrmann's score, with its hypnotic arpeggios, is important, but it is part of an overall effect and not dominant during Hitchcock's vertigo-producing sequences. In *Psycho* the scoring generally maintains the tension in moments of relative tranquillity. During the killings, however, the music picks up the visual motif of birds as

predators; violins are scraped during the three attacks to sound like shrieking birds. Sound and visual effects work together to provide three of Hitchcock's most terrifying sequences. (That the scoring alone is not so terrifying is indicated by the fact that on the fourth occasion when the violins shriek—during Norman's run down from the house after Marion's murder—the audience does not cringe in terror.) A crucial aspect of the scoring here is that the shrieking not only associates Norman with his stuffed birds of prey but it also associates the viewers with the onscreen victims. That is to say, the cries of the victims, the screeches of the violins, and the screams of the audience merge indistinguishably during violent sequences. The distinction between screen victim and audience is broken down. By contrast, the subjective films rarely elicit screams during the violent sequences. such as the cornfield attack in *North by Northwest* or the struggle on the carousel in *Strangers on a Train*. The attacks in *Psycho*, however, almost always incite the audience, and Hitchcock has guaranteed these screams by inserting them into the sound track to prime the viewer's response. During Norman's attack on Lila there are screams added to the violin shrieks that may or may not be attributed to Norman or Lila. It does not matter who makes them. The moment is one of abject terror for attacker, victim, and viewer alike. If each attack in *Psycho* evokes such strong identification between victim and viewer, how then does Hitchcock move beyond identification with the characters to more direct audience involvement? The impact derives from the severity of the attacks plus the interchangeability of the victims. The viewer suffers more intensely and more often in *Psycho* than in past Hitchcock films. However, because the viewer survives the attacks on each character with whom he had identified, he begins to feel a generalized terror dissociated from any specific victim.

By the time of *The Birds*, screeches are even more important than visual techniques for terrorizing the audience during attacks. Indeed, bird sounds sometimes replace visuals altogether. Moreover, Hitchcock carefully manipulates the sound track so that the birds can convey terror even when they are silent or just making an occasional caw or flutter. As Truffaut points out, "The bird sounds are worked out like a real musical score."[7] Instead of orchestrated instruments there are orchestrated sound effects. If in

Psycho music sounds like birds, in *The Birds* bird sounds function like music. Hitchcock even eliminates music under the opening titles in favor of bird sounds. Moreover, once Hitchcock has established the birds as a menace, he controls suspense simply by manipulating the sounds of flapping and bird cries that recur quite unrandomly for the rest of the film. At any point in the film a bird noise can be introduced naturally, so Hitchcock has a means of controlling tension even more effective and less obtrusive than musical cues. Of course, he also introduces birds visually, but the audience is much more conscious of their appearances than of their sounds. To introduce a bird visually without an attack is to tease the audience with a red herring, and so Hitchcock cannot manipulate the images as freely for suspense as he does the sound track.

One reason the sound effects in *The Birds* directly touch the fears of the audience is that they are relatively abstract—especially the bird cries. It is probably the abstract stridency of bird cries that accounts for their appeal to Hitchcock in *Blackmail* (Alice's chirping canary), *Sabotage* (a saboteur's bird shop), *Young and Innocent* (the sound and sight of shrieking sea gulls that precede the disclosure of the corpse), and *Psycho* (the violin shrieks). (I do not include some mewing sea gulls heard in *Under Capricorn* or *Jamaica Inn* because Hitchcock uses the sound in those films not for emotional resonance but simply for atmosphere, as any director might.) Because the bird cries are partly computer-generated in *The Birds*, that sound is particularly nonspecific, as is the electronic flutter that indicates the flapping of wings. The bird sounds are often so stylized that if the visual source were not provided, the sounds could not be identified. The effect of the resulting ambiguity is to universalize the noises—much as Hitchcock universalizes the arguments between spouses by muffling the specifics of their quarrel. Cameron and Jeffery consider this universality to be the essence of *The Birds:* "The ambiguity of the film's meaning is a prime virtue. If it had a specific allegorical meaning, it would have a particular relevance to each spectator, who could then deal with it on its own level. But its very ambiguity makes the threat operate irresistibly at every level of audience consciousness."[8]

The bird sounds are all the more abstract and terrifying when they come from unseen sources. As in *Rear Window*, the enemy is

most threatening when invisible. The film's most frightening attack is the sixth, in which only a bird or two is seen. Mitch has boarded up the windows of his house. Ironically, his hammering, which is heard before it is seen, sounds like the tapping of beaks, a dominant noise during the attack. The situation is claustrophobic: as the human victims listen to and fight off the assault, they realize that the home is as much a trap as a protection. The attack's end is signaled by the receding of bird noises. Meanwhile, the audience has felt as threatened as the characters. By keeping the menace aural rather than visual Hitchcock has once more broken down the barrier between audience and screen. The theater and the living room have seemed one continuous space—one continuous trap. If this were the only attack, *The Birds* would be a subjective film (from Melanie's perspective). However, the attacks are not restricted to any character's private space.

There is a second scene in which the bird noises clearly are more menacing than the sight of them alone. William Pechter describes the shift in mood: "In one of the most amazing images of the film, we suddenly see the town, now burning in destruction, in a view from great aerial elevation; from this perspective, one sees everything as part of a vast design, and the scene of chaos appears almost peaceful, even beautiful; then, gradually the silence gives way to the flapping of wings and the birds' awful shrieking, and the image, without losing its beauty, is filled with terror as well."[9] We can distinguish the added effect of the sound because it is introduced later than the image of the birds and changes the mood of the shot.

At other times, however, the silence of the birds can be more frightening than their shrieks. There are seven attacks in all, and Hitchcock clearly was challenged by a desire to differentiate them. There are two sets of variables that he seems to be manipulating in relation to the sound effects: whether the birds are introduced first aurally or visually and whether the birds are ominously noisy or ominously silent.

One of the reasons *The Birds* is so unsettling is that there is no apparent logic or predictability about when or whom the birds will attack. (Hitchcock has said, "I made sure that the public would not be able to anticipate from one scene to another."[10]) Part of our

unease is determined by Hitchcock's shifting of whether we first
hear or see the birds. The choice depends on whether he wants
suspense or surprise for the attack. The first attack is made by one
gull on Melanie as she drives a motorboat. The gull enters the
frame well before Hitchcock adds the sound of wings or the bird's
screech. He has now established suspense; after having surprised
us the first time we now know that the birds can strike without
warning. Any bird caw can make us nervous. For the second
attack, at a children's birthday party, Hitchcock uses visual and
aural effects simultaneously. At the height of the attack, the
screams of birds and children are indistinguishable. Hitchcock
extends the havoc both visually and aurally by having the birds pop
balloons with their beaks. It enables him to add to the avian
destructiveness without his actually having to show birds pecking
at children's heads. (He saves the more gruesome sights for later
impact.) The third attack, in which finches flood Mitch's fireplace,
also involves simultaneous sounds and images. It is not so terrify-
ing in effect except for our realization that the birds are now inside
the home. Before the fourth attack, on the school children, Hitch-
cock shows the birds building up silently, unnoticed at first, for an
attack on a schoolhouse. In counterpoint to their ominous silence
we hear the innocent voices of children singing. The preparation
for the scene is considerably more terrifying than its realization.
(The attack itself is so ambitious as a special-effects project that
the more sophisticated viewer tends to speculate about how Hitch-
cock created the effects rather than to identify with the victims.)

The fifth attack alternates between silence and screaming. In a
restaurant Melanie and other onlookers watch in silence as a man
lights a cigarette next to a puddle of spilled gasoline. The people
are inside a window and gesticulate wildly in pantomime. When
they suddenly get the window open they all scream at once at the
man not to throw down his match, but their babbled screams are as
ineffective as their silence; they simply startle the man, and he
tosses away the match, igniting an explosion. Hitchcock ends this
sequence with the high overhead shot described above by Pechter,
in which the silent image takes on terror when the bird cries are
added. It is significant to the viewer's response that the sequence
begins from Melanie's point of view but shifts with the overhead

shot to the apparently safe perspective of the birds themselves. At first we feel relief at our emotional removal from the holocaust below, but with the introduction of the terrifying screams we soon feel that even this space is threatening; there is no place where we can feel safe.

The sixth attack is the assault on Mitch's house that is created almost entirely through sound. By the end of this attack the birds have gained the advantage. Hitchcock himself has described how for the seventh and last attack he no longer needed to have the birds scream.

> When Melanie is locked up in the attic with the murderous birds we inserted the natural sounds of wings. Of course, I took the dramatic licence of not having the birds scream at all. To describe a sound accurately, one has to imagine its equivalent in dialogue. What I wanted to get in that attack is as if the birds were telling Melanie, "Now we've got you where we want you. Here we come. We don't have to scream in triumph or in anger. This is going to be a silent murder." That's what the birds were saying, and we got the technicians to achieve that effect through electronic sound. [11]

Thus Hitchcock has characterized his birds in the same way that he characterized many of his murderers; their silence is a sign of their control. Having established this connection between silence and supremacy, Hitchcock maintains it for the rest of the film. In his words:

> For the final scene, in which Rod Taylor opens the door of the house for the first time and finds the birds assembled there, as far as the eye can see, I asked for a silence, but not just any kind of silence. I wanted an electronic silence, a sort of monotonous low hum that might suggest the sound of the sea in the distance. It was a strange, artificial sound, which in the language of the birds might be saying, "We're not ready to attack you yet, but we're getting ready. We're like an engine that's purring and we may start off at any moment." All of this was suggested by a sound that's so low that you can't be sure whether you're actually hearing it or only imagining it. [12]

The shift in terror in *The Birds* from noise to silence is essential to its extrasubjective style. The film eventually makes us feel just as vulnerable in moments of relative tranquillity as during attacks. It is one thing to feel threatened when under attack; it is another to be frightened at all times, to feel that life is a permanent state of siege. Thus Hitchcock has achieved his career-long aim of making us wary, not so much of blatant evils, but of our precarious daily condition.

Another aspect of the film's sound track that is so insidiously frightening is the cross-identification of noises human, mechanical, and avian. Although the major antagonists in the film are the natural order (birds) and the human order, the distinctions become blurred when we consider that both worlds are associated at times on the sound track with mechanical sounds. The associations can be made precisely because Hitchcock has established a norm of abstracted, stylized sounds. The birds, when screeching and flapping their wings, sound at times like an engine screeching and crackling.

Hitchcock describes the low hum of their menacing silence as "like an engine that's purring," and throughout the film motor noises seem to link bird and human noises. Under the opening titles the electronic flapping sounds of wings are intermingled with the almost imperceptible sound of a truck motor. Although we see birds during the titles (the titles, as abstracted as the sound track, are presented as fragments that converge and then disintegrate), we do not see a truck until their close, when a van roars by shortly after a trolley car, on a busy San Francisco street where Melanie is walking. She enters a bird shop where she will meet Mitch and attempt to talk to him over the loud sounds of bird chatter. The sequence ends with Melanie rushing into the street to watch Mitch's car take off noisily. The bird store has no doors, and the sounds of chirping cross-fade into the sounds of traffic. Thus Hitchcock has shifted by the end of the first sequence from bird sounds with an undercurrent of truck noise, to obvious truck noise cross-fading to bird noise, to bird noise plus human speech, to bird noise cross-fading to truck noise.

A few minutes later Melanie is herself driving a sports car. During this sequence (in which Melanie takes two birds to Mitch's

sister) Melanie shifts the car's gears noisily and often. In one shot the car is initially hidden by a hill, and we know of her impending approach only by the noise of the car motor. A close-up of the lovebirds swaying on their perches as she rounds the corners too fast is accompanied by the sound of screeching tires and shifting gears. It may be that Hitchcock wants us to identify Melanie with mechanical noises because at this point we are to peceive her behavior as cold and mechanical. Her intrusion into the peaceful hamlet of Bodega Bay is suggested predominantly by the noise of the sports car as she drives through the quiet streets. Soon Melanie is associated with the noise of a motorboat she rents to deliver Mitch's birds. It is possible to interpret the film as implying that Melanie does indeed bring the bird attacks with her to the town.[13] This interpretation is supported by the emphasis Hitchcock puts on Melanie's noisy approach by car to the town and by her noisy departure in the last shot of the film (an extremely long take of the car in which she and Mitch's family are escaping), the motor sound gradually dying out as they disappear into the distance.

Motor noise is associated with a second woman in the film, Mitch's mother, who resembles Melanie in appearance and apparent coldness. Hitchcock has described his use of motor noise as an extension of the mother's feelings just after she discovers a neighbor who has been killed by the birds:

> The screech of the truck engine starting off conveys her anguish. We were really experimenting there by taking real sounds and then stylizing them so that we derived more drama from them than we normally would. . . . In the previous scene we had shown that the woman was going through a violent emotion, and when she gets into the truck, we showed that this was an emotional truck, not only by the image, but also through the sound that sustains the emotion. It's not only the sound of the engine you hear, but something that's like a cry. It's as though the truck were shrieking.[14]

Insofar as the women are doubles, there has been an aural reversal. Earlier, when Melanie was still untouched by any deeply felt experience, she was identified as something less than human by being

associated with her car motor. Now the mother is indeed suffering, and the motor is taking on human qualities. At first a person sounded like a machine; now a machine sounds like a person.

The machine also sounds like a bird. Hitchcock uses the word *shrieking* to imply that he was anthropomorphizing the truck, but the word he has chosen also describes bird noises. In other words, there are aural cross-references of all sorts: the birds sound like machines because of the electronic origins of their sounds, the human beings sound like birds (especially when the children shriek during attacks), and in the above example the machines sound like birds or people. The aural exchanges in the film match its overall visual exchanges. It starts in a bird shop where hundreds of birds are caged. By the end of the film it is the human beings who are caged by birds—in phone booths, homes, and vehicles. All in all, the film offers a bleak picture of humanity as trapped by forces beyond its control; the world depicted seems all the more impersonal and hostile because of the mechanical nature of the sound track.

There is one more issue raised by the aural continuities of things human, avian, and mechanical, and that is the nature of film-making itself. Any film requires a certain subordination of human subjects to mechanical and technical necessities. Hitchcock's closed style has always emphasized that technical control, and *The Birds* is the most mechanical of all his films. Not only does the sound track incorporate computer-generated noises, but the visual effects include 371 trick shots combining drawn and model animation and elaborate matting techniques.[15] The birds, then, are the mechanical creation of a director who fully exploits the mechanical resources of his medium.

However, Hitchcock further emphasizes his connections with the birds. The shift from Melanie's point of view at the start of the gas station sequence to the final aerial shot is quite literally a shift to a bird's-eye view. It is also a shift to the omniscience of the director himself. (In *Psycho* Hitchcock also associates the director's perspective with a bird's-eye view when he cuts to overhead shots during the murder sequences.) Hitchcock is fond of overhead shots that reveal his characters to be trapped by a destiny that they cannot control. Within the world of film, however, it is not fate but

the director who is in control. Hitchcock's avian and human attackers are simply the agents of a malevolent fate imposed by the director on his characters. Yet most critics would agree with Wood that the essential meaning of *The Birds*, along with many other Hitchcock films, is that in a precarious and hostile world "the only (partial) security is the formation of deep relationships."[16] This humane message is presented paradoxically in a highly mechanical film. Hence the special importance of the film's last scene, which balances the humane and the mechanical. Although physically battered, the central characters have at least created genuine emotional bonds with each other—two shots establish a new tenderness between Melanie and Mitch's mother—and Hitchcock allows them to escape. Once again, however, they are observed from the birds' point of view. The car's retreat into the distance is photographed from the family's front porch, and in the foreground are hundreds of birds perched on their newly conquered territory.

The birds are in control, but so is the director. His last shot is a composite of thirty-two pieces of film[17] and dozens of artificial and natural bird sounds. In previous shots the predominant sound has been that low, artificial hum of menace. This "electronic silence" is so important to the tension that when Mitch tenuously starts up and drives Melanie's sports car out of the garage there is absolutely no motor sound—from the same car that Hitchcock has previously shown to be particularly noisy. Thus, the silence that Hitchcock ascribes to the birds is ultimately a sign of the director's control over his characters, his viewers, and his art.

Notes

1. *Rope* also has no score, but there is a considerable amount of source music from the onscreen piano and a radio that is left on.

2. François Truffaut, *Hitchcock* (New York: Simon and Schuster, 1967; originally published as *Le Cinéma selon Hitchcock* [Paris: Robert Laffont, 1966]), p. 224.

3. Donald M. Spoto, in his *The Art of Alfred Hitchcock* (New York: Hopkinson and Blake, 1976), makes a similar point about *Psycho*.

4. Peter Bogdanovich, *The Cinema of Alfred Hitchcock* (New York: Museum of Modern Art, 1963), p. 42.

5. Mike Prokosch, *"Topaz,"* unpublished manuscript, 19 February 1970, p. 17.

6. William S. Pechter, "The Director Vanishes," *Moviegoer* 2 (Summer/Autumn 1964), p. 48.

7. Truffaut, *Hitchcock*, p. 223.

8. Ian Cameron and Richard Jeffery, "The Universal Hitchcock," *Movie*, no. 12 (Spring 1965), p. 21.

9. Pechter, "The Director Vanishes," p. 49.

10. Truffaut, *Hitchcock*, p. 217.

11. Ibid., p. 224.

12. Ibid., p. 225.

13. See, e.g., John Belton, "Hitchcock: The Mechanics of Perception," *Cambridge Phoenix*, 16 October 1969. Belton argues that *The Birds* is a subjective film in which the whole world is a reflection of Melanie's state of mind.

14. Truffaut, *Hitchcock*, p. 224.

15. Bogdanovich, *The Cinema of Alfred Hitchcock*, p. 45.

16. Robin Wood, *Hitchcock's Films* (London: A. Zwemmer; Cranbury, N.J.: A. S. Barnes, 1965, rev. 1969), p. 151.

17. Bogdanovich, *The Cinema of Alfred Hitchcock*, p. 45.

9 Silence and Screams_____

Silence appears as both a thematic and formal element in almost
every Hitchcock film. As in *The Birds*, it is usually associated with
control, a concept which, as I showed in chapter 4, is at the heart
of the tension between the need for social order and the need for
individual expression. This same tension between order and ex-
pression also underlies all art, of course, and Hitchcock's work is
no exception. Nowhere is his association between silence and con-
trol clearer than in his montage sequences, his moments of greatest
suspense and audience manipulation. Like a murderer, Hitchcock
seems to think that these are most effective when done silently. For
a villain murder is the act requiring greatest control. Hence,
Hitchcock's stylistic and thematic interests intersect precisely at
the point where a crime or murder is committed by a silent villain
and is shot as a silent montage sequence. Other than in the mon-
tage sequences, silence is more an idea than a literal ploy. That is
to say, when Hitchcock or most writers refer to a silent passage
(e.g., the extended sequence in *Vertigo* in which Scottie pursues
Madeleine by car around San Francisco), they are actually speak-
ing of a sequence without dialogue. In most cases the absence of
dialogue in such sequences pertains to the use of silence as motif,
which is the central subject of this chapter.
 As a motif associated with control, silence is the common end
point of several different continua of behavior. At the other end of
each continuum is some form of oral expression—garrulity, a con-
fession, a scream—each of which I shall examine in turn. I have
already introduced some of the antinomies implied by the continua:
emotional paralysis versus spontaneous expression *(The Man Who
Knew Too Much)*, oral ellipsis versus self-honesty *(Secret Agent)*,
the suppression versus the confession of guilt *(Blackmail)*. In addi-
tion, an important continuum that involves a character's manner of
speaking ranges from taciturnity to glibness. Hitchcock does not

consistently endorse or condemn any given mode of behavior; indeed, he suggests that flexibility is necessary to survival. What is consistent throughout his work, however, is a vision of behavior in terms of such continua. Because so much of the behavior of Hitchcock's characters falls along parallel lines, a pattern emerges that invites comparisons between characters. These comparisons are essential to Hitckcock's central aim of revealing the continuities between good and evil, sane and insane behavior.

Although villains are agents of social chaos in Hitchcock's universe, their efficacy depends on personal control. Hence, the silence that usually characterizes Hitchcock's murderers defines both their temperament and their method of killing. Many of them keep a low profile, like Mr. Verloc, the saboteur of *Sabotage*, who is described by his wife as a "quiet" man who "doesn't want to draw a lot of attention" to himself. The German villain of *Lifeboat*, not revealing that he speaks English, keeps silent until he gains the upper hand. In *Dial M for Murder* the murderer instructs the man who will strangle his wife for him that "there must be as little noise as possible." Hitchcock usually characterizes his government agents as quiet killers barely if at all more humane than the enemy they are chasing; in *North by Northwest* the sight of Mount Rushmore prompts an agent's remark that "Roosevelt's head is saying 'Speak softly and carry a big stick.'" Bruno, the murderer of *Strangers on a Train*, tells a captivated audience of party guests that strangling is the best form of murder because it is "simple, silent, and quick—the silent part being the most important." Bruno's strangling of Miriam is indeed swift and silent, but he himself is very glib. He belongs to a class of charming villains (such as Abbott in *The Man Who Knew Too Much* and the murderers of *Shadow of a Doubt* and *Frenzy*) whose glibness is part of the personable facade they maintain in order to befriend their potential victims.

The distinction between silent killing and bumbling, talkative inefficiency is at the heart of the contrast between the two couples of Hitchcock's last film, *Family Plot* (1976). Indeed, it is the comparison of the two couples that would seem to have most intrigued Hitchcock when designing the film.[1] The more villainous couple is Arthur and Fran. Arthur is a perfectionist. He finds

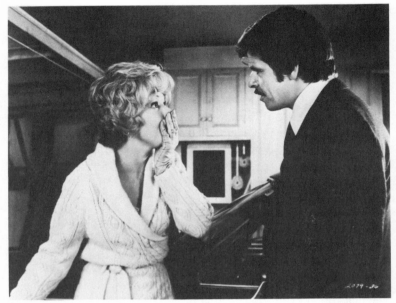

Family Plot. *William Devane versus Barbara Harris. The two couples contrast silent killing with talkative inefficiency.*

fulfillment in planning and executing perfect crimes (kidnappings) in exchange for a ransom of perfect gems (diamonds). He succinctly characterizes his method of operation when he says, "Let me do this in my own quiet way." Most of the time he assigns Fran to make contact with outsiders. Arthur insists that the kidnappings be carried out wordlessly. When Fran, in disguise, communicates with the police, she remains mute, expressing her wishes in writing or pantomime. After her first such escapade Arthur tells Fran, "I told you you could learn to keep your mouth shut if you try." Yet Fran is not so controlled or ruthless as is Arthur. When he first informs Fran that they must kill the other, snooping couple, she abandons her low, sedate whispers in a jewelry shop and yells,

"Stop it!" Later, when they are carrying out their plans, Fran complains, "If I'm talking too much it's because you're not talking at all. That's because murder doesn't agree with me." In short, the lessening of Fran's professionalism as a criminal is indicated by the increase in her talking.

By contrast, Blanche and George, two petty, but not malevolent, con artists, are nonstop talkers. Blanche spends most of the film nagging George, a would-be actor. Whereas Fran in her professional (criminal) role must remain mute, Blanche must talk in hers: she is a spiritualist who speaks in the voices of her contacts. Both couples are introduced with the woman partner acting in her professional capacity, the one mute, the other speaking in a strange voice.

There are even parallel scenes in which the women alternate between their professional and their private voices. George comes to see Blanche at her home while she is holding a seance.[2] She talks with George in the kitchen using her own voice while occasionally projecting out a loud phrase in her contact's voice, for the benefit of her client in the next room. Similarly, when Fran visits Arthur in his jewelry shop, she alternates between using a loud voice that can be heard by other customers (she pretends to buy a necklace) and using a whisper with which she and Arthur discuss their kidnapping problems.

The contrast between the couples is emphasized whenever their plots intersect. The first time, George and Blanche are so busy talking in George's cab that they almost run over Fran, who is crossing the street. We cut from the garrulous couple, who have just halted their car with a screech, to the silent Fran, whom we follow on her mute visit to the police. The plots intersect a second time in a cathedral, where George goes to talk to a bishop, whom Fran and Arthur abduct during services. Whereas a priest cautions George not to talk so loudly, Arthur and Fran execute their abduction in total silence—the sequence is filmed as a silent montage that emphasizes their quicker-than-the-eye efficiency. With typical irony Hitchcock has George scolded for a minor impropriety while the criminals get off scot-free.

In order to win out over the more silent, efficient couple, George and Blanche finally learn to control their voices and to work

efficiently rather than at cross-purposes with each other. Together they free Blanche and trap Fran and Arthur (in their own cellar prison) by first keeping quiet—George tiptoes around with his shoes off and Blanche feigns unconsciousness—until the right moment, when Blanche startles her captors with an Apache yell and eludes their grasp.

On a lesser scale of criminality than murderers whose silence signifies cold control and ruthlessness are those characters who simply do not speak up at the proper time. At its worst this behavior constitutes withholding of evidence and is legally as well as morally culpable. This is the case in *Blackmail*, for instance, when Alice delays telling the police that the suspect they are chasing is innocent of the artist's murder. The crosscutting between her hesitation and the suspect's death puts the blame properly on her. In *Shadow of a Doubt* Charlie's silence about her uncle's identity similarly allows the death of a wrongly accused suspect being pursued by the police. (Conversely, the withholding of evidence can *save* a life in those films requiring a heroine to trust in the innocence of a falsely accused hero.) The connection between the silence of professional killers and the silence of heroines whose reticence causes deaths is one more instance of the linkage Hitchcock likes to show between the obviously criminal and the apparently innocent—it is only a distinction between active and passive murder.

Most often reticence is an emotional rather than a legal matter. In this case a character's silence represents an avoidance of emotional commitment to another person. In *Notorious* the hero, Devlin, a CIA agent, is characterized as almost wordless. He is introduced as a silent silhouette, his back to the camera, while the heroine, Alicia, prattles away at him and her other guests at a party. When Devlin finally does speak, he typically uses short phrases. Devlin's reticence extends to his behavior as a lover. After he and Alicia fall in love, Alicia tries to elicit some verbal acknowledgment from Devlin but must be satisfied with his saying, "When I don't love you, I'll let you know." As Alicia becomes more and more involved with Sebastian, a German spy whose activities she is assigned to monitor, she hopes that Devlin will tell her to stop, but he will not assume that responsibility for her actions.

"One word," she scolds him, after committing herself to a dangerous marriage to Sebastian, "if only you had said one word." Devlin insists throughout most of the film that "actions speak louder than words" (he says just this before kissing Alicia, when she asks if he loves her). Yet, while rescuing Alicia from Sebastian, he finally prefaces his confession that he loved her all along with the concession that he could not abandon her in Brazil because he "had to speak [his] piece." Devlin's change of heart about speaking *to* Alicia is paralleled by his change of attitude when speaking *about* her. Whereas during his first visit with his CIA colleagues he raises no objections to derogations of Alicia's character, during the second visit he defends her behavior.

Cary Grant, who plays Devlin, is at the other end of the rope in his role as Roger Thornhill in *North by Northwest*. Here he plays the civilian very much hurt by an American spy (Eve Kendall) with whom he falls in love. She cannot confess her love for him because it conflicts with her duty as a double agent. Thornhill is extremely glib; he is a Madison Avenue executive who lies readily. (Grant's role here is much closer to his usual suave persona.) Like Devlin, Thornhill confesses to a basic fear of women. In Thornhill's case glibness rather than silence is a means of avoiding real conversation. Thornhill's superficial chatter, like Devlin's taciturnity, is a defense mechanism that must be destroyed before he can enter into a genuine relationship with a woman.

The initial verbal reticence on the part of agents Devlin and Kendall is in part a commitment to their professional rather than personal lives. Erica, the heroine of *Young and Innocent*, also distinguishes between love and duty when she chooses to be silent, but in her case learning to express feelings of love is seen as a process of growing up. In the course of the film Erica learns to trust a young man who is a fugitive from injustice. The film's action can be seen as a journey that is a metaphor for Erica's growth from childhood to maturity. From the beginning of the film Erica shields the fugitive, Robert, from the police who seek him, by refusing when interrogated to reveal his whereabouts. However, she will also not reveal her feelings for Robert to the young man himself. During a romantic interlude in which Robert tenderly encourages Erica to be brave in the face of danger, he finally begs her, "Erica,

The Birds. *Jessica Tandy. A silent scream in the face of unspeakable horror.*

dear, do say something," only to be told, "I can't; I just can't." Yet as soon as he takes his leave, Erica, who has appeared to be asleep, whispers tenderly to the absent young man, "I don't want anything to happen to you, either." It is important that the chief of the police hunt is Erica's own father; her refusal to tell him about Robert is an essential step of growing up—the transference of affection from a father to another man.

In Hitchcock's world, reticence at its extreme is emotional paralysis, a psychological state indicated by total silence. In *Vertigo* this is the form of breakdown exhibited by the hero, Scottie, who seeks total withdrawal after feeling responsible for the death of

Vertigo. *James Stewart and Barbara Bel Geddes. Hitchcockian heroes who are emotionally paralyzed are often reduced to total speechlessness.*

a woman. His complete withdrawal after a traumatic experience is the logical extension of his previous tendency to avoid reality. As in *Rear Window*, Hitchcock enables the audience to "see" a character's state of mind by finding a literal situation that expresses his emotional state.

Speechlessness can also indicate a more temporary impotence to which Hitchcock reduces characters who confront horrors too awful to articulate. The adjective *unspeakable* is made literal in *The Birds* when the hero's mother discovers a neighbor whose eyes have been gouged out by invading birds. She runs out of the house and opens her mouth to speak, but no sound comes out. Then she drives home and confronts her son with her mouth agape, but she is still unable to speak of what she has seen.

The use of speechlessness to indicate shock occurs most fre-

quently on a smaller scale. For example, in *Family Plot*, when the hero discovers his girlfriend's blood-smeared pocketbook, we hear his, "Oh, my God!" as we see the pocketbook with him. But the more eloquent indication of his shock is the cut back to a close-up of his speechless staring. Of course, this kind of reaction shot is by no means unique to Hitchcock, but it is consistent with his more salient extensions of speechlessness in whole scenes or films.

Paralysis, too, is a literal extension of an emotional problem in Hitchcock's films. In *Rear Window* (1954), Jeff's immobility (his leg is in a cast up to his waist) symbolizes his emotional paralysis (he is engaged to but will not marry Lisa). Hitchcock treats this situation in expanded form in both his first half-hour television film *Breakdown* (1955) and his first hour-long television film *Four O'-Clock* (1957). In each case a man's inability to communicate with others is translated from a figure of speech into a literal situation in which he must communicate to save his life.

In *Breakdown* a businessman's emotional paralysis is introduced in a prologue showing the callousness with which he treats the tearful pleading of an employee he has fired. Soon afterward, the businessman breaks his neck in an automobile crash. Because he is paralyzed, he is nearly interred before he manages to let people know that he is alive. It is not words that finally save his life, but a tear welling in his éye. The tear is an especially appropriate form of communication because it means that the man is finally exhibiting the genuine feeling he had scorned in his employee.

In *Four O'Clock* a paranoid clockmaker prepares to murder his wife and her supposed lover by exploding a bomb in their home at the time of the presumed daily tryst. However, shortly after he sets the bomb to go off at four o'clock, two boys break into the home and, finding the man in the cellar, bind him, gag him, and leave him to become the victim of his own bomb. The rest of the film consists of his overhearing that his wife's male visitor is merely her brother and of his attempts to communicate his presence to his wife upstairs before the bomb goes off. At first Hitchcock is rather flexible about aural and visual point of view. Although he gives us a stream-of-consciousness narration of the man's thoughts, he also feels free to cut upstairs to reveal the wife's activities. As the tension increases, however, the camera becomes confined to the

cellar. Shots of the clock become progressively closer, and the sound of ticking becomes progressively louder, to correspond not only to the man's intensified concentration on the clock but to the intensification of his heartbeat. Through a subjective style Hitchcock makes the audience suffer the agonies of impotence, as the man fails to make himself heard.

The speechlessness of characters reduced to impotence might seem to be just the opposite of the silence that typifies effective villains. However, both sets of characters are emotionally paralyzed; as I showed in chapter 4, Hitchcock's murderers deliberately suppress their feelings in order to maintain control. Hence, Hitchcock often pairs a strong villain with a weaker partner who shows and sometimes breaks under the strain (e.g., Abbott in the British *Man Who Knew Too Much*, Mrs. Drayton in the American version, Sebastian in *Notorious*, Fran in *Family Plot*). If Hitchcock shows that his heroes are not altogether good, he also shows how hard it is for his villains to be altogether bad.

The eruption of guilt that causes a character to break his silence in the majority of Hitchcock's films usually comes in the form of a confession, a ritual Chabrol sees as an acceptance of responsibilities and "the supreme exorcism and the principal condition of Man's final triumph."[3] His metaphysical reading is supported by the fact that the director's most disturbing films are often those which deny a character the release of confessing. Such a character may enter into an uneasy companionship with the only other person who shares his guilty secret. *Sabotage* is a perfect example of the film that describes the psychological and moral state of its heroine in these terms. At the start of the film the heroine, Mrs. Verloc, is a talkative, extroverted, innocent person, unlike her uncommunicative husband, who, without her knowledge, is a saboteur. However, once the husband allows her brother to be killed, she refuses to speak to him. Her accusing silence forces an apologetic confession from the guilty husband, who prefaces his confession with the frustrated complaint, "You might answer a fellow." Mrs. Verloc's silence is at first one of impotence, but it also suggests something sinister about her. Indeed, she soon stabs her husband—in a typical silent montage of murder. Except for a cry emitted as she knifes the husband, the heroine emits no sound during or after the

murder in reaction to the heinousness of her own actions. When she finally does decide to confess to the authorities, it is her detective friend who, like the detective-fiancés in *Blackmail* and *Shadow of a Doubt*, interferes with her attempts. Once more a film ends with a hero and heroine uncomfortably facing a future with the shared knowledge of the heroine's unconfessed guilt.

I Confess actually contains a whole series of confessions. The murderer, Otto Keller, gets off relatively easily by confessing his crime to his wife and to his priest, Father Logan, both of whom suffer acutely from the transference of the guilty secret. Father Logan stands trial for the murder of which Keller is guilty because as a priest he cannot betray the confidence of the confession. The most purgative confession is made by Logan's friend, Ruth. In order to establish an alibi for Logan's whereabouts during the time of the crime, she confesses (in a complicated flashback) to the police in front of her husband that she had loved Logan before and even after she married her husband. Her confession is not altogether true (she romantically implies adultery, which did not, in fact, take place), and it does not clear Logan. But its psychological benefit to her is suggested in the film's final sequence, a deadly showdown between Logan and Keller. Ruth turns with her husband to leave before Logan's problems are resolved. The gesture indicates that she is at last psychologically disengaged from her romantic illusions that her postmarital love for Logan was requited; Ruth and her husband are now ready to begin a more open and healthy marriage.

Father Logan's unconfessed knowledge puts him in the worst position of the characters. First, he feels obliged to martyr himself because he is unwilling to betray Keller's confidence. Then Hitchcock puts his silence in a more ambiguous context: his refusal to speak becomes a cause of death to innocent people. Inspector Larrue makes this idea explicit when he reminds Logan that his silence has cost the lives of Keller's wife and a hotel worker. However laudable Logan's motives, his silence is once more a passive form of murder.

The short distance between good and evil characters can also be seen by comparing how different groups use oral ellipsis to describe their activities. Just as the "good" spies in *Secret Agent*

avoid saying the word *murder*, so also the Nazi spies in *Notorious* speak bluntly about their research but not their killing. They may speak in polite circumlocutions. For example, they inform a scientist colleague that he will pay with his life for a small indiscretion by referring to a car trip from which he will not return. (He remonstrates that they should not go to so much trouble to drive him home.) Or they may simply stop short of finishing their sentences. For example, just after Sebastian discovers that his wife is an enemy agent, he tells his mother, "I stood looking at her while she was asleep. I could have. . . ." The Germans' elliptical use of language is yet another indication of their hypocritical gentility. At work here is a paradox that reveals Hitchcock's bleak view of the possibility of human communication. On the one hand, Hitchcock seems strongly in favor of characters' speaking their feelings (e.g., that Devlin and Erica should acknowledge their love to, respectively, Alicia and Robert). Yet, on the other hand, Hitchcock justifies his heroes' distrust of language by confirming their suspicions that it will be used against them. In *Young and Innocent* Robert learns that the police twist his innocent words when charging him with murder, so that his payment from an actress for writing a script, for example, becomes "received money from her on former occasions."

Hitchcock himself appears to have distrusted words. He carefully cultivated a public persona who used language guardedly in order to conceal his real opinions or feelings. He also always insisted that in his films actions reveal more than dialogue. Godard has pointed out in his analysis of *The Wrong Man* that its hero, Manny Balestrero, distrusts language.[4] Here, too, the police use Manny's own language against him, when he is forced to read an implicating note he writes. (It misspells the same word as did a note for the holdup of which he is accused.) When Manny simply tells the truth to establish his alibi, the police inform him that he will have to provide "a better story" if he wants to defend himself. *The Wrong Man* may be based on a true incident, but even in his totally fictional films Hitchcock similarly puts his characters into such incredible situations that the sane bystanders or policemen to whom they invariably appeal for help will never believe their stories—unless they *see* the evidence for themselves.

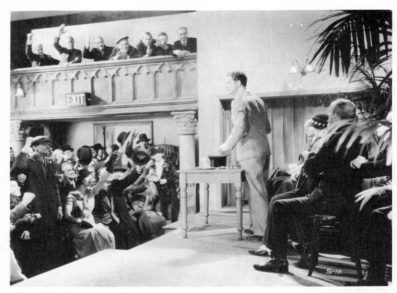

The Thirty-nine Steps. *Disdain for language: Robert Donat's double-talk succeeds at a political rally.*

The disdain for language that Hitchcock reveals in the absurd telephone conversation of *Blackmail* is repeated in later comic situations. Hitchcock often places his characters, during comic interludes, in hotel lobbies where the babble of several foreign languages is heard as sheer chaos. Spoto sees in *Foreign Correspondent* the theme that "ordinary language, at a time of international crisis, can conceal and reveal hidden meaning."[5] However, Hitchcock's most satiric comment about the deceptiveness of language comes in *The Thirty-nine Steps*, when the hero finds himself mistaken for the guest speaker at a political rally. Surrounded by pursuers, the hero fakes a speech combining pompous generalities with references to his own problems. His double-talk is cheered

and applauded by his audience as eloquent support for their candidate.

At the furthest end of the continuum from silence there is usually a scream, an outburst of pure, noncognitive feeling. If silence is the common denominator of most sorts of control, the scream is the common denominator of most extreme emotions. Hitchcock deliberately plays with the multiple reasons for a scream by confounding our expectations. I have already mentioned that in *Secret Agent* screams of terror turn out to be responses to sexual attack. Similarly, in *Strangers on a Train* the scream that we hear shortly after Bruno nears his intended victim, Miriam, in a Tunnel of Love turns out to be sexual. By reversing our expectations Hitchcock emphasizes the sexual undercurrents of his murders (a great many of his murderers have sexual problems). After Miriam's (silent) death, Hitchcock cuts from the screams of the man who discovers the corpse to the screams of riders on a Ferris wheel. Their screaming, like that of an audience watching a Hitchcock thriller, is half in fun and half in terror. I have shown that in *Psycho* Hitchcock inextricably mingles the screams of his audience with those of his characters. It is precisely by using the scream to link various kinds of experience that Hitchcock makes us appreciate, in a direct, emotional way, his central tenets that the connections between sexual, murderous, and voyeuristic impulses are closer than we usually care to admit.

Because screaming is just as frequent as its antinomy, silence, and considerably more perceptible, it is to this thematic constant of Hitchcock's career that I shall turn for a final survey that, among other things, recapitulates the evolution of Hitchcock's aural style.

As I mentioned in the preface, the very first image of the film that Hitchcock considered his first personal picture,[6] *The Lodger* (1926), is a close-up of a girl screaming. Hitchcock thus announces from the start of his career the double nature of his films: his interests will be both sensational (the scream will be a staple of the thriller genre when sound arrives) and metaphysical (because the scream here is silent, its primary aural function is eliminated, and it must have some other meaning). By opening with a scream (screams also begin *Murder*, *Rope*, and *To Catch a Thief*) the

director also initiates the action in medias res with a victim's
announcement that evil (chaos) has entered the community.

In *The Lodger* the scream creates tension; in *Blackmail* the
heroine's (second) scream relieves tension, for both the audience
and the girl, because it functions as a cathartic release of previ-
ously suppressed guilt. Here Hitchcock's expressionist heritage is
clearly at work. In *The Writer in Extremis* Sokel writes that "Herr-
mann Bahr, the Viennese critic, playwright, and essayist, singled
out the shriek as the chief characteristic of Expressionism."[7] For
expressionists, psychological reality took precedence over mere
external appearances, and the scream became an essential
manifestation of inner anguish, as in Edvard Munch's influential
lithograph, "The Scream."

Hitchcock's most famous scream is a transitional device of *The
Thirty-nine Steps* (1935) that merges a woman's scream with a train
whistle. The standard film histories often cite this transition as an
innovative use of sound, but, oddly enough, this is one sound
innovation for which Hitchcock does not deserve credit. The effect
can be found in *Pett and Pott*, an experimental General Post Office
film promoting the use of the telephone, which was released the
year before Hitchcock's film. (In 1934, Grierson, writing in *Sight
and Sound*, boasted of *Pett and Pott:* "Notice how the sound strip
invades the silent strip and turns a woman's cry into an engine
whistle."[8])

For the rest of the thirties the equation of human and mechanical
screams is a favorite Hitchcockian device. In *Sabotage*, for exam-
ple, the villains think that the scream of a window fan has come
from a screen character in an adjacent movie theater. Then in *The
Lady Vanishes* Hitchcock repeats the merging of human and train
screams. In each case the scream is a bravura effect that typically
obtrudes on the otherwise more subdued classical style of the film.
By contrast, train noises in the subjective films (especially *Shadow
of a Doubt, Spellbound, Strangers on a Train, The Wrong Man,* and
North by Northwest) are much more subtly orchestrated to heighten
tension and extend the feelings of the main characters. Hitchcock
eliminates the introduction of the human scream and simply gives
us the train whistle as the correlative of human emotion. It is the
equivalent of a shift from a simile (which announces an equation

with *like* or *as*) to figurative language that couches the analogy without proclaiming its cleverness.

The thrust of the subjective films is to reduce the hero to a state of utter vulnerability, and so it is significantly the hero himself who utters a scream at the film's climax. In *Under Capricorn* (1949) the heroine screams for help after she discovers that the housekeeper has been poisoning her. The housekeeper arrives first, but for once the wife refuses her help and insists on waiting for her husband. This choice is the turning point of her fortunes. The wife's rejection of the villainous housekeeper represents a rejection of her own weaker, passive nature and her renewal of trust in her husband. Whereas in *Rear Window* the hero's scream marks his dependence on other people, in the American version of *The Man Who Knew Too Much* the heroine's scream paradoxically marks her declaration of independence. The earlier part of the film reveals the wife to be the victim of a subtly domineering husband. He has forced her to abandon her professional identity (by refusing to move his medical practice to a large city where she could resume her career as a famous singer), and he has pacified her with sedatives when their child is kidnapped. In the two climaxes of the film it is the wife who, with her voice, first saves a diplomat and then rescues her son. The prolonged presentation of the Albert Hall sequence from her anguished point of view makes this version of the film subjective because the action is essentially a working out of her identity problems (so that ultimately the family can be reunited spiritually as well as physically). In Hitchcock's last subjective film, *Marnie*, the heroine "hears" a scream when her horse is injured. She runs to a nearby house and begs, "Get me a gun; my horse is screaming!" Only later do we understand that her shooting of the horse is a reenactment of her childhood killing of a sailor, while screaming hysterically. When she relives the original traumatic experience, she ends by trying to soothe her victim; she pats him on the head and says, "there, there," in the voice of the little girl to whom she has regressed. We then recall that she did the same thing with the horse.

In *Psycho* and *The Birds* Hitchcock introduces us to horror through the perceptions of his characters, but he ultimately dissociates the screams from their sources as he moves beyond the

subjective experience to a more direct presentation of horror. In the late films *(Torn Curtain, Topaz, Frenzy,* and *Family Plot),* Hitchcock shows little interest in either subjectivity or character development. Ernest Lehman, the scriptwriter of both *North by Northwest* and *Family Plot,* reported that Hitchcock actively resisted character exposition in *Family Plot:* "Here and there he sort of dropped things in to pay lip service to who these people are, but he really didn't want the explanations in the picture. I pleaded with him, so he put them back in the script and shot them, then edited them out of the picture."[9] Because Hitchcock is less interested in having the audience identify with the characters in the late films, he has less need to depend on the sound track as a resource for unobtrusive, subjective distortion.

Hitchcock also has less need in the late films for sound effects that assault the audience; the tone of his last four films is more meditative, and the director invites the audience to share his detachment. LaValley has succinctly defined Hitchcock's approach in these films: "He draws us away from what is happening to make us think about what it implies, about the relationship of one event to another, of event to character, of the expectations of genres to reality. He ponders his patterns."[10] Instead of probing the psyche of one character, Hitchcock encourages us to judge behavior by comparing characters; hence, the large number of principals (who are all spies) in *Topaz* or of mismatched couples in *Frenzy.*[11] When he does use sound to emphasize the contrast between characters, he can be openly stylized; hence, the extreme and abrupt alternations in *Family Plot* between the noisy couple and the silent couple.

In the late films Hitchcock still sees his characters as struggling in a largely hostile, impersonal world, but he invites us to share his ironic (though no less sympathetic) perspective rather than their anguish. Whereas earlier he waited inside with his characters as their private spaces were threatened by the aural intrusion of reality from outside, now he stays (or moves) outside. Nowhere is his exterior view of human destiny clearer than in *Frenzy,* where he literally shifts from interiors to exteriors in two sequences built around our expectations about the extremes of silence and screams. After showing the rape and strangling of the hero's ex-

Frenzy. *A stifled scream. Hitchcock builds two sequences around our expectations about the extremes of silence and screams.*

wife in her business office, Hitchcock cuts outdoors to a shot of the doorway and alley leading to her building. Hitchcock plays here with the clichéd expectation that a scream will be heard by deliberately holding the shot for a very long time with no noise and no motion. Finally, the victim's secretary returns from lunch, and, after still another wait, we hear her scream. Two women who are walking by at the time hear the scream, glance around perfunctorily, shrug, and keep on walking. The pessimistic implication is that even if the victim had managed to scream, no one would have helped anyway.

Having shown us one rape, Hitchcock does not bother to show the second, even though the victim is the most sympathetic woman in the film (she plays the familiar role of the woman who trusts a wrongly accused man). Hitchcock shows her going upstairs with

the rapist, who repeats to her the words he told his last victim. However, when the couple enter his apartment, the door is closed in the viewer's face, and in one long, slow camera movement Hitchcock withdraws back down the stairs, out the front door, and across a busy, noisy Covent Garden street. Hitchcock said of the shot: "I brought the sound up three times its volume, so that the audience subconsciously would say, 'Well, if the girl screams, it's never going to be heard.' "[12]

As a measure of the continuities and changes in Hitchcock's style over nearly half a century of filmmaking, it is instructive to compare the sequences in which victims do or do not scream in Hitchcock's three rape films, *The Lodger, Blackmail,* and *Frenzy.* Each example reveals Hitchcock's distinctive stylization and perversity. In the silent *Lodger,* with its opening close-up of a woman shrieking, Hitchcock gives us a scream where we would expect silence. (The shot is a paradigm of Arnheim's contention that a visualized sound in a silent film can be more effective than a real sound in a talking picture.[13]) By contrast, in the above shots in *Frenzy* Hitchcock gives us silence (or traffic noise) where we would expect screams. It is most useful to contrast the two shifts in *Frenzy* to the perspective of the oblivious outside world with the cut to the oblivious policeman in *Blackmail* during the rapist's attack. In the earlier film, it will be recalled, the shot, photographed through a window, maintains the perspective of the screaming victim. All four of these sequences typify Hitchcock's approach to the sound track. His sounds (and silences), like his images, are seldom merely functional; they not only further the narrative but also embody the director's basic attitudes and ideas. The most striking of these aural (and visual) concepts often crystallize Hitchcock's overall view of the human condition. Such is the case with the two postattack sequences in *Frenzy,* sequences that, by comparison with their earlier counterparts, suggest how far Hitchcock's art has developed since his earliest films. The sequences in *Frenzy* are more elaborate in conception and execution but also much more profound in implication. The mature Hitchcock has become highly aware and highly confident of his style. His vision is no less profound for having moved from the depths of the soul to the heights of social perspective. As Andrew Sarris has said, "When Hitchcock

described how he had adjusted the sound in two sequences in *Frenzy*, once downward to convey nothingness and once upward to convey a cosmic outsideness, he revealed himself once more to be one of the greatest of all film poets, at once lucid in communicating with others and lyrical in expressing his own feelings. And above all selective in shooting less than he knows so that we can feel more than we see."[14] I would amend that to read "more than we see or *hear*."

Notes

1. The contrast between one couple's control and the other couple's sloppiness extends to their relative styles of eating, dress, and housekeeping but is most thoroughly worked out in terms of their speaking styles.

2. He attracts her attention by tinkling a glass wind chime. Even the decor for the garrulous couple is noisier than that for the silent couple, whose most conspicuous piece of furnishing is an immobile chandelier.

3. Claude Chabrol, "Hitchcock Confronts Evil," *Cahiers du Cinéma in English*, no. 2 (1966), p. 69; originally published as "Hitchcock devant le mal," *Cahiers du Cinéma*, no. 39, (October 1954), pp. 18–24.

4. Jean-Luc Godard, "Le Cinéma et son double," *Cahiers du Cinéma*, no. 72 (June 1957), p. 39.

5. Donald M. Spoto, *The Art of Alfred Hitchcock* (New York: Hopkinson and Blake, 1976), p. 105.

6. François Truffaut, *Hitchcock* (New York: Simon and Schuster, 1967; originally published as *Le Cinéma selon Hitchcock* [Paris: Robert Laffont, 1966]), p. 31.

7. Walter H. Sokel, *The Writer in Extremis* (Stanford, Calif.: Standford Univ. Press, 1959), p. 4.

8. John Grierson, "Introduction to a New Art," *Sight and Sound* (Autumn 1934), p. 104.

9. Quoted in Chris Hodenfeld, "Murder by the Babbling Brook," *Rolling Stone*, 29 July 1976, p. 42.

10. Albert J. LaValley, in his *Focus on Hitchcock* (Englewood Cliffs, N.J.: Prentice-Hall, 1972), p. 13, is speaking only of *Torn Curtain* and *Topaz*, but his comments apply as well to the films released after the publication of his work.

11. The couples in *Frenzy* are compared by T. J. Ross in "Aspects of Hitchcock," *December* 18, nos. 2 and 3 (1976): 85–89.

12. Quoted in Eric Sherman, ed., *Directing the Film: Film Directors on Their Art* (Boston: Little, Brown, 1976), p. 21.

13. Rudolf Arnheim, *Film as Art* (Berkeley, Calif.: Univ. of Calif. Press, 1957), pp. 106–9.

14. Andrew Sarris, "Films in Focus," *The Village Voice*, 22 June 1972.

Appendix: Hitchcock Filmography___

The date of a British film indicates the year of its initial presentation at a trade show; the date of an American film indicates the year of its American premiere. The studio listing indicates the major studio involved in the production of each film; individual producers and releasing companies are usually not included. Cast listings are provided for those actors who are identified above by name as opposed to role (e.g., "the heroine"). The listing of television films is taken from the article by Jack Edmund Nolan. More complete credits for Hitchcock's feature films can be found in the books by Truffaut and Wood.

Feature Films Directed by Hitchcock

1925 *The Pleasure Garden*, Gainsborough

1926 *The Mountain Eagle*, Gainsborough (U.S. title: *Fear o' God*)

 The Lodger, Gainsborough (U.S. title: *A Story of the London Fog*)

1927 *Downhill*, Gainsborough (U.S. title: *When Boys Leave Home*)

 Easy Virtue, Gainsborough

 The Ring, British International Pictures (B.I.P.)

1928 *The Farmer's Wife*, B.I.P.

 Champagne, B.I.P.

1929 *The Manxman*, B.I.P.

 Blackmail, B.I.P.

 Alice—Anny Ondra

 Frank—John Longden

 The Artist—Cyril Ritchard

 Tracy—Donald Calthrop

1930 *Juno and the Paycock*, B.I.P.
 Murder, B.I.P.
 Sir John—Herbert Marshall
 Diana—Norah Baring
 Markham—Edward Chapman
1931 *The Skin Game*, B.I.P.
1932 *Rich and Strange*, B.I.P. (U.S. title: *East of Shanghai*)
 Number Seventeen, B.I.P.
1933 *Waltzes from Vienna*, Tom Arnold (U.S. title: *Strauss's Great Waltz*)
1934 *The Man Who Knew Too Much*, Gaumont British
 Abbott—Peter Lorre
 Lawrence—Leslie Banks
 Clive—Hugh Wakefield
 Ramon—Frank Vosper
 Mrs. Lawrence—Edna Best
1935 *The Thirty-nine Steps*, Gaumont British
1936 *The Secret Agent*, Gaumont British
 Elsa—Madeleine Carroll
 Ashenden—John Gielgud
 The General—Peter Lorre
 Marvin—Robert Young
 Caypor—Percy Marmont
 "R"—Charles Carson
 Sabotage, Gaumont British (U.S. title: *The Woman Alone*)
 Mrs. Verloc—Sylvia Sidney
 Verloc—Oscar Homolka
1937 *Young and Innocent*, Gainsborough/Gaumont British (U.S. title: *The Girl Was Young*)
 Robert—Derrick de Marney
 Erica—Nova Pilbeam
1938 *The Lady Vanishes*, Gainsborough
 Gil—Michael Redgrave
 Dr. Hartz—Paul Lukas
1939 *Jamaica Inn*, Mayflower

1940 *Rebecca*, Selznick
 Foreign Correspondent, Walter Wanger/United Artists
1941 *Mr. and Mrs. Smith*, R.K.O.
 Suspicion, R.K.O.
1942 *Saboteur*, Universal
1943 *Shadow of a Doubt*, Universal
 Uncle Charles—Joseph Cotten
 Charlie—Teresa Wright
 Lifeboat, Twentieth Century–Fox
 Gus—William Bendix
 Willy—Walter Slezak
1945 *Spellbound*, Selznick
1946 *Notorious*, R.K.O.
 Alicia—Ingrid Bergman
 Devlin—Cary Grant
 Sebastian—Claude Rains
1947 *The Paradine Case*, Selznick
 Mrs. Paradine—Alida Valli
1948 *Rope*, Transatlantic/Warner Brothers
 Philip—Farley Granger
 Rupert—James Stewart
1949 *Under Capricorn*, Transatlantic/Warner Brothers
1950 *Stage Fright*, A.B.P.C./Warner Brothers
 Charlotte Inwood—Marlene Dietrich
1951 *Strangers on a Train*, Warner Brothers
 Bruno—Robert Walker
 Miriam—Laura Elliot
1953 *I Confess*, Warner Brothers
 Keller—O. E. Hasse
 Logan—Montgomery Clift
 Ruth—Anne Baxter
 Larrue—Karl Malden
1954 *Dial M for Murder*, Warner Brothers
 Tony—Ray Milland

Rear Window, Paramount
 Jeff—James Stewart
 Lisa—Grace Kelly
 Miss Lonelyhearts—Judith Evelyn
 Thorwald—Raymond Burr
1955 *To Catch a Thief*, Paramount
 The Trouble with Harry, Paramount
1956 *The Man Who Knew Too Much*, Paramount
 Dr. MacKenna—James Stewart
 Jo MacKenna—Doris Day
 Mrs. Drayton—Brenda de Banzie
 The Wrong Man, Warner Brothers
 Manny Balestrero—Henry Fonda
1958 *Vertigo*, Paramount
 Scottie—James Stewart
 Madeleine—Kim Novak
 Midge—Barbara Bel Geddes
1959 *North by Northwest*, MGM
 Thornhill—Cary Grant
 Eve Kendall—Eva Marie Saint
1960 *Psycho*, Paramount
 Marion—Janet Leigh
 Norman—Anthony Perkins
 Lila—Vera Miles
 Sam—John Gavin
1963 *The Birds*, Universal
 Melanie—Tippi Hedren
 Mitch—Rod Taylor
1964 *Marnie*, Universal
 Marnie—Tippi Hedren
1966 *Torn Curtain*, Universal
1969 *Topaz*, Universal
1972 *Frenzy*, Universal

1976 *Family Plot,* Universal
 Blanche—Barbara Harris
 George—Bruce Dern
 Fran—Karen Black
 Arthur—William Devane

Television Films Directed by Hitchcock

1. *Revenge,* "Alfred Hitchcock Presents," CBS, 2 October 1955.
2. *Breakdown,* "Alfred Hitchcock Presents," CBS, 13 November 1955.
3. *The Case of Mr. Pelham,* "Alfred Hitchcock Presents," CBS, 4 December 1955.
4. *Back for Christmas,* "Alfred Hitchcock Presents," CBS, 4 March 1956.
5. *Wet Saturday,* "Alfred Hitchcock Presents," CBS, 30 September 1956.
6. *Mr. Blanchard's Secret,* "Alfred Hitchcock Presents," CBS, 23 December 1956.
7. *One More Mile to Go,* "Alfred Hitchcock Presents," CBS, 7 April 1957.
8. *Four O'Clock,* "Suspicion," NBC, 30 September 1957.
9. *The Perfect Crime,* "Alfred Hitchcock Presents," CBS, 20 October 1957.
10. *Lamb to the Slaughter,* "Alfred Hitchcock Presents," CBS, 13 April 1958.
11. *Dip in the Pool,* "Alfred Hitchcock Presents," CBS, 14 September 1958.
12. *Poison,* "Alfred Hitchcock Presents," various dates in late 1958.
13. *Banquo's Chair,* "Alfred Hitchcock Presents," CBS, 3 May 1959.
14. *Arthur,* "Alfred Hitchcock Presents," CBS, 27 September 1959.
15. *The Crystal Trench,* "Alfred Hitchcock Presents," CBS, 4 October 1959.

16. *Incident at a Corner*, "Ford Star Time," NBC, 5 April 1960.
17. *Mrs. Bixby and the Colonel's Coat*, "Alfred Hitchcock Presents," NBC, 27 September 1960.
18. *The Horseplayer*, "Alfred Hitchcock Presents," NBC, 14 March 1961.
19. *Bang! You're Dead!*, "Alfred Hitchcock Presents," NBC, 17 October 1961.
20. *I Saw the Whole Thing*, "Alfred Hitchcock Presents," CBS, 11 October 1962.

A Selected Bibliography

Articles and Books on Hitchcock

Because bibliographies on Alfred Hitchcock may be readily obtained, the articles listed below are only those of historical importance or greatest relevance to this study. An exhaustive bibliography of writings about Hitchcock in English from 1925 to 1975 was compiled by C. Cramer for the Museum of Modern Art in New York City and is available at its Film Study Center. An extensive annotated bibliography may be found in *Focus on Hitchcock*, edited by Albert J. LaValley. Special attention should also be drawn to the four following periodical issues devoted largely to articles on Hitchcock: *Cahiers du Cinéma*, no. 39 (October 1954); *Cahiers du Cinéma*, no. 62 (August/September 1956); *Cahiers du Cinéma in English*, no. 2 (1966); and *Take One* 5 (21 May 1976).

Amengual, Barthélemy, and Borde, Raymond. *Alfred Hitchcock*. Premier Plan, no. 7. Lyon: Serdoc, 1960.

Bazin, André. "Hitchcock versus Hitchcock." *Cahiers du Cinéma in English*, no. 2 (1966), pp. 51–54. Originally published in *Cahiers du Cinéma*, no. 39 (October 1954), pp. 25–32.

Belton, John. "Hitchcock in Britain." *The Thousand Eyes* 2 (Winter 1979), pp. 5–9.

————."The Mechanics of Perception." *Cambridge Phoenix*, 16 October 1969.

————. "Dexterity in a Void: The Formalist Aesthetics of Alfred Hitchcock." *Cineaste* 10 (Summer 1980): pp. 9–13.

Bogdanovich, Peter. *The Cinema of Alfred Hitchcock*. New York: Museum of Modern Art, 1963.

Bond, Kirk. "The Other Alfred Hitchcock." *Film Culture*, no. 41 (Summer 1966), pp. 30–35.

Bordonaro, Peter. *Dial M for Murder:* A Play by Frederick Knott/A Film by Alfred Hitchcock." *Sight and Sound* 45 (Summer 1976):175–79.

Bordwell, David. "Alfred Hitchcock's *Notorious.*" *Film Heritage* 4 (Spring 1969):6.

Braudy, Leo. "Hitchcock, Truffaut, and the Irresponsible Audience." *Film Quarterly* 21 (Summer 1968):21–27.

Cameron, Ian. "Hitchcock and the Mechanics of Suspense." *Movie*, no. 3 (October 1962), pp. 4–7.

———. "Hitchcock 2: Suspense and Meaning." *Movie*, no. 6 (January 1963), pp. 8–12.

Cameron, Ian, and Jeffery, Richard. "The Universal Hitchcock." *Movie*, no. 12 (Spring 1965), pp. 21–24.

Cameron, Ian, and Perkins, V. F. "Hitchcock: Interview." *Movie*, no. 6 (January 1963), pp. 4–6.

Chabrol, Claude. "Hitchcock Confronts Evil." *Cahiers du Cinéma in English*, no. 2 (1966), pp. 67–70. Originally published as "Hitchcock devant le mal." *Cahiers du Cinéma*, no. 39 (October 1954), pp. 18–24.

Douchet, Jean. "Hitch et son public." *Cahiers du Cinéma*, no. 113 (November 1960), pp. 7–15.

———. *Alfred Hitchcock*. Paris: Cahiers de l'Herne, 1967.

Durgnat, Raymond. *The Strange Case of Alfred Hitchcock; or, The Plain Man's Hitchcock*. Cambridge, Mass.: MIT Press, 1974.

Dyer, Peter John. "Young and Innocent." *Sight and Sound* 30 (Spring 1961):80–83.

Farber, Manny. "Clutter." In *Negative Space*. New York: Praeger, 1971.

Ferguson, Otis. Reviews of *Secret Agent*, *The Lady Vanishes*, *Jamaica Inn*, *Rebecca*, *Foreign Correspondent*, *Mr. and Mrs. Smith*, and *Suspicion*. Reprinted in *The Film Criticism of Otis Ferguson*, edited and with a preface by Robert Wilson. Philadelphia: Temple Univ. Press, 1971.

Godard, Jean-Luc. "Le Cinéma et son double." *Cahiers du Cinéma*, no. 72 (June 1957), pp. 35–42.

Gilliatt, Penelope. "The London Hitch." *The New Yorker*, 11 September 1971, pp. 91–94.

Greenspun, Roger. "Plots and Patterns." *Film Comment* 12 (May/June 1976):20–22.

Haller, R. "Alfred Hitchcock: Beyond Suspense." *Notre Dame Student-Faculty Film Society*, n.d.

Hardison, O. B. "The Rhetoric of Hitchcock's Thrillers." In *Man and the*

Movies, edited by W. R. Robinson. Baton Rouge, La.: Louisiana State Univ. Press, 1967, pp. 137–52.

Hardy, Forsyth. "Films of the Quarter." *Cinema Quarterly* 3 (Winter 1935):119.

Haskell, Molly. *"Stage Fright." Film Comment* 6 (Fall 1970):49–50.

Higham, Charles. "Hitchcock's World." *Film Quarterly* 16 (Winter 1962):3–16.

Higham, Charles, and Greenberg, Joel. "Alfred Hitchcock." In *The Celluloid Muse: Hollywood Directors Speak*. Chicago: Angus and Robertson, 1971.

Hitchcock, Alfred. "Direction." In *Footnotes to the Film*, edited by Charles Davy. London: Lovat Dickson & Thomson, 1937. Reprinted in *Focus on Hitchcock*, edited by Albert J. LaValley. Englewood Cliffs, N.J.: Prentice-Hall, 1972.

————. *"Rear Window." Take One* 2 (November/December 1968):18–20.

Hodenfeld, Chris. "Murder by the Babbling Brook." *Rolling Stone*, 29 July 1976: pp. 38–42.

Houston, Penelope. "The Figure in the Carpet." *Sight and Sound* 32 (Autumn 1963):159–64.

Kane, Lawrence. "The Shadow World of Alfred Hitchcock." *Theatre Arts* 33 (May 1959):33–40.

Kaplan, George (pseud.). "Lost in the Wood." *Film Comment* 8 (November/December 1972):46–53.

Lambert, Gavin. "Hitchcock and the Art of Suspense." *American Film* 1 (January/February 1976):22.

LaValley, Albert J., ed. *Focus on Hitchcock*. Englewood Cliffs, N.J.: Prentice-Hall, 1972.

Low, Rachel. *The History of the British Film: Volume IV, 1918–1928*. London: Allen and Unwin, 1971.

Mazzocco, Robert. "It's Only a Movie." *New York Review of Books*, 26 February 1970, pp. 27–31.

Millar, Gavin. "Hitchcock versus Truffaut." *Sight and Sound* 38 (Spring 1969):82–86.

Naremore, James. *Filmguide to "Psycho."* Bloomington, Ind.: Indiana Univ. Press, 1973.

"New York Close Up." *New York Herald Tribune*, 26 February 1950, p. 18.

Noble, Peter. "An Index to the Creative Work of Alfred Hitchcock." *Sight and Sound* supplement, index series, no. 18. London, 1949.

Nolan, Jack Edmund. "Hitchcock's TV Films." *Film Fan Monthly* 84 (June 1968):3–6.

Pechter, William S. "The Director Vanishes." *Moviegoer*, no. 2 (Summer/Autumn 1964), pp. 37–50.

Perkins, V. F. "*Rope*." *Movie*, no. 7 (February 1963), pp. 11–13.

————. *Film as Film: Understanding and Judging Movies*. Middlesex: Penguin Books, 1972.

Perry, George. *The Films of Alfred Hitchcock*. London: Studio Vista, 1965.

Prokosch, Mike. "*Topaz*." Unpublished manuscript, 19 February 1970.

Rohmer, Eric, and Chabrol, Claude. *Hitchcock*. Paris: Editions Universitaires, 1957. Republished in English as *Hitchcock: The First Forty-four Films*, trans. Stanley Hochman. New York: Frederick Ungar, 1979.

Ross, T. J. "Aspects of Hitchcock." *December* 18, nos. 2 and 3 (1976):75–91.

Russell, Lee. "Alfred Hitchcock," *New Left Review*, no. 35 (January / February 1966), pp. 88–92.

Samuels, Charles Thomas. "Hitchcock." *American Scholar* 39 (Spring 1970):295–304.

Sarris, Andrew. "Alfred Hitchcock." In *The American Cinema*. New York: E. P. Dutton, 1968, pp. 56–61.

————. "Films in Focus." *Village Voice*, 22 June 1972, p. 69.

Schickel, Richard. "We're Living in a Hitchcock World All Right." *The New York Times Magazine*, 29 October 1972, p. 22.

————. *The Men Who Made the Movies*. New York: Atheneum, 1975. (Excerpts from interviews for WNET television series "The Men Who Made the Movies," 1973.

Sherman, Eric., ed. *Directing the Film: Film Directors on their Art*. Boston: Little, Brown, 1976.

Simsolo, Noel. *Hitchcock*. Cinéma d'Aujourd'hui, no. 54. Paris: Editions Seghers, 1969.

Sonbert, Warren. "Alfred Hitchcock: Master of Morality." *Film Culture*, no. 41 (Summer 1966), pp. 35–38.

Spoto, Donald M. *The Art of Alfred Hitchcock*. New York: Hopkinson and Blake, 1976.

————. "Sound and Silence in the Films of Alfred Hitchcock." *Keynote* 4 (Apr. 11, 1980), pp. 12–17.

Taylor, John Russell. "Alfred Hitchcock." In *Cinema Eye, Cinema Ear: Some Key Film-Makers of the Sixties.* New York: Hill and Wang, 1964, pp. 170–99.

————. *Hitch: The Life and Times of Alfred Hitchcock.* New York: Pantheon Books, 1978.

Thompson, David. *Movie Man.* New York: Secker and Warburg, 1967.

Truffaut, François. *Hitchcock.* New York: Simon and Schuster, 1967. Originally published as *Le Cinéma selon Hitchcock.* Paris: Robert Laffont, 1966.

Walker, Michael. "The Old Age of Alfred Hitchcock." *Movie,* no. 18 (Winter 1971), pp. 10–13.

Watts, Steven. "Alfred Hitchcock on Music in Films." *Cinema Quarterly* 2 (Winter 1933–34):80–83.

Wollen, Peter. "Hitchcock's Vision." *Cinema* (Cambridge), no. 3 (June 1969), pp. 2–4.

Wood, Robin. *Hitchcock's Films.* London: A. Zwemmer; Cranbury, N.J.: A. S. Barnes, 1965, rev. 1969.

Yacowar, Maurice. "Hitchcock: The Best of the Earliest." *Take One* (21 May 1976):42–45.

Articles and Books on Film Sound

Theory and Criticism

Altman, Rich, ed. *Cinema/Sound. Yale French Studies* 60 (1980).

Arnheim, Rudolf. *Film as Art.* Berkeley, Calif.: Univ. of Calif. Press, 1957.

Balazs, Bela. "Sound," "Dialogue," and "Problem of the Sound Comedy." In *Theory of Film: Character and Growth of a New Art.* New York: Roy, 1953.

Braudy, Leo. *The World in a Frame: What We See in Films.* Garden City, N.Y.: Doubleday, Anchor, 1976.

Bresson, Robert. *Notes on Cinematography.* New York: Urizen Books, 1977.

Burch, Noël. *Theory of Film Practice*. Translated by Helen R. Lane. New York: Praeger, 1973.

Clair, René. *Reflections on the Cinema*. London: William Kimber, 1963.

Eisenstein, Sergei; Pudovkin, V. I.; and Alexandrov, G. V. "A Statement on the Sound Film." In Eisenstein, Sergei, *Film Form: Essays in Film Theory* and *The Film Sense*, translated and edited by Jay Leyda. Cleveland, Ohio: World Publishing, Meridian, 1957.

Fischer, Lucy. "Beyond Freedom and Dignity. An Analysis of Jacques Tati's *Playtime*." *Sight and Sound* 45 (Autumn 1976), pp. 234–38.

Giannetti, Louis D. "Sound." In *Understanding Movies*. Englewood Cliffs, N.J.: Prentice-Hall, 1972.

Goldfarb, Phyllis. "Orson Welles's Use of Sound." *Take One* 3 (July/ August 1971): 10–14.

Gorbman, Claudia. "Teaching the Soundtrack." *Quarterly Review of Film Studies* (Nov. 1976), pp. 446–52.

Image et Son, no. 215 (March 1968). Special issue on sound.

Jacobs, Lewis, ed. "Sound," by the editor. In *The Movies as Medium*. New York: Farrar, Straus and Giroux, 1970.

Kracauer, Siegfried. "Dialogue and Sound" and "Music." In *Theory of Film: The Redemption of Physical Reality*. New York: Oxford Univ. Press, 1960.

Lambert, Gavin. "Sight and Sound." *Sequence*, no. 11 (Summer 1950), pp. 3–7.

Mitry, Jean. "Le parole et le son." *Esthétique et Psychologie du Cinéma* 2 (Paris: Editions Universitaires, 1965), pp. 87–176.

Petric, Vlada. "Sight and Sound: Counterpoint or Entity?" *Filmmakers Newsletter* 6 (May 1973): 27–31.

Potter, Ralph K. "Audiovisual Music." *Hollywood Quarterly* 3 (Fall 1947): 66–78.

Pudovkin. V. "Asynchronism as a Principle of Sound Film" and "Rhythmic Problems in My First Sound Film," in *Film Technique;* "Dialogue" and "Dual Rhythm of Sound and Image," in *Film Acting*. New York: Grove Press, 1960.

Rosenbaum, Jonathan. "Sound Thinking." *Film Comment* 14 (Sept.-Oct. 1978), pp. 38–41.

Rosenbaum, Jonathan. "Bresson's *Lancelot du Lac*." *Sight and Sound* 43 (Summer 1974), pp. 128–30.

Spottiswoode, Raymond. *A Grammar of the Film*. Berkeley, Calif.: Univ. of Calif. Press, 1960.

Stevenson, Ralph, and Debrix, J. R. "The Fifth Dimension: Sound." In *The Cinema as Art*. Baltimore, Md.: Penguin, 1965.

Weinberg, Herman G. "The Language Barrier." *Hollywood Quarterly* 2 (July 1947): 333–37.

Whitaker, Rod. "Audio Content." In *The Language of Film*. Englewood Cliffs, N.J.: Prentice-Hall, 1970.

Technique

Bigbee, Lynn. "Basic Elements of Sound Recording." *Filmmakers Newsletter* 3 (October 1970); 36–42.

Evans, Arthur G. "The Basics of Sound Synchronism." *American Cinematographer* 52 (April 1971): 324.

Groves, George R. "The Soundman." *Journal of the SMPE* 48 (March 1947): 220–30.

Lewin, Frank. "The Soundtrack in Nontheatrical Motion Pictures." *Journal of the SMPTE* 68, nos. 3, 6, 7 (March, June, July 1959).

Limbacher, James L. "Sound." In *Four Aspects of the Film*. New York: Brussel and Brussel, 1968.

McCullum, Gordon. "Sound Department." *Films and Filming* 3 (August 1957): 30–31.

Musgrave, Peter. "The Dubbing of Sound." *American Cinematographer* 43 (March 1962): 168–69.

Nisbett, Alan. *The Technique of the Sound Studio*. New York: Hastings House, 3d ed. rev. 1972.

Oringel, Robert S. *Audio Control Handbook*. New York: Hastings House, 1963.

Sturhahn, Larry. "The Art of the Sound Editor: An Interview with Walter Murch." *Filmmakers Newsletter* 8 (December 1974): 22–25.

Weatherford, Bob. "Sound Dubbing—A Specialized Recording Technique." *American Cinematographer* 39 (July 1958): 432–433.

Early Sound Filmmaking

Abbott, J. E. "Development of the Sound Film." *Journal of the SMPE* 38 (June 1942): 541.

De Forest, Lee. "Pioneering in Talking Pictures." *Journal of the SMPE* 36 (January 1941): 41.

Fielding, Raymond. *A Technological History of Motion Pictures and Television*. Berkeley, Calif.: Univ. of Calif. Press, 1967.

Fox, Julian. "Casualties of Sound—King Mike." *Films and Filming* 19 (October 1972): 34–40.

Franklin, Harold B. *Sound Motion Pictures*. Garden City, N.Y.: Doubleday, 1930.

Geduld, Harry M. *The Birth of the Talkies: From Edison to Jolson*. Bloomington, Ind.: Indiana Univ. Press, 1975.

Gomery, Douglas. "Problems in Film History: How Fox Innovated Sound." *Quarterly Review of Film Studies* (August 1976), pp. 315–30.

Grierson, John. "The G.P.O. Gets Sound." *Cinema Quarterly* 2 (Summer 1934): 215–21.

————. "Introduction to a New Art." *Sight and Sound* 3 (Autumn 1934): 101–4.

Jones, G. F. *Sound-Film Reproduction*. London: Blackie and Son, 1936.

Kellogg, Edward W. "History of Sound Motion Pictures." *Journal of the SMPTE* 64 (June 1955): 291.

Lightman, Herb. "The Film Finds Its Voice." *American Cinematographer* 50 (January 1969): 84–85.

Patterson, Richard. "Motion Picture Sound: A Long Way From the 'Ice Box.'" *American Cinematographer* 52 (April 1971): 320–23.

Salt, Barry. "Film Style and Technology in the Thirties." *Film Quarterly* 30 (Fall 1976): 19–32.

Sponable, Earl. "Historical Development of Sound Films." *Journal of the SMPE* 48 (April 1947): 275.

Stewart, James G. Interview of Brian E. Foy. Presented at the "Eastman House Symposium on the Coming of Sound to the American Film, 1925–1940." Rochester, N.Y., Oct. 1973.

Theisen, W. E. "Pioneering in the Talking Picture." *Journal of the SMPE* 48 (April 1947): 415.

Walker, Alexander. *The Shattered Silents: How the Talkies Came to Stay*. New York: Wm. Morrow and Co., 1979.

Wente, F., et al. "Synchronized Reproduction of Sound and Scene." Monograph reprinted from *Bell Laboratories Record* (Nov. 1928).

Music

Alwyn, William. "Composing for the Screen." *Films and Filming* 5 (March 1959): 9.

Antheil, George. "New Tendencies in Composing for Motion Pictures." *Film Culture* 1 (Summer 1955): 16–17.

Dane, Jeffrey. "The Significance of Film Music." *American Cinematographer* 42 (May 1961): 302.

Eisler, Hans. *Composing for the Films*. New York: Oxford Univ. Press, 1946.

Evans, Mark. *Soundtrack: The Music of the Movies*. New York: Hopkinson and Blake, 1975.

Forrest, David. "From Score to Screen." *Hollywood Quarterly* 1 (Jan. 1946): 224–29.

Fothergill, Richard. "Putting Music in Its Place." *Films and Filming* 5 (March 1959): 10.

Gilling, Ted. "The Colour of the Music: An Interview with Bernard Herrmann." *Sight and Sound* 41 (Winter 1971–72): 36–39.

Green, Philip. "The Music Director." *Films and Filming* 3 (June 1957): 12.

Johnson, William. "Face the Music." *Film Quarterly* 22 (Summer 1969): 3–19.

London, Kurt. *Film Music: A Summary of the Characteristic Features of Its History, Aesthetics, Technique and Its Possible Developments*. London: Faber, 1936.

Manvell, Roger, and Huntley, John. *The Technique of Film Music*. New York: Hastings House, Communications Arts Books, 1957.

Morton, Lawrence. "Composing, Orchestrating, and Criticizing." *Quarterly of Film, Radio and Television* (Winter 1951):191–206.

Nelson, Robert U. "Film Music: Color or Line?" *Hollywood Quarterly* 1 (October 1946):57–65.

Thomas, Tony. *Music for the Movies*. New York: A. S. Barnes, 1973.

Other Works Cited

Adams, Jack A., and Chambers, Ridgely. "Response to Simultaneous Stimulation of Two Sense Modalities." *Journal of Experimental Psychology* 63 (1962):198–206.

Dallenbach, Karl M. "Attention." *Psychological Bulletin:* vol. 23 (1926):1–18; vol. 25 (1928):493–512; and vol. 27 (1930):497–513.

Renoir, Jean. *My Life and My Films*. Translated by Norman Denny. New York: Atheneum, 1974.

Sokel, Walter H. *The Writer in Extremis*. Stanford, Calif.: Stanford Univ. Press, 1959.

Wölfflin, Heinrich. *Principles of Art History: The Problem of the Development of Style in Later Art*. Translated by M. D. Hottinger. New York: 1950.